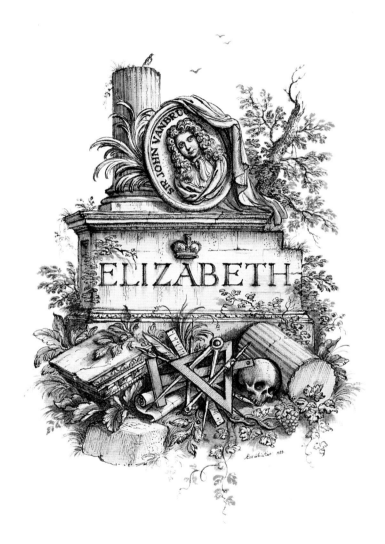

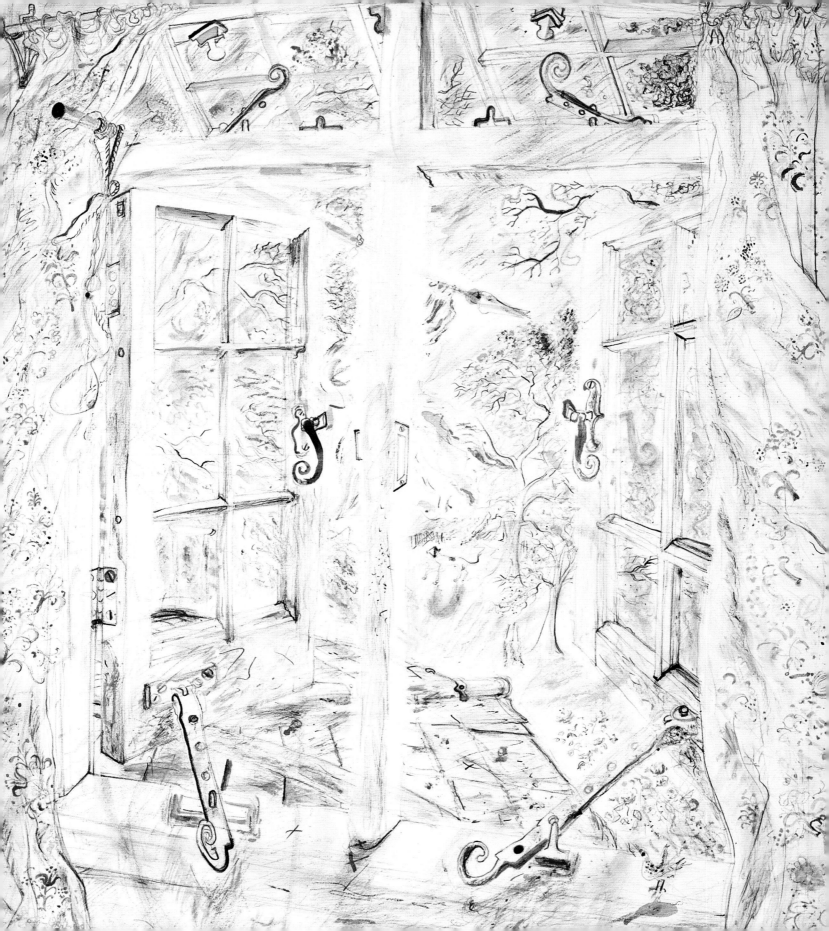

Watercolours and Drawings
from the Collection of
Queen Elizabeth
The Queen Mother

Susan Owens

Royal Collection Publications

This publication has been generously supported
by Sir Harry Djanogly, CBE

Published by
Royal Collection Enterprises Limited
St James's Palace
London SW1A 1JR

For a complete catalogue of current publications,
please write to the above address or
visit the website at www.royal.gov.uk

© 2005 Royal Collection Enterprises Limited
Text and reproduction of all items in the Royal Collection
© 2005 HM Queen Elizabeth II

139121

ISBN 1 902163 78 8

British Library Cataloguing in Publication Data:
a catalogue record of this book is available from
the British Library.

Designed by Mick Keates
Produced by Book Production Consultants plc, Cambridge
Printed and bound by Studio Fasoli, Verona

ILLUSTRATIONS

Half title
Rex Whistler, 'book-plate' for Queen Elizabeth drawn inside the
front cover of Laurence Whistler, *Sir John Vanbrugh. Architect
and Dramatist*, London, 1938
Pen and ink. 22.2 × 14.9 cm (8¼″ × 5⅞″) RCIN 933864

Frontispiece
David Jones, *'The outward walls'*, 1953
Pencil, coloured pencil, watercolour and bodycolour
79 × 58.7 cm (31⅛″ × 23⅛″) RCIN 453574 (no. 58, detail)

Opposite Foreword
Hugh Buchanan, *Desks in Royal Lodge*, 2000
Pencil, watercolour and acrylic with airbrush
76 × 56.4 cm (29¹⁵⁄₁₆″ × 22³⁄₁₆″) RCIN 453573 (no. 22, detail)

Opposite Preface
Paul Sandby, *Deputy Ranger's Lodge, Windsor Great Park,
with figures in foreground*, 1798
Pencil, watercolour and bodycolour
51.9 × 41.3 cm (20⁷⁄₁₆″ × 16¼″) RCIN 453594 (no. 19, detail)

EXHIBITION DATES

The Queen's Gallery, Palace of Holyroodhouse
March – September 2005

The Queen's Gallery, Buckingham Palace
June – October 2006

Contents

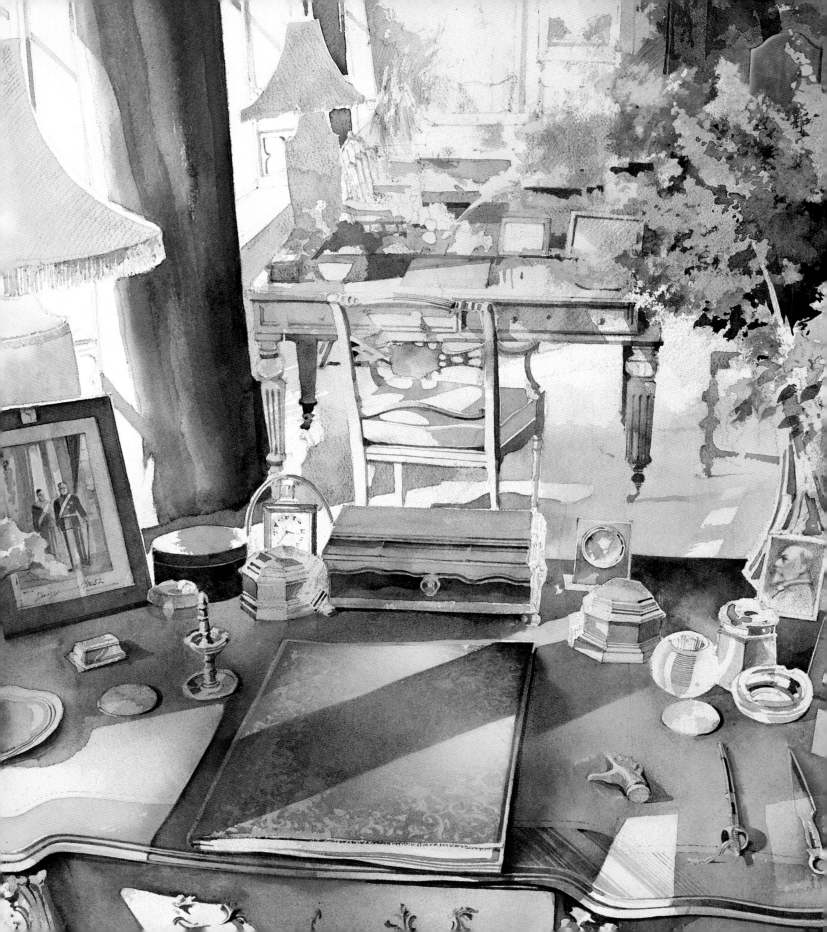

CLARENCE HOUSE

My Grandmother's lifelong delight in good draughtsmanship and her eye for the original and unusual is well reflected in this varied selection of works from her extensive collection of watercolours and drawings. Among the many images with which Queen Elizabeth surrounded herself, the ones I particularly remember noticing from an early age were the dramatic and romantic views of Windsor Castle, commissioned from John Piper at an especially bleak period of the Second World War. A commission such as this – and there were many other examples of Queen Elizabeth's independent-minded patronage of young, progressive artists in the figurative tradition – gave a tremendous boost to morale and much-needed encouragement to struggling artists in the dark wartime days. Her delight in the company of artists and her interest in new work remained with her always – from Rex Whistler and Augustus John in the 1930s, to Hugh Casson and John Bratby in the 1980s.

I very much hope that this exhibition will allow as wide a number of visitors as possible to share in the pleasure that my beloved Grandmother always took in these works when they hung at Clarence House and Royal Lodge.

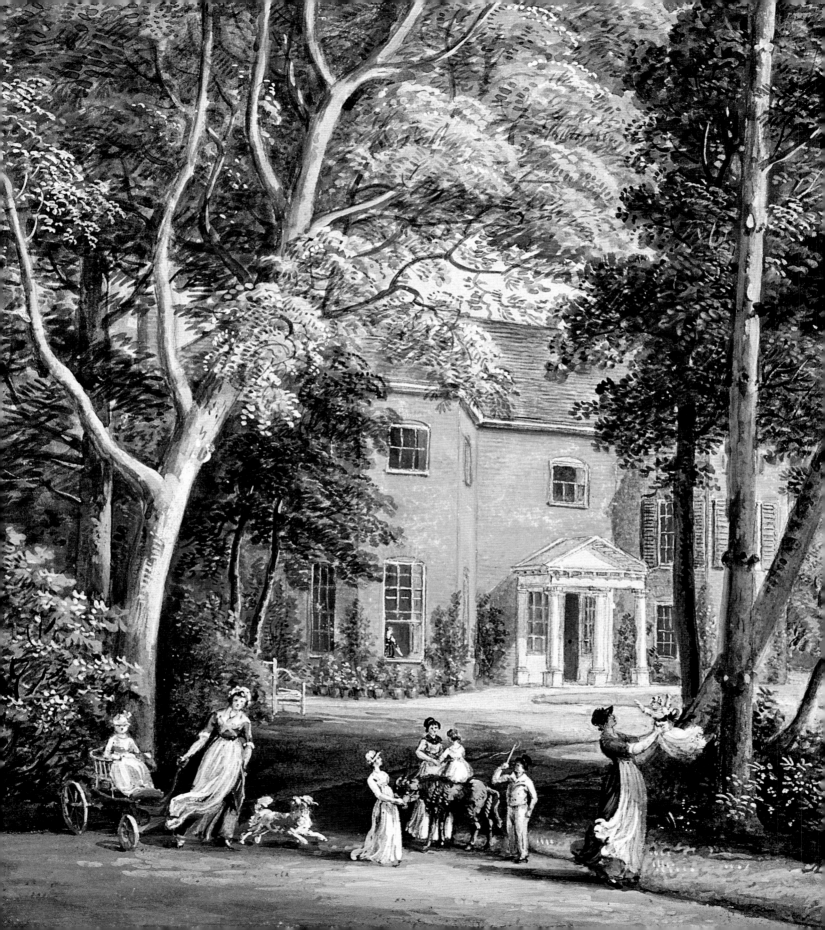

Preface

The seventy-three works selected for the present catalogue have been chosen from a group of around 550 watercolours and drawings from the collection of Her Majesty Queen Elizabeth The Queen Mother. Her collection also included around 300 paintings and 350 prints. The majority of Queen Elizabeth's pictures decorated her residences; in her lifetime forty-seven of the drawings and watercolours included in this catalogue hung at Clarence House, and twenty-three at Royal Lodge. Three, which Queen Elizabeth presented directly to the Royal Collection upon acquisition (nos. 50, 51 and 54), are kept in the Print Room at Windsor. On the death of Queen Elizabeth her personal collection passed to Her Majesty The Queen.

The catalogue is arranged in groups which reflect the distinct areas of Queen Elizabeth's collection: a biographical section, incorporating portraits and records of events of both personal and national significance; a section drawn from Queen Elizabeth's extensive collection of views of her residences; and a diverse section of landscapes, topographical watercolours, still lifes and figure studies by artists ranging from Thomas Gainsborough to John Bratby.

Where possible Queen Elizabeth The Queen Mother is referred to by her contemporary titles: Lady Elizabeth Bowes-Lyon (1904–23), the Duchess of York (1923–36) and Queen Elizabeth, Consort of King George VI (1936–52). As Queen Mother she continued to be known as Queen Elizabeth, the title which has principally been used here.

I should like to acknowledge the gracious permission granted by Her Majesty The Queen to consult the personal papers of Queen Elizabeth The Queen Mother. Within the Royal Household, thanks are due to all my colleagues in the Print Room, the Royal Library, the Royal Archives, the Royal Photograph Collection, the Pictures section, Works of Art section and Royal Collection Enterprises. I am particularly grateful for the help given by Jane Roberts, Librarian and Curator of the Print Room, and by Martin Clayton, Deputy Curator of the Print Room.

I should also like to thank the following for their valuable assistance: David Addey, Sir Alastair Aird, Hugh Buchanan, Stephen Calloway, Frances Carey, the late John Cornforth, Simon Fenwick, David Fraser, the Duke and Duchess of Grafton, the Earl Haig, Charlotte Halliday, Julian Hartnoll, Simon Houfe, Anthony Hyne, David Fraser Jenkins, Clarissa Lewis, Alan Carr Linford, Anne Lyles, Martin Muncaster, Richard Ormond, Sir Adam Ridley, The Hon. William Shawcross, Sir Reresby Sitwell Bt., Kim Sloan and the Earl of Snowdon.

Queen Elizabeth
as a Collector

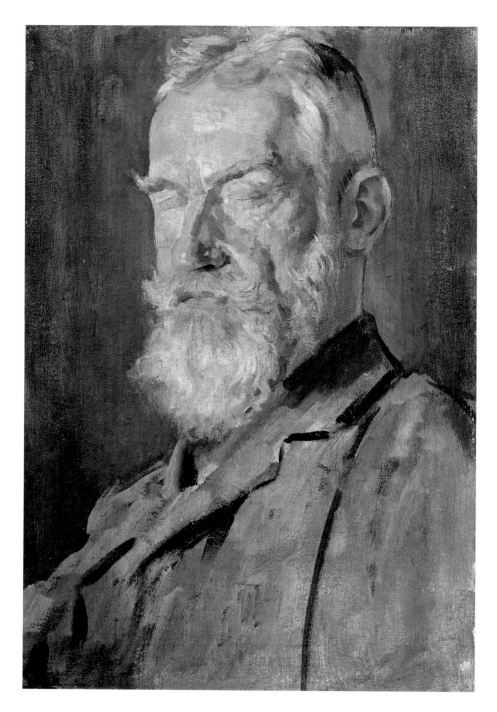

Figure 1

Augustus John, *'When Homer nods' (George Bernard Shaw)*, 1915

Oil on canvas. 61.3 × 41.1 cm (24⅛" × 16³⁄₁₆") RCIN 409024

Queen Elizabeth as a Collector

In a private letter of March 1938, Sir Kenneth Clark (1903–83) made an enthusiastic response to Queen Elizabeth's first major acquisition of a modern British painting, Augustus John's portrait of George Bernard Shaw, *'When Homer nods'* (fig. 1):

> May I say how extremely valuable to all of us who care for the arts is
> Your Majesty's decision to buy the work of living painters. It is not too
> much to say that it will have an important effect on British art in general. ...
> Under Your Majesty's patronage British painters will have a new confidence,
> because you will make them feel that they are not working for a small
> clique but for the centre of the national life.[1]

This letter was written in the early part of King George VI's reign, during the course of which Queen Elizabeth was to assemble a small but important collection of modern British pictures. As Director of the National Gallery (1934–45), a post which at the time he held concurrently with that of Surveyor of the King's Pictures (1934–44), Kenneth Clark was well able to judge the degree to which a public position enabled the holder to influence the status of artists, and what is highly significant in his letter is his suggestion that the Queen was in a position to play an important role in the promotion of contemporary British art. Clark applauds the interest which Queen Elizabeth showed in living painters, and strongly encourages the continuation of her support by predicting that it would hasten a British renaissance, a flowering of the kind of national 'confidence' in artists which in this period was most strongly vested in the School of Paris. For Clark, it was clear that the Queen's support and enthusiasm would play a leading part in bringing about a new ascendancy of contemporary art in Britain.

Whatever revival of strong, directive patronage Clark may privately have hoped for, Queen Elizabeth's approach had little in common with that which had shaped the arts in previous centuries.[2] The structure of the artistic establishment had changed over the course of the nineteenth century, and moved decisively away from the control of monarchs and the aristocracy, leaving as important an institution as the Royal Academy increasingly alienated from contemporary artistic innovation by the 1930s. Moreover, in the early years of the twentieth century artists had begun to see themselves less in terms of meeting the demands of patrons and more in terms of belonging to artistic communities concerned with the exploration of new movements in art. A consequence of this shift was the need for a new kind of support, which came

to be supplied by the vigorous championship of figures like Clark and John Rothenstein of the Tate Gallery, and also by the first state-funded organisation of its kind, the Council for Encouragement of Music and the Arts (later to become the Arts Council) which was founded in 1940. However, as Clark makes clear in his letter, the monarch – although no longer the pinnacle of grand patronage – was far from redundant in this new era, and the Queen was uniquely placed to put her symbolic position to practical use. By purchasing the work of contemporary British artists Queen Elizabeth would inevitably generate public support by directing attention to their work, and could bestow a powerful seal of approval. As an editorial in *The Times* of April 1938 put it after reporting her purchase of John's portrait of Shaw:

> The Queen has decided that contemporary British painting matters –
> irrespective of subject represented or fashionable tendency in style; and it
> will be against all experience if, according to their means, the decision is not
> followed by many of her subjects – to the raising of the general level of taste,
> and to the practical advantage of good artists who, less from insensibility
> to their merits than from uncertainty about the importance of art in life,
> are apt to be neglected.[3]

With a few notable exceptions, Queen Elizabeth's patronage was expressed not by commissioning artists to paint a particular person, object or event but by purchasing existing works, and thus helping to foster creative autonomy. This is in sharp contrast to earlier royal patronage. Queen Elizabeth's nearest predecessor as a royal collector of paintings and watercolours by living artists was Queen Victoria, whose approach of principally employing artists to record state occasions, visits, residences, friends and family shaped her collection into a visual chronicle. Queen Elizabeth, on the other hand, displayed a more disinterested appreciation of pictures as well as a good eye for aesthetic values (which Queen Victoria herself had claimed to lack). The pictures collected by Queen Elizabeth are mostly by British artists and, with the exception of a group of early English watercolours, are principally early to mid-twentieth-century works. Although her taste was by no means avant-garde, it was for progressive rather than conservative academic art, and one of the most cohesive sections of her collection is formed by the younger generation of living painters who were working outside the somewhat staid artistic establishment of the time. Her collection came to include works by Matthew Smith (fig. 2), Paul Nash, Graham Sutherland, John Piper and David Jones, alongside paintings by an older generation represented by William Nicholson, Augustus John and Walter Sickert.

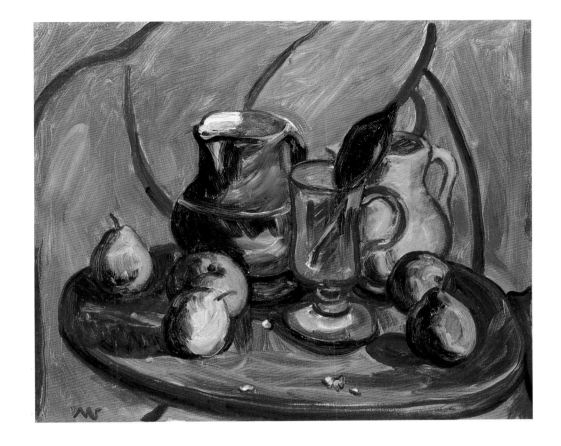

Figure 2
Sir Matthew Smith, *Still life
with jugs and fruit*, 1938
Oil on canvas
54.8 × 65.6 cm (21⁹⁄₁₆" × 25¹³⁄₁₆")
RCIN 409009

In her choice of artists Queen Elizabeth was working independently of the judgement of the establishment of the day, which was largely in opposition to Clark and inclined to denigrate his championship of contemporary painters. Clark wryly claimed to have been considered a 'dangerous revolutionary' in Royal Academy circles.[4] When, on behalf of the British Council, he arranged an exhibition of modern British art for the United States, he was warned that the Royal Academicians were insulted that the works selected were all by modernists – Sutherland, Piper, Henry Moore – and not by the traditionalists Sir Alfred Munnings, Sir George Frampton or Philip Wilson Steer.[5] Exhibitions of contemporary art which Clark organised for the National Gallery during the Second World War were described by two members of the Royal Academy as 'just jokes by incompetent youngsters who don't know what they're playing at.'[6] Similarly, in the second volume of his autobiography, published in 1966, Sir John Rothenstein, Director of the Tate Gallery between 1938 and 1964, described the influential nature of this establishment and the difficulties it presented to artists working in the 1930s: 'Today the old "establishment" that once dominated the art

world has all but disintegrated. Today to acclaim the new is the easiest of all courses. Inevitably the prevailing fluidity of outlook leads to the acclamation of much sheer folly, but it also makes easier the recognition of talent, whatever its character. In the 'thirties this was still far from being the case.'[7]

Interestingly, when Rothenstein took over the directorship in 1938, some important modern British artists – including Jones, Piper and Sutherland – were completely omitted from the Tate's collection and many others were poorly represented. This situation was quickly rectified owing to both increased funds and directorial vision. As Robin Ironside, Assistant to the Director of the Tate Gallery, 1937–46, noted in an article of 1941, 'Ironically enough, since the beginning of 1939, the Gallery has had greater funds at its disposal for the purchase of modern pictures than ever before in its history … Acquisitions since the beginning of the war, either by purchase, gift or bequest, include examples of the principal school of painters with which the Tate has become associated.'[8] Although assemblages of such widely differing aims and scope are clearly incommensurable, the fact that the Queen Consort was establishing a collection of contemporary art at the same time that the Tate, the national gallery of British art, was seriously bolstering its own collection in this area, gives some indication of her independence of taste and willingness to establish a new relationship with artists.

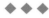

An interest in art had been cultivated during Lady Elizabeth Bowes-Lyon's childhood. Her parents, the Earl and Countess of Strathmore, possessed a collection of family portraits and commissioned a number of portraitists to record their youngest daughter (born in 1900). The greatest artistic mentor of her early life, however, was her maternal grandmother, Mrs Cavendish-Bentinck, who married as her second husband Henry Warren Scott. In 1882 Mrs Scott went to live at the Villa Capponi outside Florence, where the young Lady Elizabeth would visit for holidays. In her 1928 biography of the Duchess of York, Lady Cynthia Asquith described the atmosphere of the interior of the Villa Capponi as 'a stately solemn room, yet full of comfort and brightness. Lovely furniture, flowers, books, beauty everywhere. And the little chapel with its few exquisite pictures, and walls covered with red damask.'[9] Mrs Scott and her daughter Violet would take Lady Elizabeth to see paintings at the Uffizi Gallery and the Pitti Palace.[10] As a wedding gift to her niece in 1923, Violet Cavendish-Bentinck commissioned Ricciardo Meacci, a Florentine artist popular with English patrons, to paint an elaborate triptych celebrating the marriage (no. 6).

Before the accession of King George VI, the Duchess of York's interest in the arts was largely confined to visiting exhibitions and sitting for portraits. As well as sitting to Sargent just before her wedding to the Duke of York (nos. 4 and 5), she sat for the Russian artist Savely Sorine (fig. 3) and for Samuel Warburton in 1923, the year of her marriage, and to the Hungarian society portraitist Philip de László twice, in 1925 and again in 1931.

The years of the King's reign, from 1937 to the beginning of 1952, were those which coincided with the period of Queen Elizabeth's greatest collecting activity. That this should be the case suggests that she regarded involvement with the arts as an important royal duty. Her custodianship of the Royal Collection, a role gratefully left to her during these years by the King, put her in direct contact with the extraordinary treasures commissioned and collected by successive monarchs; and as well as her many purchases for her private collection Queen Elizabeth made a number of judicious additions to the Royal Collection, including drawings by Max Beerbohm and Augustus John (see nos. 50, 51 and 54). She also contributed works which were appropriate to the Collection because of their royal connection or topographical relevance; in a letter to Queen Elizabeth of 3 February 1943 the Royal Librarian Sir Owen Morshead wrote: 'May I first return warmest thanks for the two pretty little watercolours of palace interiors which are most welcome in the Royal Library? They are just the kind of thing which we like most to acquire.'[11] She also supported the cataloguing of the Collection, contributing financially to the publication costs for Leo van Puyvelde's catalogue of the Dutch and Flemish drawings in the Royal Collection, published in two volumes in 1942 and 1944.[12] Another aspect of this sense of duty was her support of national artistic institutions; her many patronages included the National Art Collections Fund, the Contemporary Art Society and the Royal Watercolour Society.

King George VI's reign was dominated by the Second World War, which shaped the Queen Consort's role and brought public duty very much to the fore. In some ways Queen Elizabeth's collecting activity can be seen as a patriotic response to the war, as a way of supporting British artists and the charities in aid of which they often exhibited. Far from being a fallow period, the war years were a time of intense activity for artists. This was largely due to Kenneth Clark's energy in organising projects such as *Recording Britain* and his influence as Chairman of the War Artists' Advisory Committee, a position which enabled him to give valuable assistance to young British painters from the autumn of 1939.[13] As he later put it, his principal aim during the war was 'to keep artists at work on any pretext, and, as far as possible, to prevent them from being killed.'[14] In a letter of December 1942 Clark discusses his role in the arts

during the war, and comments on what he saw to be the growing success of Queen Elizabeth's public support of artists:

I am deeply grateful to Your Majesty for your very kind letter
& especially for what you say about my efforts to keep the arts going
in wartime. I have often thought that I ought to join up & do a bit
of fighting, although as a senior (!) Civil Servant I am technically
forbidden to do so. Your Majesty will therefore understand how
immensely encouraging it is for me to know that you approve of
what I am doing. There has, in fact, been a really remarkable increase
in the appreciation of art during the last three years & to this
(I would venture to say) Your Majesty's interest & understanding
has contributed very greatly.[15]

Of course, the contribution made by Queen Elizabeth during this period was part of a widespread reassessment of the significance of the arts. In his memoirs John Rothenstein noted that the arts were valued more highly during the Second World War than in the immediately preceding years, and that a sudden acute shortage of books, concerts, theatre and exhibitions caused by wartime privations had the paradoxical effect of increasing interest. Moreover, he observed that the intense focus imposed by the war had a galvanising effect on artists themselves: 'those concerned with the arts were accordingly made aware that they were not engaged in some marginal activity but were fulfilling an imperative need. When pictures were shown, they aroused intense interest …'[16] The artist David Bomberg made a strong case for the purpose of art in wartime in an unpublished letter sent to *The Times* in October 1939: 'In a war fought for freedom and progressive culture, the artist surely has a vital rôle to play. The government should call in the artists to inspire the people, to express their ideals and hopes, and create a record of their heroic effort for future generations. The spiritual and cultural need that art alone can satisfy is greater now than in peace time.'[17]

One of the organisations to which Queen Elizabeth gave her support during the war was the Civil Defence Artists, an organisation whose name makes explicit their direct contribution to the war effort. Their first exhibition was held in October 1941 at the well-regarded Cooling Galleries in London. Clark was on the selection committee for the exhibition, and the short catalogue includes an introduction by Sacheverell Sitwell in which the importance of artists during the war, and the necessity for vigorous patronage, is passionately articulated:

This first exhibition of the work of painters and sculptors engaged in
Civil Defence has an importance, actual and theoretical, which is difficult
to exaggerate. For the arts are part of a world which we have lost, for a
time, and are determined to regain. Painters, no less than their pictures,
have become a symbol. It is essential that their work should continue in
the spare time that they can give to it. … Artists, of every sort, have never
been more necessary than now. And never, themselves, in more dire
necessity. In more ways than one they are part of our Civil Defence,
and they deserve all encouragement that can be given to them during
these years of war.[18]

When Queen Elizabeth bought a work by Anthony Devas, *Pansies and sorrel*, from a
Civil Defence Artists exhibition, the Honorary Organising Secretary Denis Mathews
wrote warmly to her on 25 May 1942, thanking her for 'the great kindness and
interest' which she showed in the exhibitions. He added: 'it has been an incentive to
all the artists throughout Civil Defence and those of us who started them cannot too
sincerely say that it has been an encouragement to further effort beyond any hopes we
might have had.'[19]

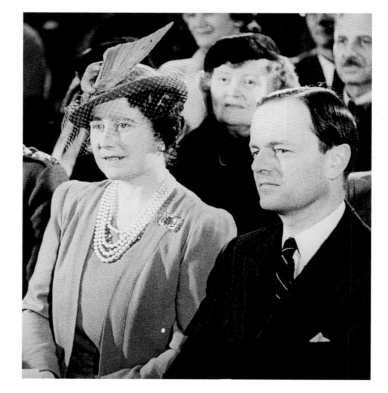

Figure 4
Queen Elizabeth and Kenneth Clark
attending a Myra Hess concert at
the National Gallery, *c*.1939.

This continuation of artistic activity during
the war was helped by exhibitions of modern
British pictures at the National Gallery. Paintings
from the National Gallery and from the Royal
Collection had been taken out of London to
relative safety, leaving the galleries at Trafalgar
Square empty. In September 1939 the pianist
Myra Hess suggested that the galleries should be
used for concerts, several of which were attended
by Queen Elizabeth (see fig. 4), and the gallery
owner and contemporary art dealer Lillian Browse
proposed an exhibition programme. The first of
these exhibitions, held in 1940, was *British
Painting Since Whistler*, to which Queen Elizabeth
lent two paintings, *October morning* by Ethel
Walker (RCIN 409033) and Augustus John's
portrait of George Bernard Shaw, '*When Homer
nods*' (fig. 1). A great many private collectors lent
liberally to this exhibition, which became a

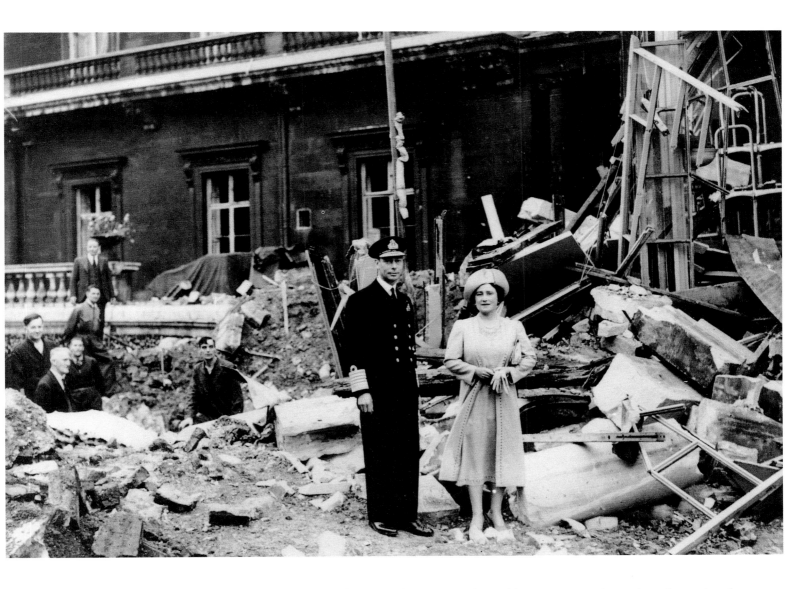

Figure 5
King George VI and Queen Elizabeth
after the bombing of Buckingham
Palace, 10 September 1940.

celebration of modern British art – a major achievement at a time when the national collections were in storage. The quality of the 355 exhibits listed in the catalogue suggests that the owners lent treasured works to the exhibition through patriotic motives, generously using their own possessions to fill the gap created by the conditions of war. A further nineteen temporary exhibitions were held at the National Gallery during the war, alongside a permanent changing display of pictures by War Artists.

Buckingham Palace received a number of direct hits during the Blitz (fig. 5), and Queen Elizabeth's practical concern for the safety of works of art at this time is

illustrated by an anecdote related in the published diaries of James Lees-Milne recording how, in 1942, she initiated the evacuation of treasures from Apsley House, the residence of the Dukes of Wellington. Lees-Milne records that Queen Elizabeth telephoned the Duchess of Wellington to ask if it was true that no pictures had yet been moved from the house and, finding this to be the case, announced 'Well, then, I am coming round at 11 with a van to take them to Frogmore.' She arrived with the King and made lists of what was to be removed and what had to be left, saying 'You mustn't be sentimental, Duchess. Only the valuable pictures can go.'[20]

Many watercolours and drawings were purchased by Queen Elizabeth at charity auctions before and during the Second World War. In supporting charitable concerns through art she was following royal precedent: in 1833 Princess Elizabeth, daughter

Figure 6
The Duchess of York leaving Knoedler's Gallery, London, after visiting the Philip de László exhibition held in aid of the Artists' General Benevolent Institution, 21 June–22 July 1933.

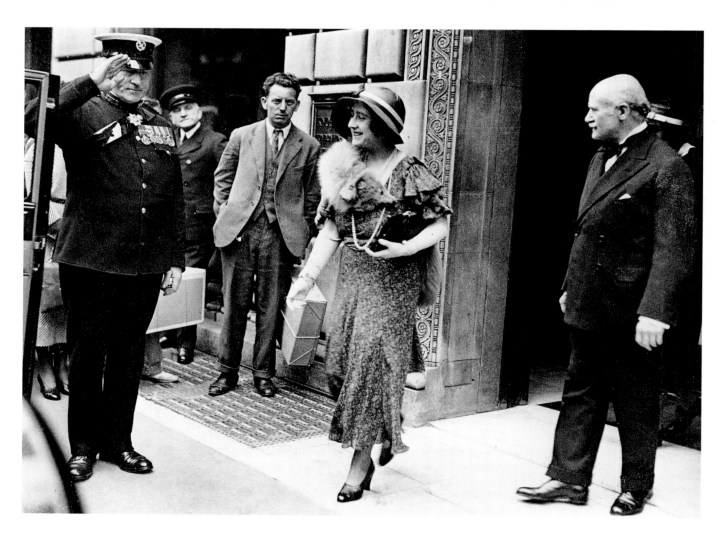

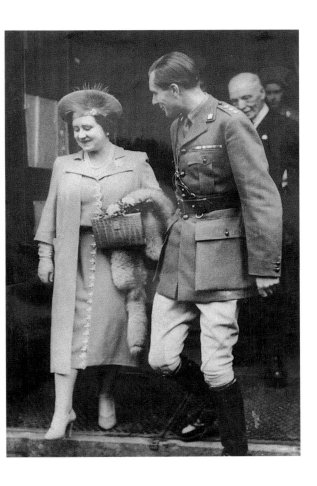

Figure 7
Queen Elizabeth with Lord Haig at his exhibition of watercolours and paintings made as a prisoner of war, held at the Scottish Gallery in Edinburgh in aid of Lady Haig's Poppy Factory and the Red Cross, 1945.

of George III, published a volume of lithographs after her drawings in aid of a crèche for the daughters of working mothers; in 1900, during the Boer War, Queen Victoria donated some of her own drawings and prints to the Artists' War Fund exhibition and auction, and her children gave a number of their works to charitable causes.[21] In 1933 the Duchess of York visited the exhibition of paintings by Philip de László at Knoedler's Gallery which was held in aid of the Artists' General Benevolent Institution (fig. 6), while the proceeds of the Christie's sale in May 1939 – at which she purchased a drawing by John Downman (RCIN 453424) – were donated to the Lord Baldwin Fund for Refugees. Queen Elizabeth's close friend Sir Jasper Ridley was involved in the organisation of a sale in aid of the Red Cross in 1942; pictures were first exhibited at Knoedler's galleries in September and then sold at Christie's. In a letter of September 1942 Ridley expressed the hope that Queen Elizabeth would 'look in' at Knoedler's, adding that 'it would give enormous pleasure and encouragement to people & prices'.[22] A beautiful pastel drawing of sailors by the Official War Artist William Dring, 'On leave' (no. 60), was astutely purchased by Queen Elizabeth from the Artists' Aid China Exhibition, which was held in 1943 at the Wallace Collection for Lady Cripps' United Aid to China Fund.

Shortly after the end of the war in 1945, Queen Elizabeth visited an exhibition of drawings and watercolours by George Douglas, the 2nd Earl Haig, son of Field Marshal the Earl Haig, Commander-in-Chief of the British Expeditionary Force during the First World War. The 2nd Earl's mother had been Maid of Honour to Queen Victoria, and after the Queen's death she and her sister Violet Vivian were Maids of Honour to Queen Alexandra, who became Haig's godmother. His aunt Alexandra, Lady Worsley, was later one of Queen Elizabeth's Ladies-in-Waiting, and Haig himself was a Page of Honour at the coronation of King George VI. Haig had fought in the war with the Royal Scots Greys. He was captured in 1942, and during the following years as a prisoner of war he devoted much of his time to drawing and painting, building on the art education that he had received at Stowe and making carefully observed studies of his surroundings and fellow prisoners. On his return home to Scotland in 1945 the Scottish Gallery in Edinburgh held an exhibition of his work in aid of the Red Cross and the Poppy Fund, a charity organised by his mother. Queen Elizabeth visited the exhibition with the Princesses (fig. 7), and on this occasion Haig presented her with a watercolour which

she had particularly admired, representing an improvised orchestra in a prison camp (no. 71).

The *Recording Britain* exhibitions organised by Kenneth Clark and held at the National Gallery were another important aspect of wartime patronage. The project, 'Recording the changing face of Britain', instigated in the autumn of 1939, was funded by the Pilgrim Trust and administered by Clark; by P.H. Jowett, Principal of the Royal College of Art; and by Sir William Russell Flint, representing the Royal Academy. Clark's intention was for the scheme to provide opportunities for landscape painters whose unsuitability as War Artists left them with little work during these years. Artists were asked to make topographical watercolours of places and buildings of national interest or importance, particularly those which were in danger of damage or destruction during the war, either by enemy action or as a result of necessary defensive measures. Clark wrote to Queen Elizabeth in August 1942, inviting her to see one of the exhibitions, and his letter makes their shared interest in these pictures evident: 'The Recording Britain show will be open till the end of the month, & there are also some good new War Artists' pictures if Your Majesty can find time to come to the gallery on your return.'[23] It was at this initial *Recording Britain* exhibition that Queen Elizabeth first saw the work of John Piper, out of which arose the commission to record Windsor Castle (see nos. 26–31).

Figure 8
Queen Elizabeth with the Australian artist Norma Bull at the exhibition at Australia House, London, of Bull's *Paintings of Wartime Britain*, 1947.

Queen Elizabeth also purchased a number of works by the Australian artist Norma Bull, who, working in London and other British cities during the war, had made submissions to the War Artists' Advisory Committee. In 1947 Bull held an exhibition of her watercolours at Australia House, from which Queen Elizabeth purchased pictures recording the damage suffered by the Royal Hospital, Chelsea, the Wren church of St Nicholas Cole Abbey, Queen Victoria Street, and other London buildings (figs. 8 and 9; see no. 63). These watercolours of London during this period joined two iconic paintings by Duncan Grant of St Paul's Cathedral of 1939

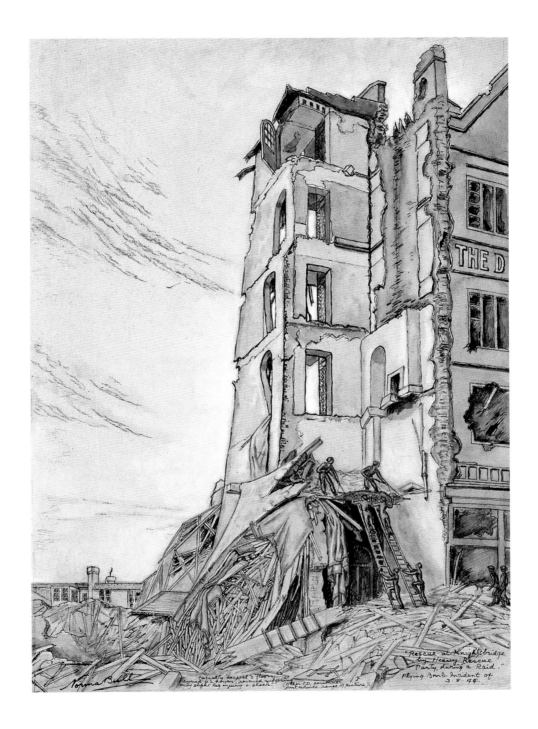

Figure 9

Norma Bull, *Rescue at Knightsbridge by heavy rescue party during a raid – flying bomb incident of 3.8.44*, 1944

Pencil, pen and ink and watercolour. 56 × 39.6 cm (22¹⁄₁₆″ × 15⁹⁄₁₆″; sight size) RCIN 453415

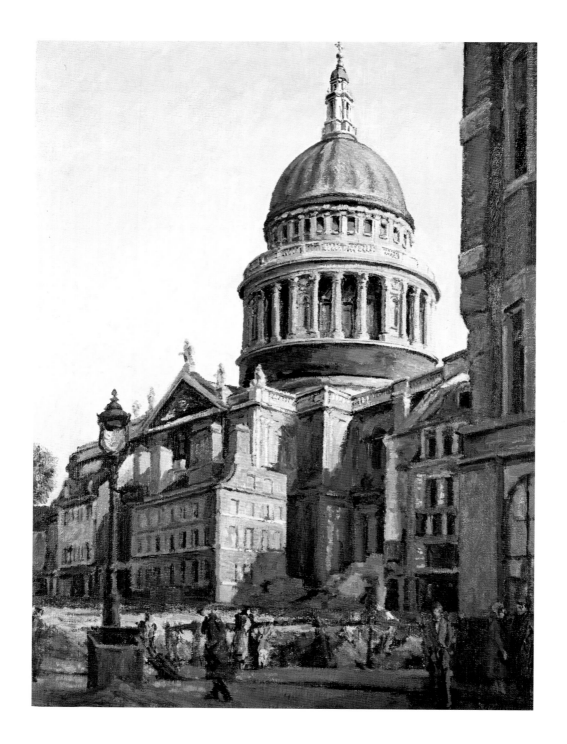

Figure 10

Duncan Grant, *St Paul's Cathedral*, 1947. Oil on canvas. 103.8 × 76.5 cm (40⅞″ × 30⅛″) RCIN 409052

and 1947, the first acquired from Thomas Agnew's, the second purchased directly from the artist (fig. 10).

Like royal collectors of previous centuries, Queen Elizabeth relied upon well-informed friends and advisers to keep her abreast of interesting artists and new pictures coming onto the market. The most important figure in this respect was, of course, Kenneth Clark, one of whose duties as Surveyor of the King's Pictures it was to suggest purchases for the Royal Collection – but who also gave valuable advice over the years to the Queen on potential additions to her own collection. Their friendship began when she was Duchess of York; the first extant letter from Clark is in response to a letter sent by the Duchess in which she expressed her enjoyment of a lecture she had recently attended:

> Your very kind letter about my lecture on English landscape has just
> reached me. Thank you so much for writing. No one can ever judge their
> own work, but I have always been rather ashamed of that lecture, because
> it is so full of half truths. I am so flattered & delighted to think that you
> enjoyed it that I am venturing to send you a copy of a book I wrote almost
> ten years ago, *The Gothic Revival*. I have not reread it since it came out,
> but I remember that the subject interested me, & some of the later chapters
> may still be amusing. Your Royal Highness might like the one on Pugin,
> who was a fascinating character.

Clark and the Duchess of York had recently visited an exhibition together, held by Sir Philip Sassoon at 45 Park Lane in aid of the Royal Northern Group of Hospitals, to which a group of Gainsborough paintings from the Royal Collection had been lent. Clark went on in his letter to praise her approach to art: 'It was a very great pleasure to go round the Exhibition with Your Royal Highness. So few people seem to enjoy pictures: they look at them stodgily, or critically – or acquisitively; seldom with real enthusiasm.'[24]

Perhaps because of this shared interest their friendship rapidly gained ground, and in most of Clark's letters to Queen Elizabeth he writes with enthusiasm about pictures and artists. In March 1939 he writes on the subject of 'a very charming figure piece' by Wilson Steer: 'I think Your Majesty might like it so have instructed them to send it in.'[25] Clark quickly became a frequent guest for weekends at Windsor Castle. Unfortunately Queen Elizabeth's side of the correspondence no longer exists, but Clark's many letters are written with a great degree of warmth and an assumption of shared taste and knowledge that we may assume was reciprocated.[26] His letters had an

important informative function, and a typical expression is: 'May I take this opportunity of telling Your Majesty about several other things which are happening in the arts?'[27] Clark frequently invited Queen Elizabeth to the National Gallery, for example in this letter when he tells her about a new exhibition of what he terms 'our mixed bag of modern & ancient pictures':

As Your Majesty mentioned bringing the Princesses to the National Gallery, I would suggest that the morning is really the best time, about 10.30, as it is not so crowded then. Thursdays & Fridays are copying days, & although the copies are sometimes quite interesting, they spoil the effect of the rooms & distract the attention. So that really means that Tuesday & Wednesday are the best days, but if ever Your Majesties were in London on a Sunday the gallery is shut on Sunday mornings & I could take you round without anyone about, which would be great fun, as the children could run from one picture to another & talk as loud as they liked.[28]

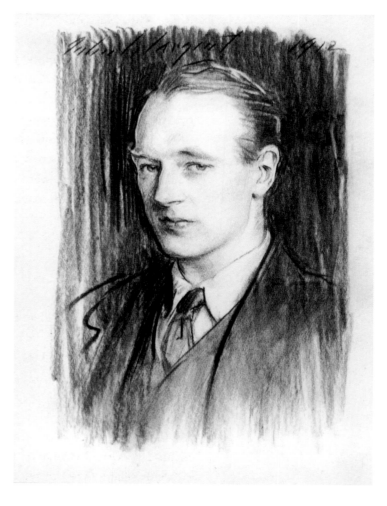

Figure 11
John Singer Sargent,
The Hon. Sir Jasper Ridley, 1912
Charcoal

There can be no doubt that Clark influenced Queen Elizabeth's taste, introducing her to artists whom he wished to promote and suggesting the purchase of particular works. Clark's tremendous energy, erudition, great personal charm and passionate dedication to the cause of contemporary British art were a persuasive combination which proved to be extremely effective in numerous areas. However, it would be a mistake to regard Clark as a Svengali figure, or to underestimate Queen Elizabeth's own knowledge and judgement. It is clear that they shared a taste, one which tended to encompass modern figurative pictures and was largely averse to Abstraction, and in this area Queen Elizabeth relied upon Clark for information and suggestions; however, it was she who ultimately made the decision about every purchase.

Another important friendship was with the Hon. Sir Jasper Ridley (1887–1951; fig. 11), the second son of Sir Matthew Ridley, 5th Baronet and later 1st Viscount

Ridley. He was a banker by profession, a director of the National Provincial Bank and of Coutts, and eventually chairman of both. He served as Chairman of the Board of Trustees of the Tate Gallery, was a Trustee of the National Gallery and the British Museum, and was on the Committee of the Contemporary Art Society, later becoming Honorary Secretary. Ridley, whose friendship with Queen Elizabeth pre-dated her marriage, was an urbane and amusing character, and his 'firm grasp of practical affairs, his wide social connections, his imperious charm and his personal disinterestedness' were welcomed at the Tate by John Rothenstein.[29] Rothenstein recalls Queen Elizabeth remarking that 'if there were more people like him in the world what a safe place it would be.'[30] Ridley's approach presents an interesting parallel with Queen Elizabeth's own unconventional support of young artists from a position at the heart of the establishment, and in this they were close allies. In his autobiography Rothenstein remarks that Ridley was 'welcome in any society, but his closest sympathies were with artists and scholars', and goes on to observe that there was:

> no trace of the 'outsider' about Jasper: if he praised, in the company, say, of
> fellow-bankers, some work of art beyond the natural range of their sympathies,
> the effect would be likely not to alienate but to persuade them. He was
> therefore an ideal Wooden Horse, who introduced ideas that would have
> been suspect from most other sources into the most unimpeachable circles.[31]

Ridley assembled an impressive personal collection of contemporary British pictures, including works by Henry Moore, Matthew Smith, Mark Gertler, John Minton, Keith Vaughan, Piper, Sutherland and Stanley Spencer. His letters reveal the extent to which he was involved with the development of Queen Elizabeth's own collection, informing her of pictures coming up for sale and acting as a go-between, arranging to have works sent over to Buckingham Palace for her approval. In January 1938 he writes:

> I have discovered that the John 'Portrait of a young man' is not sold, and
> that the Sickert of King George V is probably available. They are *asking*
> 300 guineas for the John, but I don't yet know about the other. I propose
> to speak to Kenneth Clark about them both. I don't see that there can be
> any harm in their being sent to Buckingham Palace for you to see when
> you get back there. There would be no commitment of any sort in that
> and if you hated them that would end the matter. Whatever you get you
> must like, but it would be such a great thing if somehow a bit of money
> could be found to buy a few good pictures every year.[32]

Queen Elizabeth initially rejected Sickert's austere *Conversation piece at Aintree* (fig. 12), a small painting of King George V with his stud manager Major F. H.W. Fetherstonhaugh based on a photograph taken through a car window in 1927 – by this point it had also been turned down by the Glasgow Art Gallery, the Tate Gallery and the Victoria Art Gallery in Bath – but eventually relented and purchased it from Christie's in 1951.

After Queen Elizabeth's important purchase in 1943 of Paul Nash's visionary painting of the Wittenham Clumps in Oxfordshire, *Landscape of the vernal equinox* (fig. 13), which had been brokered by Ridley, he wrote to her:

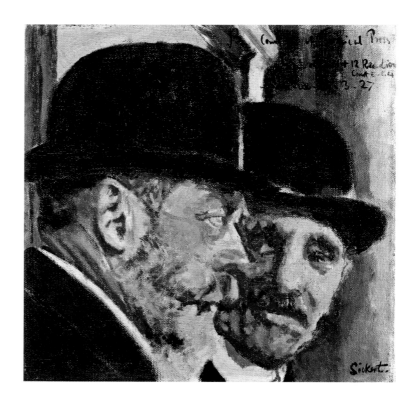

Figure 12
Walter Sickert, *Conversation piece at Aintree*, *c*.1927
Oil on canvas
46.4 × 46.4 cm (18¼″ × 18¼″)
RCIN 409022

But I am delighted that you like the Nash so well. You will find people who say that Nash is the best 'intellectual' painter in England. Tiresome word, but I suppose there are lots of painters who don't think at all, and Nash does put brains and ideas in his things. I expect that's why in time his pictures mean more and more. And really, when there is a gradually discovered meaning in a picture, it has the effect of MAGIC, as you say; and magic is an agreeable and domestic relic of the old old world, which is not the same thing as the grand new world.[33]

Ridley's commentary gives an important insight into Queen Elizabeth's emotional response to pictures, and her evident appreciation of the Romantic symbolism invested by Nash in the English landscape.

Queen Elizabeth took a serious interest in the Tate Gallery, and made frequent visits to exhibitions drawn from the Gallery's collections. On 19 May 1942, accompanied by Ridley, she visited an exhibition of new acquisitions made during the war by the Tate under the directorship of John Rothenstein. As the Tate Gallery had been evacuated, this exhibition was held at the National Gallery. These accessions included twenty works by Sickert, paintings by Augustus and Gwen John, William Nicholson, Max Beerbohm, Matthew Smith, Paul and John Nash, Mark Gertler, Spencer, Moore, David Jones, Piper and Sutherland.[34] In 1951 Rothenstein's diary

entry for 4 July reads: 'Queen spent nearly an hr. at Gy. from 3.30. She admired Gr. Sutherland's "Maugham", our new wall coverings; indeed she praised the gallery most generously; also visited Turner, Hogarth and Moore exns (said Moore "such a nice man").'[35] Years later, when in 1963 the Tate staged an exhibition, *Private Views*, of works from the collections of twenty Friends of the Tate, Queen Elizabeth lent paintings by John, Seago and Sickert, four of Piper's watercolours of Windsor Castle and the large watercolour of the Scuola and Chiesa di San Rocco in Venice (no. 59) which Piper had presented to her the previous year.

Kenneth Clark's successor as Surveyor of the King's Pictures, Anthony Blunt (1907–83), seems also to have had a friendly rapport with Queen Elizabeth.[36]

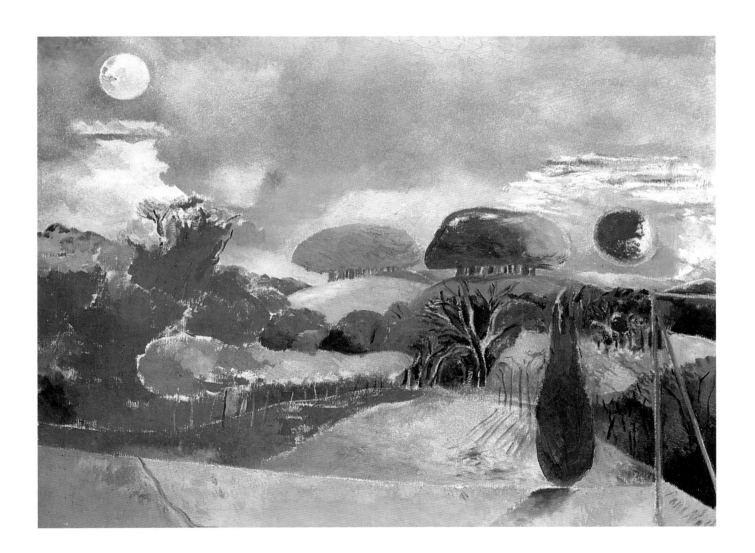

Figure 14
Cecil Beaton, *Queen Elizabeth*, 1939

Unfortunately few letters from Blunt to Queen Elizabeth survive, although like Clark he seems to have acted as an adviser on suitable directions for patronage. When in the late 1940s Queen Elizabeth had the idea of having portrait drawings made of members of the Royal Household, she asked Blunt to suggest suitable artists. In 1950 he wrote to Captain Sir Arthur Penn (at that time Queen Elizabeth's Treasurer): 'I believe that oddly enough Stanley Spencer would do the job very well. I do not know if you have seen his exhibition at Tooth's, but besides the to me tiresome apocalyptic pictures there are half a dozen pencil drawings of heads which are quite admirable and completely naturalistic.'[37] However, this ambitious project of portrait drawings by Spencer was never realised.

Her personal engagement with contemporary art, as well as her sense of her symbolic role in its promotion in Britain, was also reflected in Queen Elizabeth's choice of portraitist. An innovation in the public image of the monarchy was made in 1939 when Queen Elizabeth commissioned the fashionable and distinctly avant-garde photographer Cecil Beaton (1904–80) to take a series of portrait photographs. Her choice reflects a desire to create an image of queenship which was closely allied with artistic modernity, and in this she was very different from her predecessor as Queen Consort, Queen Mary, whose image – formed in the Edwardian era – had remained resolutely untouched by changing fashion. Beaton's photographs, on the other hand, were the epitome of sophisticated 1930s glamour (fig. 14).

Beaton himself had been rather startled by the Queen's approach. In his diary in July 1939 he recorded his first contact with the Palace:

> The telephone rang. 'This is the lady-in-waiting speaking. The Queen
> wants to know if you will photograph her tomorrow afternoon.'
> At first, I thought it might be a practical joke – the sort of thing
> Oliver [Messel] might do. But it was no joke. My pleasure and excitement
> were overwhelming. In choosing me to take her photographs, the Queen
> made a daring innovation. It is inconceivable that her predecessor would
> have summoned me – my work was still considered revolutionary and
> unconventional.[38]

Indeed, many commentators have regarded the photographs taken by Beaton at this session as a defining moment in the development of a modern image of monarchy.

The most famous and undoubtedly the most important commission instigated by Queen Elizabeth was the extensive sequence of watercolour views of Windsor Castle and buildings in Windsor Home Park and Great Park by John Piper. This wartime

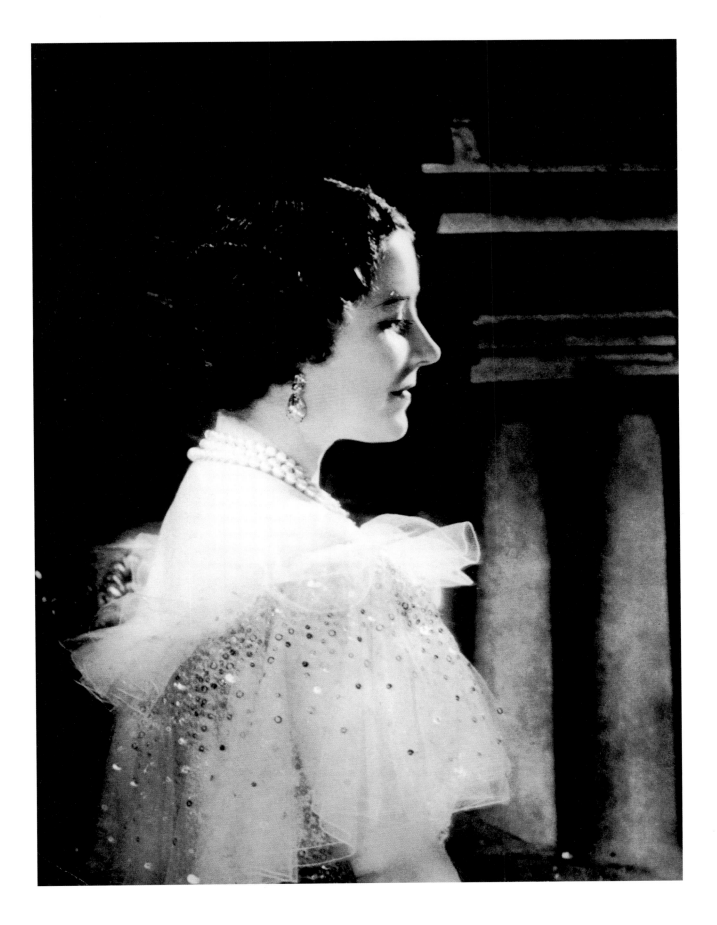

project had common aims with *Recording Britain*, both in that it was intended to create a contemporary record of the Castle against the threat of damage by enemy bombs, and in its design to provide work and valuable publicity for a contemporary artist. In the early years of the war, Queen Elizabeth had discussed with Jasper Ridley the idea of commissioning an artist to produce a series of watercolours of Windsor Castle 'in the manner of Sandby', a large number of whose watercolours of the Castle and surrounding area, made during the reign of George III, are preserved in the Royal Collection.[39] This project was probably suggested initially by the Royal Librarian, Sir Owen Morshead, who was compiling a 'Windsor view album'. At an early stage Ridley discussed the Queen's idea with Clark, and they collaborated over the choice of artist – Ridley tactically inviting Piper to stay at and paint Blagdon in Northumberland, the home of his nephew Matthew, 3rd Viscount Ridley, before the idea of the Windsor commission was raised. In August 1941 Clark wrote to Queen Elizabeth about the *Recording Britain* exhibition, strategically mentioning Piper and placing him within the great tradition of English landscape watercolourists:

> As a matter of fact I was just about to write to Your Majesty to suggest
> that you might be able to spare a few minutes to visit the exhibition of
> topographical watercolours at the National Gallery. It was an idea I had
> at the beginning of the war for giving employment to artists in a useful
> (or at least a harmless) way, & the Pilgrim Trust found the money.
> On the whole it makes a very charming show, & I think would interest
> Your Majesty on its own account. It would also be a way of finding a
> painter for the Windsor Castle project. Personally I think that by far
> the most suitable would be John Piper, who is a really beautiful romantic
> watercolourist, & a sort of re-incarnation of Cotman & Cozens without
> being at all 'Ye Olde' – I mean artificially old fashioned.[40]

Queen Elizabeth's visit to the *Recording Britain* exhibition must have taken place within a day or two of receiving Clark's letter, because within the week he wrote again: 'I have been in touch with John Piper, & he is of course honoured & delighted to carry out Your Majesty's command & do a series of drawings & watercolours of Windsor Castle. ... I do hope Your Majesty will be pleased with the result; it inspires me with more confidence than most projects of the kind.'[41]

On 23 August 1941 Piper wrote to his friend John Betjeman, whom he had first met in the offices of the *Architectural Review* in 1937, describing the commission: 'I am to do 15 to start with and, if they are approved, 100 or so. Grottoes etc. at

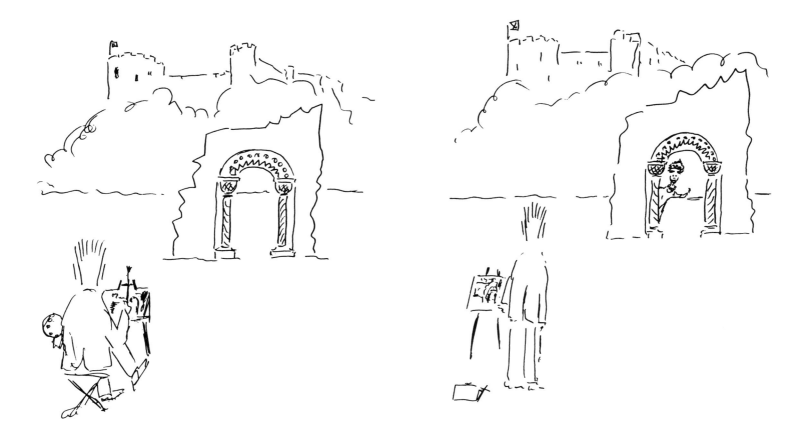

Figure 15
John Betjeman, cartoons of John Piper
at work on his watercolours of
Windsor Castle, 1941. Pen and ink

Frogmore, interiors and exteriors of Castle, etc. I am naturally excited ... I follow unworthily in the footsteps of Paul Sandby, who did 200 watercolours for George III which I am instructed to look at earnestly before starting.'[42] Towards the end of September 1941, Clark took Piper to Windsor Castle and introduced him to Owen Morshead, who as Librarian was responsible for the Sandby drawings. Morshead showed him around, and Piper visited the Castle again at the beginning of October in order to search for specific viewpoints.[43]

Piper began work on the watercolours in October 1941, with the support of Morshead, with whom he explored the Great Park in search of subjects.[44] At this time Betjeman sent him a group of typically ebullient comic drawings which portray the commission as a fairy-tale, casting Clark as 'a great magician' with the power to make artists' dreams come true, and illustrating Piper at work in the Home Park, where he encounters the Queen (fig. 15).[45] The project continued into the following year, and

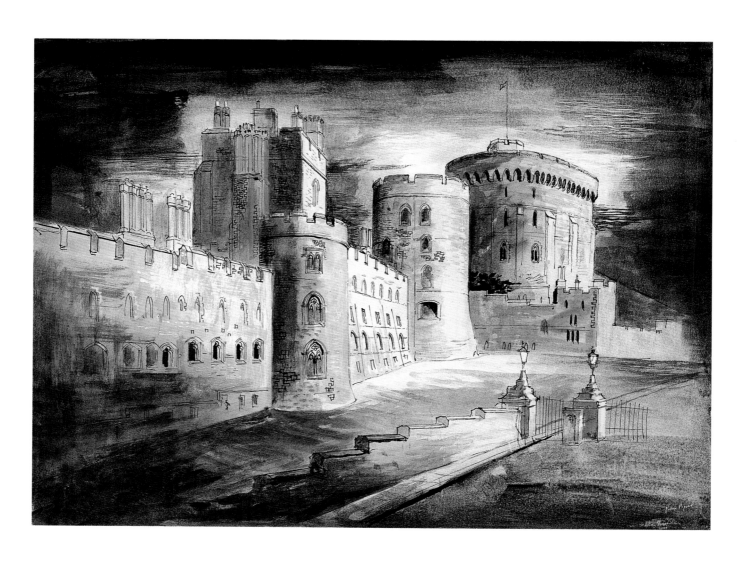

Figure 16

John Piper, *Advance Gate and Castle Hill, Windsor Castle*, 1941–2. Pencil, pen and ink, watercolour and bodycolour
41.8 × 56.1 cm (16⁷⁄₁₆″ × 22¹⁄₁₆″) RCIN 453349

at the end of February 1942 Clark wrote a memorandum to Captain Arthur Penn, Queen Elizabeth's Acting Private Secretary, with the news that Piper had brought around a dozen watercolours of Windsor to show him, on which he commented: 'I am glad to say they are well up to expectation. In fact I think they are the best things he has done.'[46]

This major commission had a much higher profile than Queen Elizabeth's various purchases of contemporary pictures from galleries and charity sales for her own collection, and the brooding Neo-Romanticism of Piper's watercolours was subject to a certain amount of wry disapproval within the Royal Household. A memorandum from Penn of 19 May 1942 to Sir Ulick Alexander, Keeper of the Privy Purse and Treasurer to the King, advising him of the imminent arrival of Piper's invoice for the first set of drawings, reads: 'A slightly melancholy artist, who appears to regard nature through a glass darkly, has recorded, by arrangement, some remarkably sombre representations of Windsor.'[47] The following day Penn wrote to Clark with a plea that Piper might be directed towards more cheerful subjects: 'The Queen wished me to ask you, when writing to Piper, to tell him that the Gothic arbour in the Frogmore Garden is at this moment covered with wisteria in full bloom. If he has the opportunity to record its beauty, the result might repay his pains.'[48] Perhaps the opportunity did not arise; in any event the watercolour which Piper made of the Gothic summer-house at Frogmore (fig. 18) is virtually monochrome, the structure glowing eerily in moonlight against a black sky.

Having been asked to continue with a second group of drawings in the spring of 1942, Piper worked at Windsor over the summer and into the autumn. He wrote to Betjeman in July 1942: 'I have been having a very nice time on the roof at Windsor. Society up there much nicer: housemaids cleaning tennis shoes with Blanco.' Perhaps unsurprisingly given their disagreement over the proper balance of expression and topography, he adds that he has had 'Several good rows about art with O. Morshead lately, but he is lending me the transcript of the Farington diary to bring home vol. by vol.: very good train reading, and makes me look as if one's working for M.I.32B.'[49] Clark wrote to Queen Elizabeth in December 1942, informing her that the new series of watercolours was, he believed, 'even better than the first.'[50]

However, despite having deliberately employed Piper to make this second set of watercolours during the summer months of 1942, Queen Elizabeth seems still to have found the Castle overly dominated by threatening black clouds. At this stage she must have suggested again that Piper might take a less gloomy approach, as Clark wrote to her just after Christmas: 'I have told Piper he must try a spring day & conquer his passion for putting grey architecture against black skies.'[51]

By the following summer Queen Elizabeth and Morshead had accepted that Piper was not an artist who could be persuaded into straight topography, and planned to commission another watercolourist more amenable to that approach (see no. 32, by Claude Muncaster). In July 1943 Morshead wrote:

I am so glad that Your Majesty has it in mind one day to commission another series of 'straight drawings' of the Castle: there are several people who could do them very well. Mr. Piper himself is one of the most interesting and agreeable people I know, with a well-furnished mind and a quiet, kindly outlook on men and things; a great reader and a very competent writer. Strange indeed that such turbulent draughtsmanship should come from so placid and well-balanced a mind. When I laugh to, and at, him about his drawings he accepts it with unruffled humour. I tell him frankly that our successors in 2043 will want to know what the Castle looked like to-day, whereas his designs only tell us about the internal stresses within his own curious mind.

However, despite Morshead's reservations about the degree to which Piper's watercolours fulfilled what he understood to be the purpose of the commission, he concludes generously: 'Still, they have a great vogue and they constitute a really important accession to the Royal Collection.'[52]

Even as late as November 1943, Clark was writing again to Queen Elizabeth in response to another enquiry about Piper's progress with the second group of watercolours, which in the event were finally completed in April 1944. Clark assured her that they were nearly finished, but tactfully acknowledged that Piper had not made any great compromise in his style in response to the Queen's request for a sunnier aspect: 'Black skies prevail, but the poor fellow has done his best to put in a little blue, & the general tone is less stormy.'[53] King George VI's famous joke in response to Piper's lowering skies, no doubt prompted by the Queen's repeated efforts to allay the unrelenting sombreness of the watercolours, is recorded in James Lees-Milne's diary entry for 10 July 1945:

Ben [Nicolson, Deputy Surveyor of the King's Pictures] said that at Windsor the other day the King was looking at his pictures with him. John Piper was present. The King closely scrutinised Piper's pictures of the Castle, turned to him and remarked, 'You seem to have very bad luck with your weather, Mr Piper.'[54]

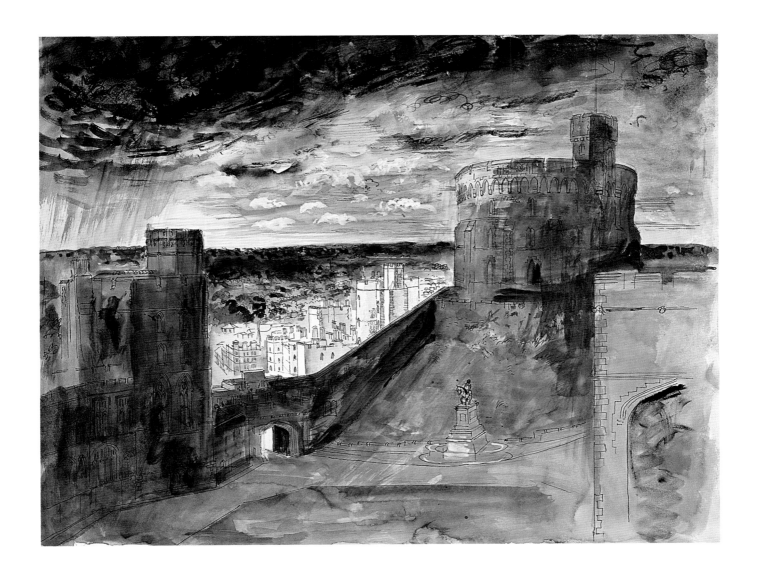

Figure 17
John Piper, *The Round Tower and St George's Gate, Windsor Castle*, 1942–4. Pencil, pen and ink, watercolour and bodycolour
44.4 × 56.5 cm (17½″ × 22¼″) RCIN 453355

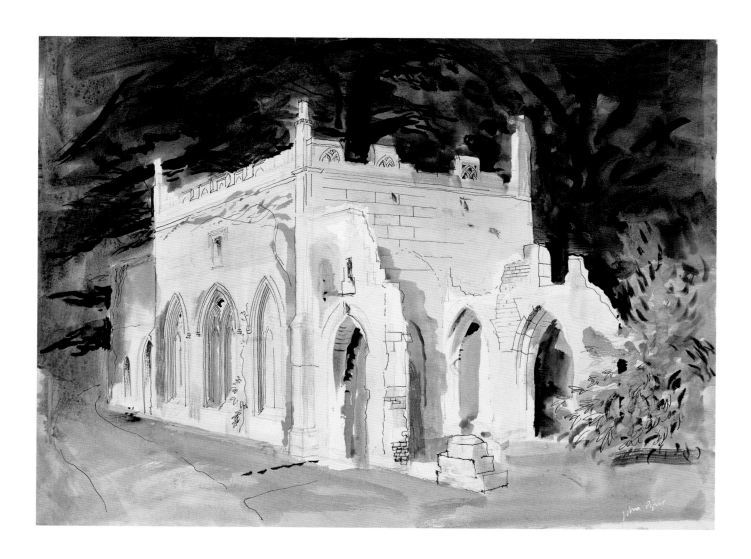

Figure 18
John Piper, *Gothic summer-house at Frogmore*, 1942. Pencil, pen and ink, watercolour, bodycolour and pastel
42.1 × 56.2 cm (16⁹⁄₁₆″ × 22⅛″) RCIN 453340

Piper's 'bad luck' was also the subject of a caricature by Osbert Lancaster in 1947 (fig. 19).

It is difficult to assess Queen Elizabeth's own reaction to Piper's watercolours from the letters and reported comments of those around her, where a sharp division can be seen between Clark, whose resources of tact and diplomacy in the face of intransigent resistance to modernity are strongly exercised, and the wry commentaries of the traditionalists Morshead and Penn. However, despite Queen Elizabeth's initial reservations, she hung Piper's watercolours prominently, latterly in the Lancaster Room at Clarence House (fig. 20), where she enjoyed them for almost fifty years, and would often show them to guests. She seems, too, to have retained a considerable regard for Piper, who, as well as his gift of the *Scuola di San Rocco* watercolour (no. 59), which followed an informal visit made by Queen Elizabeth to his home in 1962, presented her with a lively view of Sandringham House in 1970 (no. 33). When, in 1968, plans were being made for the King George VI Memorial Chantry in St George's Chapel at Windsor, Queen Elizabeth herself intervened in the discussions in order to suggest that Piper be commissioned to design the coloured glass windows.[55]

Alongside Clark and Ridley, another important patron of the arts who became a close friend of Queen Elizabeth was Osbert Sitwell (1892–1969), the eldest of the famous Sitwell siblings. Osbert provided another link to the contemporary art world, and in some areas shared the Queen's taste, approaching John Piper in April 1940 about the commission of a series of watercolours and oil paintings of his Derbyshire home, Renishaw Hall. Piper began this commission in 1942, and worked on it at the same time as the Windsor watercolours, creating a magnificent record of the house and gardens. These, and other works by Piper, were reproduced in Sitwell's five-volume autobiography, *Left Hand, Right Hand!* (1945), *The Scarlet Tree* (1946), *Great Morning* (1948), *Laughter in the Next Room* (1949) and *Noble Essences* (1950), inscribed copies of which he presented to Queen Elizabeth. Osbert and Queen

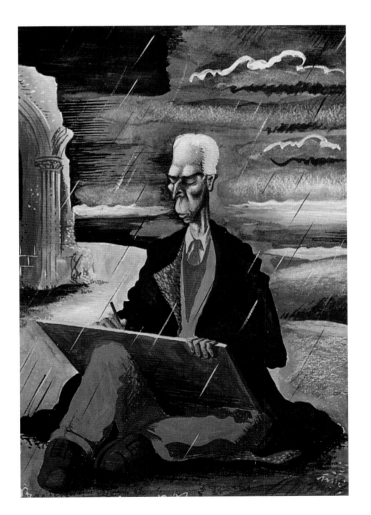

Figure 19
Osbert Lancaster, *'Mr Piper enjoying his usual luck with the weather'*, 1947
Watercolour and bodycolour
25 × 17 cm (9⅞" × 6¹¹⁄₁₆")

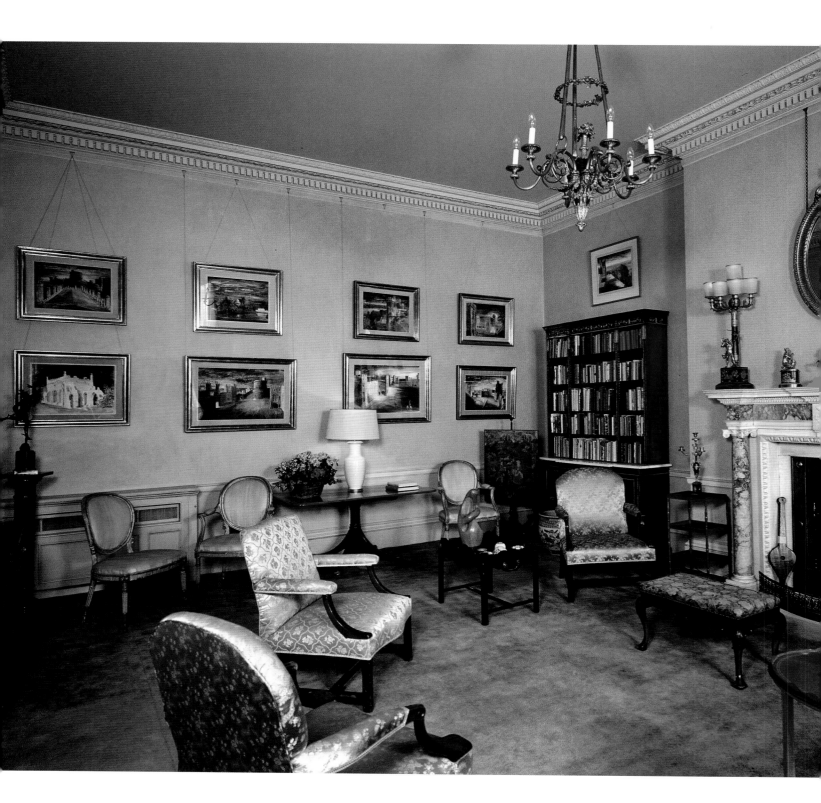

Figure 20
The Lancaster Room at Clarence
House during Queen Elizabeth's
residence, hung with John Piper's
watercolours of Windsor Castle.

Elizabeth met in around 1930, and by 1934 they were close enough friends for him to send her long, amusing, anecdotal letters about art and literature which suggest a conspiratorial alliance: in one sent from France he describes being 'ambushed every now and then, when very tired, by literary (English) bores on holiday. People whom one had avoided successfully for years bounded out of the hotels, directly we arrived, horribly tired, crying "Do you think Mr James Joyce is *sincere*?" or something of that sort.'[56] Osbert became a frequent guest for weekends at Windsor Castle, where he spent time in the Print Room; in a letter of 26 April 1937 he describes 'a delicious hour in the library, looking at the Leonardo drawings, and the Claudes and Poussins, and at the Sandby views of the Castle.'[57] In 1953 he sat in Queen Elizabeth's box in Westminster Abbey for the Coronation of HM The Queen.

It was probably through Osbert Sitwell that Queen Elizabeth met the painter, illustrator, muralist and stage-designer Rex Whistler (1905–44), who was described by Cecil Beaton in his book *Time Exposure* as 'lovable, lively, graceful and intelligent.'[58] In 1936 Whistler had been asked by Queen Elizabeth when Duchess of York to design a book-plate for her own use. In January 1937, after King Edward VIII's abdication, Whistler sent an elaborately illustrated letter to Queen Elizabeth offering best wishes for a long, happy and peaceful reign (fig. 21). He adds: 'I feel so sad that I never got the book-plate design done which, your Majesty may possibly remember, you wished me to do for you – but you said I was not to hurry over it! & perhaps it was as well, as it would not have been of use to your Majesty for long.'[59] The following month Queen Elizabeth commanded him to design ciphers containing the initials G.R.I., E.R. and G.R.E., a project which he must have completed quickly as he received a letter of 'very warmest thanks for the very lovely ciphers' from the Queen on 1 March (fig. 22).[60]

That September, Rex Whistler, along with Osbert Sitwell, was invited to stay at Balmoral Castle, the King's Highland residence. Despite finding the formality which was observed at Balmoral 'the most awful strain', he enjoyed the Gillies' Ball, which he afterwards described impressionistically as 'roars of laughter, in a sea of whirling arms and legs.'[61] Afterwards he wrote a charming illustrated letter of thanks:

I do so want to thank Your Majesty for that most delightful visit to Balmoral. I did enjoy it so enormously & I feel it was so extremely kind of both Your Majesties to have honoured me with such a lovely invitation.

I was most enchanted with the beauty of the interiors & the fascinating & interesting things which Your Majesty showed me. It was such a lovely surprise to find the rooms so pretty as I had rather imagined that they might be a bit gloomy & severe – as Victorian arrangements *sometimes* were.

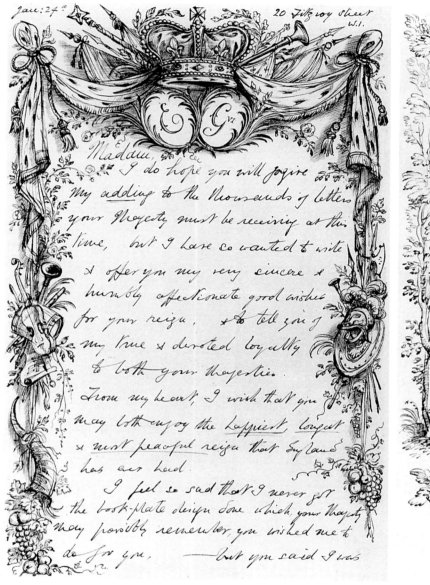

Figure 21

Illustrated letter from Rex Whistler to Queen Elizabeth, 24 January 1937

Owing to Your Majesties' great kindness in sending messages to
Holyrood, Mr Sitwell & I had the most delightful morning seeing the palace.
Some of the rooms – & particularly the ceilings – were lovelier than
anything I have seen.

Again, may I thank Your Majesties for that *most enjoyable* visit.[62]

Letters like these from friends such as Whistler, Osbert Sitwell and even Kenneth
Clark reveal the easy familiarity which they seem to have shared with Queen
Elizabeth. However, to her larger social circle, her artist and writer friends must have
seemed unconventional. A note of thanks from another guest following this stay at
Balmoral in 1937 betrays a hint of genteel alarm in a reference to 'all your charming
and exotic friends,'[63] and King George VI delighted in teasing Osbert about his total
lack of interest in the aristocratic country pursuits of hunting, shooting and fishing,
telling him that he himself had walked twenty-five miles in the hills that day in search

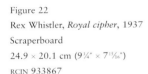

Figure 22
Rex Whistler, *Royal cipher*, 1937
Scraperboard
24.9 × 20.1 cm (9¼″ × 7¹⁵⁄₁₆″)
RCIN 933867

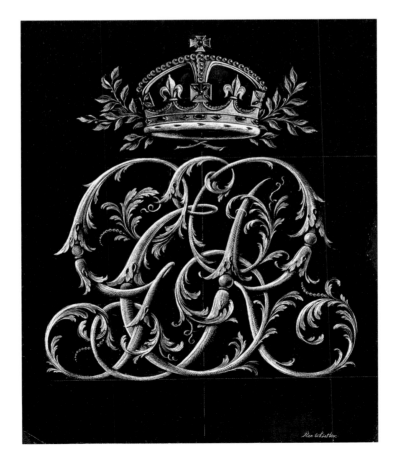

of sport, and that it would have done Osbert good to do the same.[64] The flamboyant aesthete Stephen Tennant, who when a boy had been a visitor to Glamis with his family, was also a correspondent, in particular writing a letter of consolation from his extraordinary house Wilsford Manor just after the bombing of Buckingham Palace during the war.[65] Among other gifts, in 1947 he sent Queen Elizabeth a copy of *The Masque*, comprising reproductions of Whistler's designs for the theatre with essays by Cecil Beaton and James Laver.[66]

In 1939, at the beginning of the Second World War, Whistler was one of the contributors to *The Queen's Book of the Red Cross*, a volume of pictures, short stories and poems published by Hodder and Stoughton in aid of the Lord Mayor of London's Fund for the Red Cross and the Order of St John of Jerusalem. Whistler's *memento mori* painting *In the wilderness* joined works by Edmund Dulac, Frank Brangwyn and Laura Knight among others. On the cover was reproduced one of the photographs of Queen Elizabeth taken by Cecil Beaton earlier that year. In her preface to the book Queen Elizabeth writes of the connection between the arts and the war: 'All of you who buy my book, as well as the distinguished authors and artists who prepared it, are helping forward the great work of many on the battlefield ...'

Just as art was seen to boost morale during the war, so too was literature. On 14 April 1943 Queen Elizabeth attended a poetry reading at the Aeolian Hall organised by Edith and Osbert Sitwell in aid of Lady Crewe's French in Britain Fund (fig. 23). The poets included T.S. Eliot, Walter de la Mare, John Masefield, and Edith and Osbert themselves. In common with many events organised by the Sitwells, the occasion was rather eccentric and not wholly successful.[67] Afterwards Whistler, newly enlisted in the Welsh Guards, described a conversation he had had with Queen Elizabeth shortly after the Aeolian Hall poetry reading. Whistler's battalion was stationed near Thetford in Norfolk, and on 22 April 1943 the Guards Armoured Division gave a demonstration which was attended by the King and Queen (Whistler presented a watercolour of their manoeuvres in the form of a *trompe-l'oeil* print to Queen Elizabeth; RL 33885). With his colonel and the general he was summoned to dine with the royal family at Sandringham. In a letter to his mother, he wrote: 'After dinner I had a most enjoyable talk with the Queen about paintings she had bought – and painters – and books – and poets – and that fantastic *Poetry-reading orgy*, and we bellowed with laughter.'[68]

Another perhaps more unlikely friendship developed between Queen Elizabeth and the Bohemian artist Augustus John (1878–1961). As we have seen, her purchase of John's portrait of George Bernard Shaw, brokered by Clark in 1938, marked the beginning of Queen Elizabeth's collection of modern British pictures. More

acquisitions quickly followed, including *'The sisters'*, purchased from the Redfern Gallery in 1939 (fig. 24). In 1925, during the reign of King George V and Queen Mary, the British Ambassador to Berlin Lord D'Abernon, whose portrait in Garter robes John was to paint, had suggested him as a royal portrait painter. The initial reaction from the King's Private Secretary Lord Stamfordham was not encouraging: 'No! H.M. wouldn't look at A.J.!! And so A.J. wouldn't be able to look at H.M.!!' Yet again, what was inconceivable for King George and Queen Mary was encouraged by their daughter-in-law. When King George VI came to the throne, Queen Elizabeth's stockbroker and old friend Hugo Pitman invited John to meet her, at which point the possibility of a portrait was first raised.[69] However, despite a number of convivial sittings, accompanied by a string quartet, John was unable to finish the portrait and eventually put it in the basement of his studio, where it stayed until it was rediscovered by a dealer in 1961. It was included in an exhibition of 'Paintings and Drawings not previously exhibited', and shortly afterwards was presented to

Figure 23
Queen Elizabeth, Princess Elizabeth, Princess Margaret and Osbert Sitwell at the Aeolian Hall poetry reading, 1943.

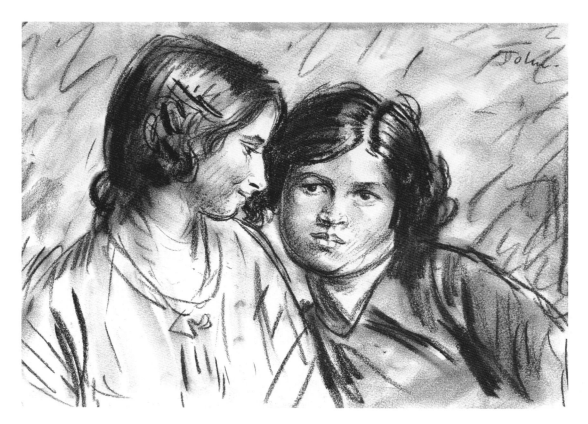

Figure 24
Augustus John, *Ida and Dorelia*,
c.1905–6
Black and red chalk
24.4 × 34.7 cm (9⅝″ × 13¹¹/₁₆″)
RCIN 453380

Queen Elizabeth (fig. 25). She was delighted to have it after so many years, and wrote to John on 19 July 1961: 'I want to tell you what a tremendous pleasure it gives me to see it once again. It looks so lovely in my drawing-room, and has cheered it up no end! The sequins glitter, and the roses and the red chair give a fine glow, and I am so happy to have it …'[70] In his reply John wrote:

> Your most kind letter has given me the greatest pleasure. I was chary
> of exposing the picture in Mr Tooth's show, as being so incomplete, but now
> that it hangs upon your wall, I am convinced that with all its faults, there is
> something there which is both true and loveable. I have really thought so all
> along but have not dared to say so. Perhaps there is a secret in it which only
> few can share. I'd like to think so. Anyhow with all its short-comings you
> have made me happy in spite of bombs & broken windows. I have so often
> thought of continuing the work but am deeply aware of your Majesty's
> ceaseless activities. I have followed your wide travels with admiration &
> even awe, for your Majesty always leaves behind an imprint of unaffected
> grace and benignity in a world so much in need of both.[71]

Figure 25
Augustus John, *Unfinished portrait
of Queen Elizabeth*, 1939–41
Oil on canvas.
127.4 × 102.3 cm (50⅛″ × 40¼″)
RCIN 409137

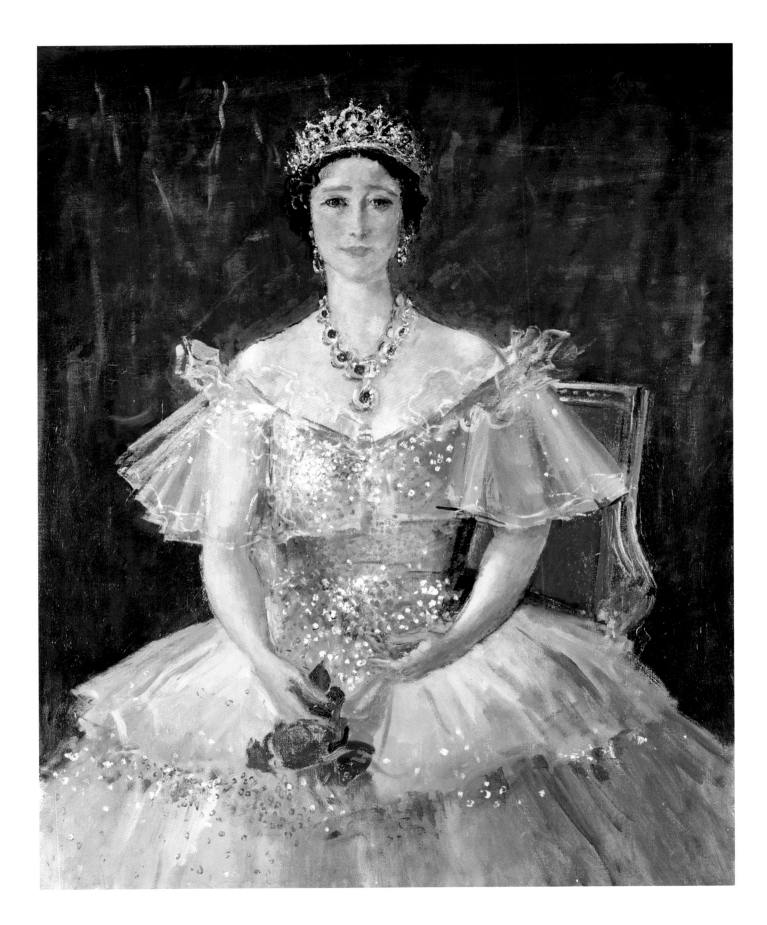

Like Clark and Ridley, John also discussed modern British pictures with Queen Elizabeth. He recalled that in 1941 he had taken a painting by his friend Matthew Smith, *Peaches* (1937), to Buckingham Palace and tried – unsuccessfully, however – to persuade her to buy it.[72]

Another artist friend was the Norfolk painter Edward Seago (1910–74), who became a frequent guest at Sandringham and a regular correspondent. Queen Elizabeth took a keen interest in Seago's painting, and he wrote to her in 1954: 'Your Majesty's encouragement and interest in my work is an inspiration which I value more than I can possibly express.'[73] His letters often refer to their shared love of the particular landscape and quality of light to be found in Norfolk, which he so effectively captures in his paintings and watercolours. Each year on Queen Elizabeth's birthday, and again at Christmas, Seago presented her with one of his own works. In 1955 he proposed a portrait of Queen Elizabeth, enclosing a sketch in his letter and writing: 'If you would ever consider accepting a "conversation piece" I would love to paint it. Something perhaps on the lines of the enclosed scribble. A room in Clarence House I imagine, and Honey [a favourite corgi] on the floor – with a white dress and a beam of light from the window'[74] (fig. 26). Seago painted the portrait of the actor and playwright Noël Coward (1899–1973) for the Garrick Club in 1966, and Coward, who was also a friend of Queen Elizabeth, described the painting and the sittings in a letter: 'I think it is very good, whether or not the Garrick club thinks the same remains to be seen. We talked of you a great deal and most lovingly which is not to be surprised at.'[75] An amateur painter himself, Coward took an interest in Queen Elizabeth's collection, at one point arranging to visit Clarence House specifically to see her Monet, *Study of rocks, the Creuse: 'Le Bloc'* (1889; RCIN 409201).[76] A painting by Coward in Queen Elizabeth's collection, *Sortie de l'église, Jamaïque* of 1960 (RCIN 409032), was probably a gift from the artist.

Although, as we have seen, her period of greatest activity as a patron of artists coincided with the King's reign, Queen Elizabeth steadily added to her collection of pictures throughout her life. In 1973 she bought a late work by Duncan Grant, *Still life with Matisse* (fig. 27), which joined Grant's two paintings of St Paul's Cathedral, acquired during and shortly after the war. She purchased Sir James Gunn's full-size charcoal study for *Conversation piece at Royal Lodge*, commissioned by the Trustees of the National Portrait Gallery in 1950, when it came up for sale in 1977 (RCIN 453397). Increasingly in later years, many works entered her collection as gifts,

Figure 26

Edward Seago, *Sketch for a portrait of Queen Elizabeth*, 1955

Pencil. 17.8 × 19.7 cm (7" × 7¼") RCIN 453684

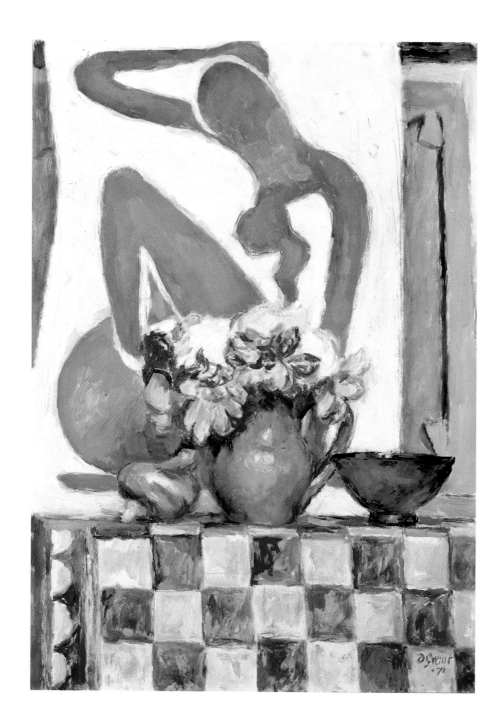

Figure 27

Duncan Grant, *Still life with Matisse*, 1971. Oil on paper

56 × 36.5 cm (22⅟₁₆″ × 14⅛″; sight size) RCIN 453629

both from official organisations and from friends and family, including a large number of watercolours of rooms, buildings and events by Sir Hugh Casson, President of the Royal Academy 1976–84 and a personal friend.

Queen Elizabeth became Patron of the Royal Watercolour Society in 1947. In 1958 she attended the opening of the Society's 250th exhibition (fig. 28). She made a number of purchases from exhibitions at the Royal Watercolour Society, for example the Henderson Hall in the present catalogue (no. 66). As a gift on her hundredth birthday the Society presented her with an album of seventy-five watercolours by its current members.

It is a tribute to her continuing generosity and regard for artists that in 1961 Queen Elizabeth chose Graham Sutherland, whose work she had long admired, to paint her portrait for London University (for which fig. 30 is a preparatory study) and that as late as 1978 she gamely agreed to sit for John Bratby, the 'Kitchen Sink School' artist, whose portraits were a far cry from the Edwardian glamour and respectability conjured up by Sargent and de László.

Queen Elizabeth continued to visit exhibitions throughout her life, and in his last letter to her – written in 1976, forty years after their first meeting – Clark offered again to take her round the National Gallery, remarking that 'one of the joys of life is to visit ... on a Sunday morning.'[77] With her guests at Clarence House conversation was often of pictures and artists, and in July 1977 Sir John Betjeman wrote, thanking her for a lunch party and remarking of a painting by John Everett Millais which

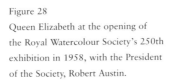

Figure 28
Queen Elizabeth at the opening of the Royal Watercolour Society's 250th exhibition in 1958, with the President of the Society, Robert Austin.

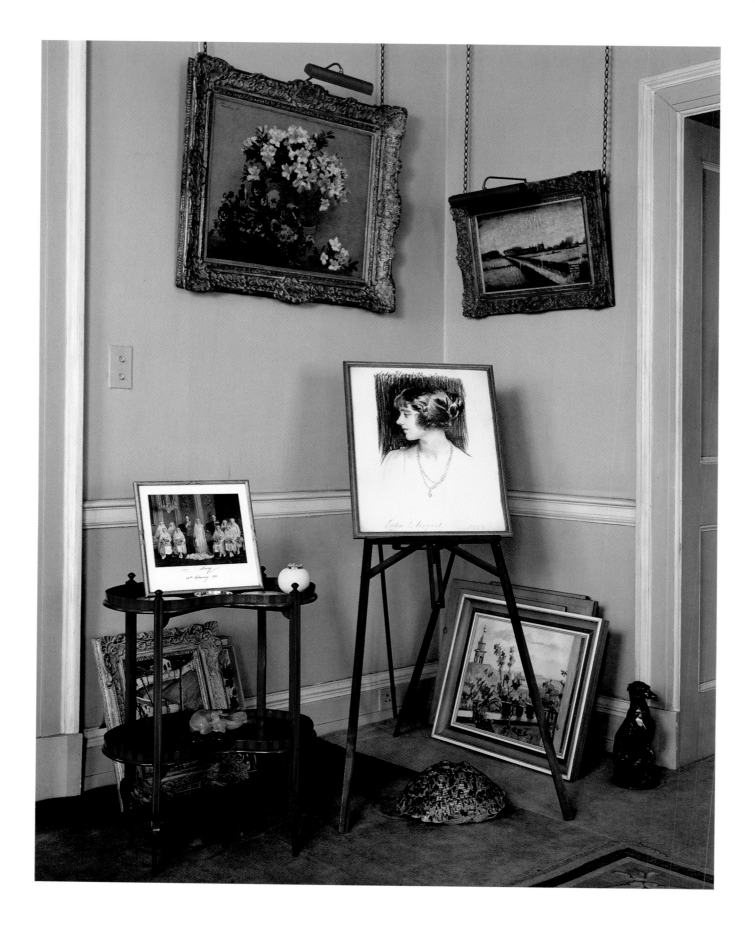

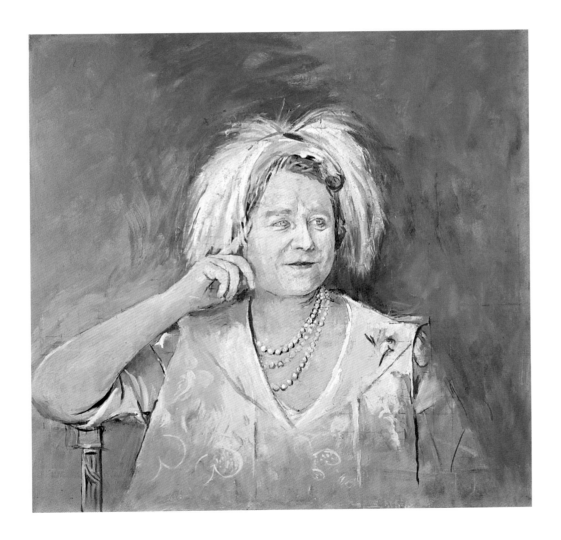

Figure 29
A group of pictures in a corner of
the Morning Room, Clarence House
during Queen Elizabeth's residence.
On the walls hang *Azaleas and pansies*
by Henri Fantin-Latour, 1881
(RCIN 409075) and *A fylde farm* by
L.S. Lowry, 1943 (RCIN 409044),
and on the easel stands a portrait of
Queen Elizabeth at the time of her
marriage in 1923 by John Singer
Sargent (no. 3).

Figure 30
Graham Sutherland, *Sketch for
a portrait of Queen Elizabeth
The Queen Mother*, 1961–7
Oil on canvas
53.9 × 54 cm (21¼" × 21¼")
RCIN 409063

she had acquired in 1942: 'I still think of the EVE OF ST AGNES, a HAUNTING &
UNFORGETTABLE picture. What a solemn contrast it is with the sunlit lawns and
geraniums of Clarence House.'[78]

What is clear from the watercolours and drawings selected for the present
catalogue, and from the oil paintings on display at Clarence House during the summer
months, is Queen Elizabeth's great pleasure in pictures, and what Clark had termed in
1942 her 'interest and understanding'. This is not to say that her collection was of the
stature of Clark's or Ridley's, nor should it be seen as an attempt to create a
representative collection of contemporary British art. Rather, it reflects her warm
friendships with artists, her deeply personal aesthetic response to particular works, and
her recognition of a quality in pictures which she called 'the effect of magic.'[79]

Notes

1 RA QEQM/PRIV/PIC: 18 March 1938 Kenneth Clark to Queen Elizabeth.

2 See Clark 1939 for his views on the decline of patronage.

3 *The Times*, Tuesday 5 April 1938, p. 17.

4 Clark 1977, p. 23.

5 Villa I Tatti, Kenneth Clark Papers, 2.1: 22 January 1942 Owen Morshead to Kenneth Clark.
 In fact Clark admired the work of Wilson Steer (Secrest 1984, p. 105).

6 Quoted in Secrest 1984, p. 151.

7 Rothenstein (J.) 1966, p. 22.

8 Ironside 1941, p. 53.

9 Asquith 1928, p. 83.

10 Cornforth 1996, p. 24.

11 RA QEQM/PRIV/PIC: 3 February 1943 Owen Morshead to Queen Elizabeth. The watercolours,
 both by Sir John Gilbert, are *Queen Victoria receiving a birthday address from the Archbishops and Bishops
 in the Royal Closet, St James's Palace, 25 May 1840* (RL 17241; Millar (D.) 1995, no. 2082) and
 Queen Victoria giving audience to an Ambassador in the Royal Closet, St James's Palace, October 1843
 (RL 17240; Millar (D.) 1995, no. 2083).

12 This was the second in the extensive series of catalogues of drawings in the Royal Collection,
 published by Phaidon. It was replaced in 1994 by a revised catalogue of Dutch and Flemish drawings
 by Christopher White and Charlotte Crawley.

13 For an account of Clark's involvement with the War Artists' Advisory Committee,
 see Harries & Harries 1983, pp. 159–63.

14 Clark 1977, p. 22.

15 RA QEQM/PRIV/CSP/PAL: 26 December 1942 Kenneth Clark to Queen Elizabeth.

16 Rothenstein (J.) 1966, p. 90.

17 Quoted in Cork 1987, p. 231.

18 *Civil Defence Artists: first exhibition*, Cooling Galleries, London, 1941.

19 RA QEQM/TREAS/ACC/BILLS/1942/330. The work by Devas is untraced.

20 Lees-Milne 1975, p. 151.

21 Roberts 1987, pp. 25–6.

22 RA QEQM/PRIV/CSP/PAL/RIDLEY: 14 September 1942.

23 RA QEQM/PRIV/PIC: 13 August 1942 Kenneth Clark to Queen Elizabeth.

24 RA QEQM/PRIV/CSP/PAL: 28 March 1936 Kenneth Clark to the Duchess of York.

25 RA QEQM/PRIV/PIC: 24 March 1939 Kenneth Clark to Queen Elizabeth.

26 Meryl Secrest states that Queen Elizabeth's letters to Clark, which she describes
 as being 'all about paintings', were burned. Secrest 1984, p. 119.

27 RA QEQM/PRIV/CSP/PAL: 10 December 1942 Kenneth Clark to Queen Elizabeth.

28 RA QEQM/PRIV/PIC: 20 February 1939 Kenneth Clark to Queen Elizabeth.

29 Rothenstein (J.) 1966, p. 170.

30 *ibid.*

31 *ibid.*, pp. 93–4.

32 RA QEQM/PRIV/CSP/PAL/RIDLEY: 23 January 1938.

33 RA QEQM/PRIV/CSP/PAL/RIDLEY: 4 December 1943.

34 Rothenstein (J.) 1966, p. 91.

35 *ibid.*, p. 170.

36 Carter 2001, p. 310.

37 RA QEQM/TREAS/ACC/BILLS/1950/318.

38 Beaton 1979, p. 67.

39 RA QEQM/PRIV/PIC: 9 August 1941 Kenneth Clark to Queen Elizabeth.

40 *ibid*.

41 RA QEQM/PRIV/PIC: 15 August 1941 (postmarked) Kenneth Clark to Queen Elizabeth.

42 John Piper to John Betjeman, 23 August 1941; collection of the University of Victoria, British Columbia.

43 RA GV/GG 12: 22 September and 6 October 1941.

44 RA GV/GG 12: 8 November 1941.

45 In a letter to Piper of 12 October 1941, Betjeman writes: 'I expect you will by now have received my drawings of you at work at Windsor ...' (Betjeman 1994, p. 298). The ten drawings are reproduced in an appendix to this volume of Betjeman's letters (*ibid*., pp. 541–51).

46 RA QEQM/TREAS/ACC/BILLS/1942/215.

47 *ibid*.

48 *ibid*.

49 University of Victoria Archives & Special Collections: July 1942 John Piper to John Betjeman.

50 RA QEQM/PRIV/CSP/PAL: 10 December 1942 Kenneth Clark to Queen Elizabeth.

51 RA QEQM/PRIV/CSP/PAL: 26 December 1942 Kenneth Clark to Queen Elizabeth.

52 RA QEQM/PRIV/PIC: 31 July 1943 Owen Morshead to Queen Elizabeth.

53 RA QEQM/PRIV/PIC: 17 November 1943 Kenneth Clark to Queen Elizabeth.

54 Lees-Milne 1977, pp. 211–12.

55 St George's Chapel Archives, CL 22/14.

56 RA QEQM/PRIV/CSP/PAL/SITWELL: 24 August 1934.

57 RA QEQM/PRIV/CSP/PAL/SITWELL: 26 April 1937.

58 Beaton 1946, p. 130.

59 RA QEQM/PRIV/CSP/PAL: 24 January 1937 Rex Whistler to Queen Elizabeth.

60 Whistler & Fuller 1960, p. 54.

61 Whistler 1985, p. 216.

62 RA QEQM/PRIV/CSP/PAL: 22 September 1937 (postmarked) Rex Whistler to Queen Elizabeth.

63 RA QEQM/PRIV/CSP/PAL: 'Tuesday' [1937] Barbara, Countess of Moray to Queen Elizabeth.

64 Ziegler 1998, p. 238.

65 RA QEQM/PRIV/CSP/PAL: 7 October 1940 Stephen Tennant to Queen Elizabeth.

66 Hoare 1990, p. 287.

67 The poetry reading is described at length in Ziegler 1998, pp. 275–7.

68 Whistler 1985, p. 261. Whistler was killed in action in 1944.

69 This story is told at length in Holroyd 1997, pp. 470–3.

70 Quoted in Holroyd 1997, p. 473.

71 RA QEQM/PRIV/PIC: July 1961 Augustus John to Queen Elizabeth.

72 Rothenstein (J.) 1966, pp. 108–9. *Peaches* was purchased by the Tate Gallery in 1941.

73 RA QEQM/PRIV/CSP/PAL/SEAGO: 29 July 1954.

74 RA QEQM/PRIV/CSP/PAL/SEAGO: 28 July 1955. In the event this portrait was not executed.

75 RA QEQM/PRIV/CSP/PAL: 28 September 1966 Noël Coward to Queen Elizabeth.

76 RA QEQM/PRIV/CSP/PAL: 4 December 1964 Noël Coward to Queen Elizabeth.

77 RA QEQM/PRIV/CSP/PAL: 21 January 1976 Kenneth Clark to Queen Elizabeth.

78 RA QEQM/PRIV/CSP/PAL: 25 July 1977 John Betjeman to Queen Elizabeth; RCIN 409156.

79 RA QEQM/PRIV/CSP/PAL/RIDLEY: 4 December 1943.

Catalogue

A Record of a Century

From the first portrait of the young
Lady Elizabeth Bowes-Lyon, to watercolours presented
on her hundredth birthday in 2000, the collection formed
by Queen Elizabeth The Queen Mother is both a personal
record and a reflection of the key events which shaped
the twentieth century. Among the portraits are three
evocative charcoal drawings by John Singer Sargent, two
of which were presented to Lady Elizabeth and the Duke of
York upon their marriage in 1923. Other watercolours
and drawings depict some of the most significant events
in her life: the Coronation in 1937, Victory Night in 1945,
the funeral procession of King George VI in 1952 and
Queen Elizabeth's hundredth birthday parade in 2000.

1. Mabel Hankey (1868–1943)
Lady Elizabeth Bowes-Lyon, 1907

A number of photographs taken of Lady Elizabeth Bowes-Lyon when she was around seven years old show her wearing a dress, apparently copied from a Velázquez painting, which her mother had made for her (see fig. 31). The artist was clearly working from such a photograph here rather than painting from life, and she painted two versions of this picture; the other was also in Queen Elizabeth's collection (RCIN 453284).

The miniature painter Mabel Hankey was born in Bath, the daughter of the professional artist Henry Eddington Hobson. She became the first wife of the painter William Lee Hankey, and exhibited with the Royal Society of British Artists, the Royal Miniature Society, the Society of Women Artists and the Royal Academy. Hankey exhibited a portrait of Lady Elizabeth Bowes-Lyon, possibly this one, at the Royal Academy in 1907 (no. 1149), a portrait of Lady Elizabeth's younger brother David in 1916 (no. 1270) and another portrait of Lady Elizabeth in 1917 (no. 1129). The Countess of Strathmore also commissioned a watercolour portrait from Hankey of her daughter aged nineteen, a picture which eventually entered Queen Elizabeth's collection (RCIN 453374).

Watercolour

37.8 × 27.2 cm (14⅞" × 11¹¹⁄₁₆")

Signed bottom left *Mabel Hankey*.

RCIN 453421

PROVENANCE Commissioned by the Countess of Strathmore; by descent

EXHIBITION London 1980, no. 1

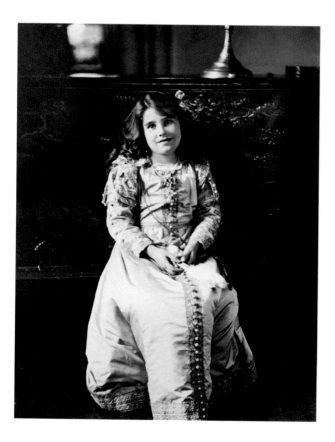

Figure 31
Lafayette, *Lady Elizabeth Bowes-Lyon*, c.1907

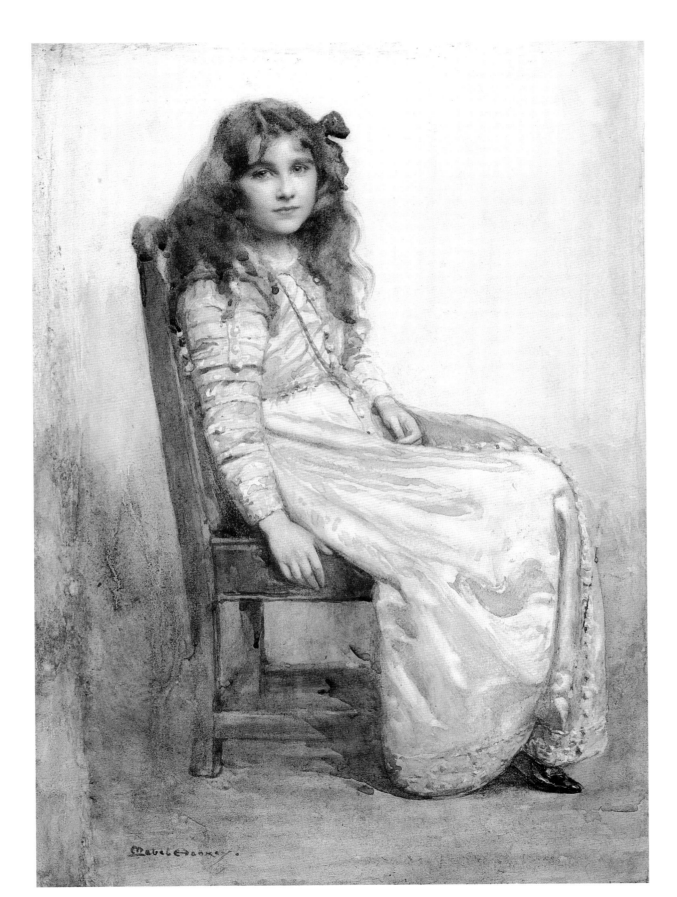

2. Mabel Hankey (1868–1943)
The Countess of Strathmore, 1923

Lady Elizabeth Bowes-Lyon's mother, Nina Cecilia Cavendish-Bentinck (1862–1938), was the daughter of Archdeacon Charles William Frederick Cavendish-Bentinck and his second wife Caroline Louisa Burnaby. Her father was the grandson of the 3rd Duke of Portland, Prime Minister in 1783 and 1807–9. In 1881 she married Claude Bowes-Lyon (1855–1944), who succeeded his father as 14th Earl of Strathmore in 1904.

The Earl and Countess of Strathmore had ten children, of whom Lady Elizabeth was the penultimate child and youngest daughter. Lady Strathmore had a very close relationship with her children, and taught the younger ones to read and write. She was generous and hospitable, delighting in musical evenings and hosting many house parties for her children's friends.

Mabel Hankey painted this watercolour portrait of the Countess in the year of Lady Elizabeth Bowes-Lyon's marriage to the Duke of York.

Pencil, watercolour and white bodycolour

56.5 × 39.5 cm (22¼" × 15½")

Signed and dated bottom left *Mabel Hankey. 1923*

RCIN 453428

PROVENANCE Wedding gift from Mrs Lancelot Hugh Smith, 1923

3. John Singer Sargent (1856–1925)
Lady Elizabeth Bowes-Lyon: profile portrait, 1923

See also nos. 4 and 5

These three portraits were made shortly before the marriage of Lady Elizabeth Bowes-Lyon to the Duke of York, which took place in April 1923. The inventory of the wedding gifts presented to the couple records that John Singer Sargent's portrait of the Duke of York was given by the American Ambassador and that his three-quarter face portrait of Lady Elizabeth Bowes-Lyon was given by Prince Paul of Serbia. The profile portrait of Lady Elizabeth is not recorded in the inventory; however, it is recorded elsewhere as having been in the collection of the Countess of Strathmore. The provenance of the full-face portraits of Lady Elizabeth and the Duke of York suggests that pendant portraits by Sargent were included on the couple's wedding list.

Although from around 1907 Sargent – renowned for his dazzling bravura paintings of society beauties, artists, writers and statesmen of the 1880s and 1890s – declined almost all commissions for paintings, he produced a large number of charcoal portrait drawings during this period. Many of these drawings possess the technical brilliance of his paintings, and like them capture the alertness of his sitters and suggest keenly observed character. Typically, as in these three examples, the head is defined against a dark background of vigorous charcoal strokes.

Sargent usually required one two-hour sitting for a charcoal portrait. He is said to have remarked that Lady Elizabeth Bowes-Lyon was 'the only completely unselfconscious sitter I have ever had.'[1]

In later years, Queen Elizabeth hung the pendant portraits at Royal Lodge, and displayed the profile upon an easel in the Morning Room at Clarence House (see fig. 29).

Charcoal

60.6 × 47.7 cm (23⅞" × 18¾")

Inscribed at top *Lady Elizabeth Lyon*, signed and dated at bottom *John S. Sargent 1923*

RCIN 453381

PROVENANCE Countess of Strathmore; by descent

LITERATURE Asquith 1928, p. 18; McKibbin 1956, p. 94

EXHIBITION Leeds/London/Detroit 1979, no. 77

1. Asquith 1928, p. 18.

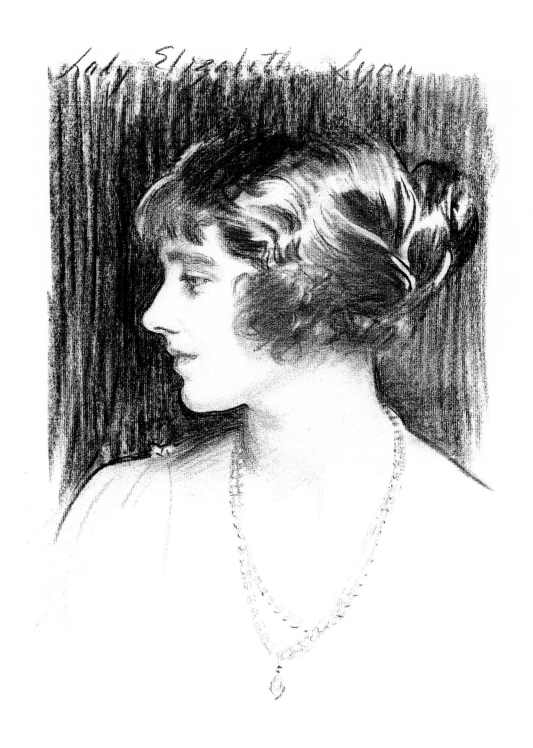

Lady Elizabeth Lyon

John S. Sargent *1923*

4. John Singer Sargent (1856–1925)
Lady Elizabeth Bowes-Lyon, 1923

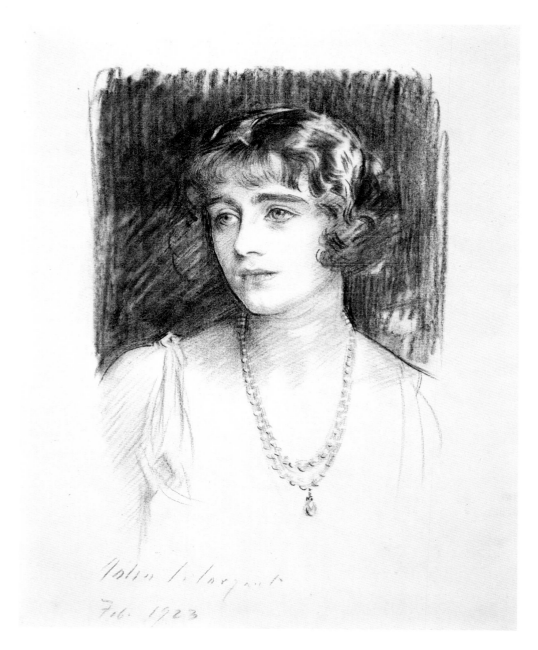

Charcoal

60.8 × 48.1 cm (23¹⁵⁄₁₆" × 18¹⁵⁄₁₆")

Signed and dated lower left
John S. Sargent / Feb. 1923

RCIN 453592

PROVENANCE Wedding gift from
Prince Paul of Serbia, 1923

LITERATURE Asquith 1928, p. 18;
McKibbin 1956, p. 94

EXHIBITION London 1926, no. 521

5. John Singer Sargent (1856–1925)
HRH The Duke of York, 1923

Charcoal

60.8 × 45.2 cm (23¹⁵⁄₁₆″ × 17¹³⁄₁₆″)

Signed and dated at top
John S. Sargent April / 1923

RCIN 453593

PROVENANCE Wedding gift
from George Harvey,
the American Ambassador
to the Court of St James, 1923

LITERATURE McKibbin 1956, p. 97

EXHIBITION London 1926, no. 523

6. Ricciardo Meacci (1856 – after 1928)
The wedding of the Duke and Duchess of York, 1923: a symbolic representation, 1922/3

Ricciardo Meacci was born near Chiusi. After attending the Academy of Fine Art in Siena between 1871 and 1880, he moved to Florence where he lived and worked for the rest of his life. He specialised in small and extremely highly worked allegorical watercolours and tempera paintings. Meacci's work, like that of the English painter John Roddam Spencer Stanhope, who also moved to Florence in 1880, has a strong historicist flavour, revealing the influence of the English Pre-Raphaelite artists and their circle, particularly Sir Edward Burne-Jones.

Meacci seems to have found his principal clients among the aristocratic expatriate English community living in and around Florence (see page 16). His watercolours,

Pencil, watercolour, bodycolour, impasto and gold

26 × 31 cm; 39 × 15.5 cm; 26 × 31 cm (10¼" × 12⅛"; 15⅜" × 6¼"; 10¼" × 12⅛")

Signed lower left of right-hand panel
R. MEACCI

RCIN 933827

PROVENANCE Wedding gift from Violet Cavendish-Bentinck, 1923

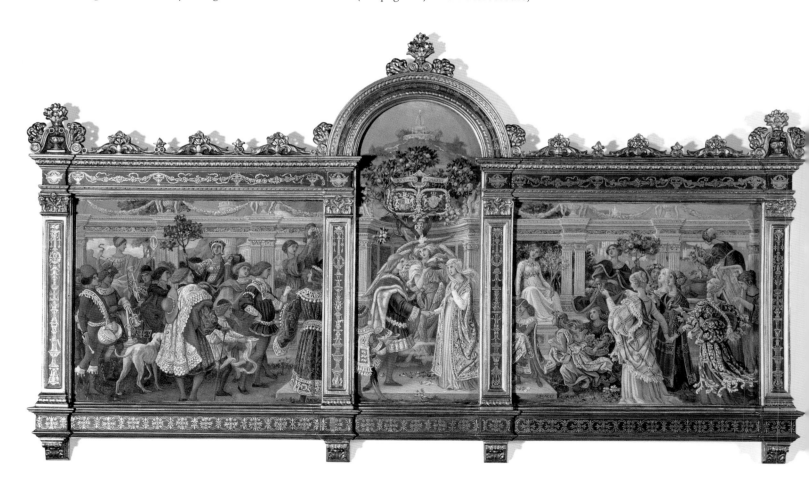

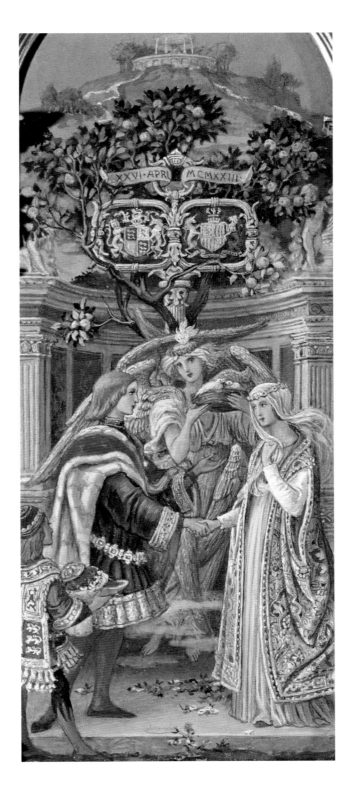

always presented in elaborately decorated frames, had the souvenir appeal of miniature versions of Renaissance altarpieces. Meacci was commissioned to decorate the missal of the English church at Florence, Holy Trinity, and he painted figures of prophets for the ceiling of the Istituto di Santa Teresa and frescos for the Palazzo Pubblico, both in Siena.

This picture was a wedding present from Violet Cavendish-Bentinck, the unmarried sister of Lady Elizabeth's mother. Miss Cavendish-Bentinck introduced Lady Elizabeth to Florentine painting when as a child she stayed with her and her grandmother (Violet's mother) Mrs Scott at the Villa Capponi outside Florence. Another wedding gift was a headboard painted by Meacci (RCIN 100153). Here the arms of the Strathmore and the British royal family are set side by side in the tree above the bride and groom in the central section, with the date of the wedding, 26 April 1923, inscribed on banners above.

7. Mabel Hankey (1868–1943) after Cecil Beaton (1904–1980)
Queen Elizabeth, 1940

See also nos. 8 and 9

Queen Elizabeth commissioned Mabel Hankey late in 1939 to paint a watercolour portrait, perhaps as a way of offering financial support to the elderly artist, who, having worked in a succession of London studios, moved to Storrington in Sussex at the outbreak of war; a memorandum written by Queen Elizabeth relating to the commission stipulates that Hankey should be paid in advance for the portrait.[1] The commissions of the portraits of the Princesses Elizabeth and Margaret Rose, and another commission for a portrait of the Queen (RCIN 453549), followed this in 1942. These pictures, probably Hankey's final works, were completed shortly before her death on 5 January 1943.

Queen Elizabeth sent Hankey photographs from which to work, which accounts for the faint pencil squaring over the portraits, showing the process by which the artist scaled the images up to the present format. For the portrait of herself she chose a favourite Beaton photograph. The portraits of Princess Elizabeth and Princess Margaret were copied from photographs taken at sittings in December 1938 and February 1939 with the fashionable child photographer Marcus Adams (1875–1959). Adams had first been commissioned to photograph Princess Elizabeth in 1926, after which his association with the royal family continued for the next thirty years.[2]

Pencil, watercolour and white bodycolour

52.6 × 42.4 cm (20¹¹⁄₁₆″ × 16¹¹⁄₁₆″)

RCIN 453681

PROVENANCE Commissioned by Queen Elizabeth

1. RA QEQM/TREAS/ACC/BILLS/1939/495.

2. Thuillier 1985, pp. 102–6.

8. Mabel Hankey (1868–1943) after Marcus Adams (1875–1959)
Princess Elizabeth, 1942

Pencil, watercolour and white bodycolour

46.3 × 33.7 cm (18¼" × 13¼")

RCIN 453525a

PROVENANCE Commissioned by Queen Elizabeth

9. Mabel Hankey (1868–1943) after Marcus Adams (1875–1959)
Princess Margaret Rose, 1942

Pencil, watercolour and white
bodycolour

46.3 × 33.7 cm (18¼" × 13¼")

RCIN 453525b

PROVENANCE Commissioned
by Queen Elizabeth

10. Claude Muncaster (1903–1974)
Waiting for their Majesties in Piccadilly, 12 May 1937, 1937

When, on 10 December 1936, King Edward VIII abdicated after a reign of less than eleven months, his younger brother – the Duke of York – unexpectedly became King, and the Duchess his Queen Consort. In modern times the coronation ceremony at Westminster Abbey has usually taken place around a year after a monarch's accession. However, in this case the planning was already in train, and the ceremony for King George VI and Queen Elizabeth took place unusually early, only five months into their reign, and on the very date that had been fixed for King Edward VIII's coronation.

Piccadilly, depicted here by Claude Muncaster (for whom see no. 32), was on the Coronation route between Westminster Abbey and Buckingham Palace, where in 1937 crowds gathered to see the King and Queen pass in the Gold State Coach. The view is at the eastern end of Piccadilly, just to the west of Piccadilly Circus, looking across the street northwards into Air Street, which cuts through to Regent Street.

Pencil and watercolour

30 × 39 cm (11⅞" × 15⅜")

Inscribed left *307*;
lower right *11.7/8 x 10 5/8 Panel A*

RCIN 453362

PROVENANCE Purchased 1974

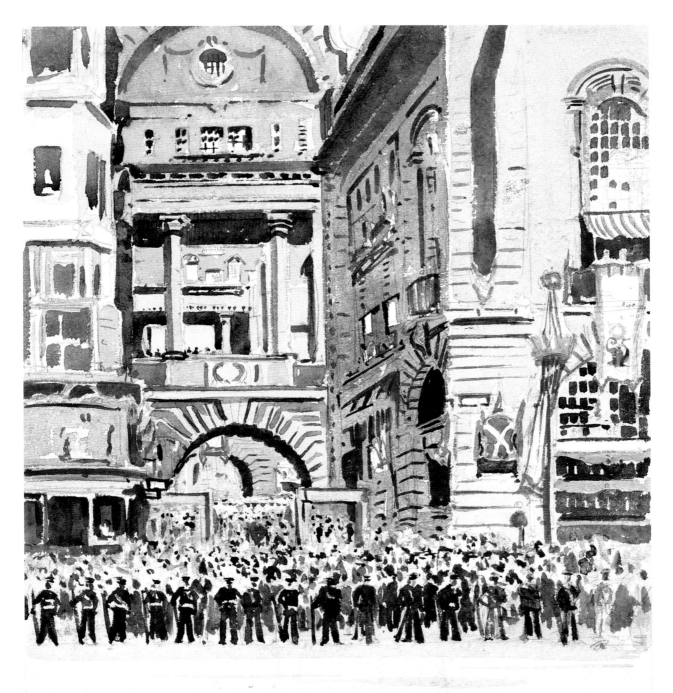
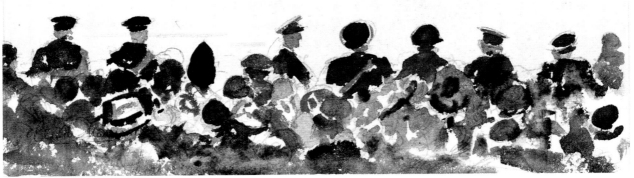

11. Sir Muirhead Bone (1876–1953)

The end of Coronation week, Buckingham Palace, 14 May 1937, 1937

Born near Glasgow, Muirhead Bone, the son of a journalist, was apprenticed to an architect in the city, and at the same time took evening classes at the Glasgow School of Art. Two of his early topographical drawings were published in the last issue (April 1897) of the 'decadent' 1890s periodical the *Yellow Book*, of which Aubrey Beardsley was a founder.

Bone moved to London in 1901, where he became a member of the New English Art Club, and in 1904 was the 'leading spirit' of the Society of Twelve, a small group of draughtsmen and printmakers including William Rothenstein, Charles Conder, Augustus John, William Nicholson, Charles Ricketts and Charles Shannon. In his memoirs Rothenstein recalled that the drawings and etchings which Bone exhibited in the Society's exhibitions found ready purchasers. He went on:

No wonder, for they were remarkable. And Bone too was a remarkable person. He could work anywhere, no matter how crowded or inconvenient the place he selected; he would begin his drawing on any scrap of paper that was handy, continuing on other scraps, which he fitted together with consummate skill. He had the eye of a bird for detail, and a remarkable sense of proportion, and he drew buildings with the skill and ease with which [Augustus] John drew his figures ...[1]

In an obituary published in *The Times* in 1953, Kenneth Clark praised Bone's 'almost miraculous skill.'[2]

Wax-based crayon

34.7 × 50 cm (13¹¹⁄₁₆" × 19¹¹⁄₁₆")

Signed lower right *Muirhead Bone*; inscribed bottom right *Buckingham Palace / May 14. 1937 / The End of Coronation Week*; inscribed lower centre *reproduction / Cut to here*; inscribed upper centre *Cut reproduction to here*

RCIN 453458

PROVENANCE Purchased from Robertson & Bruce Ltd, Dundee, 10 July 1942

1. Rothenstein (W.) 1931–2, II, p. 69.

2. *The Times*, 29 October 1953, p. 10.

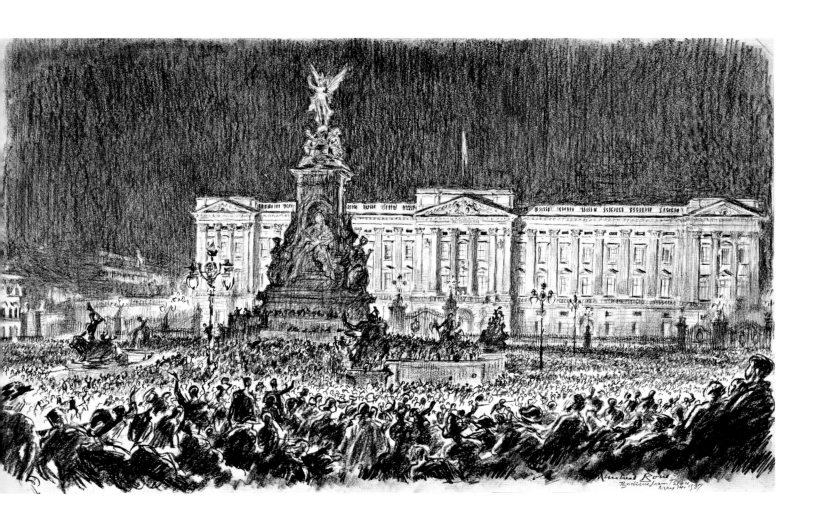

12. Norma Bull (1906–1980)
St Paul's Cathedral on Victory Night, 1945

The reign of King George VI was dominated by the Second World War, which broke
out in September 1939. The King and Queen remained in London for much of the war,
with regular visits to Windsor. At the suggestion that the Princesses should evacuate to
the safety of Canada or the United States for the duration, the Queen famously said
'The children won't go without me. I won't leave the King. And the King will never
leave.' Instead, Queen Elizabeth made a number of tours around the country, visiting
bomb-damaged cities, Civil Defence points, Red Cross centres, hospitals and factories.
Buckingham Palace itself suffered nine direct hits during the Blitz, and on 10 September
1940 the Private Chapel, the site of the present Queen's Gallery, was destroyed
(see fig. 5, page 21). Victory in Europe (VE) day, the formal end of the war, was
celebrated on 8 May 1945.

The introductory essay to the catalogue *Paintings of Wartime Britain* by Norma Bull
(for whom see nos. 63–5) records the phenomenon of repeating crosses made by
searchlights in the sky above St Paul's Cathedral on Victory Night. Bull included three
other watercolours of St Paul's in her exhibition at Australia House in London in 1947.
St Paul's Cathedral miraculously survived the Blitz, suffering only minor bomb damage
when surrounding buildings were reduced to rubble; as a result it became a symbol of
the indomitable spirit of the capital. In July 1946 Queen Elizabeth gave £100 towards
the St Paul's Cathedral Restoration Fund.

This sketch is inscribed in pencil with numbers and notes on colour – 'White';
'Green'; 'Purple'; 'blueish'; 'rainbow'; 'diamond'; 'amber'; 'mauve' – suggesting that
it was perhaps a study for a tapestry which, if made, is untraced.

Pencil and watercolour

23.8 × 13.6 cm (9⅜" × 5⅜")

Signed bottom right *Norma Bull*;
inscribed lower left *St Pauls –
Victory Night*

RCIN 453417

PROVENANCE Presented by
the artist, 1947

EXHIBITION London/Melbourne
1947 & 1949, no. 53

13. Feliks Topolski (1907–1989)
Part of the funeral procession of King George VI, 1952

King George VI's death at Sandringham on 6 February 1952 followed the gradual deterioration of his health over the previous four years. On 11 February his coffin, which had lain in the church at Sandringham, was taken by train to London, then transported on a gun carriage through the streets to Westminster Hall for the lying-in-state. In this impressionistic sketch, Feliks Topolski (for whom see no. 67) depicts sailors marching alongside the bier in the procession. The coffin was then transported to Windsor, where the King's funeral took place on 16 February.

A label attached to the back of the frame is inscribed by Queen Elizabeth's Treasurer, Captain Sir Arthur Penn: 'Mr Felix Topolski made a number of watercoloured drawings showing various aspects of the Procession. They were slight in character, very rapidly executed "shorthand notes", in fact. Queen Elizabeth was informed of their existence & asked to see them – The artist asked Her Majty's acceptance of one of them & this is it.' Two other drawings of the procession were included in the large group of drawings presented by Topolski to HM The Queen in 1986 (RL 26349 and RL 26350).

Pen, ink, watercolour and bodycolour

17.8 × 25.3 cm (7″ × 9¹⁵⁄₁₆″)

RCIN 453682

PROVENANCE Presented by the artist, 1952

14. Sir Hugh Casson (1910–1999)

HM Queen Elizabeth The Queen Mother on her birthday, Royal Opera House, Covent Garden, 1980

This watercolour was commissioned by Sir Claus Moser, Chairman of the Royal Opera House from 1974 to 1987, as an eightieth birthday present for Queen Elizabeth, Patron of the Royal Opera Company. In his diary Hugh Casson (see page 120) records the gala evening at Covent Garden on 4 August 1980 at which he made preparatory sketches for the watercolour:

> Our seats, chosen to give me a good drawing view, adjoin the royal box, and I find myself sitting next to Prince Philip, who starts immediate conversation across the partition on some technical stuff I've sent him about sail-aided marine transport.
>
> Three ballets, the first old-fashioned and unalluring, the second, *A Month in the Country*, moving, beautiful with Julia Oman's evocative sets, the third Freddie Ashton's 'special'. Nice simple classical set, gold and white, Rachmaninov music. I try miserably to sketch in the dark, so as not to be noticed. National Anthem and Happy Birthday sung with fervour by all present … silver rain from the ceiling, balloons on the stage … cheers and claps for the Queen who, on Queen Elizabeth's evening, so to speak, has difficult problems of timing – when to stand, sit, indicate 'that's enough', not too soon, not too late. Her timing is unerring. She is in pink with a pearl embroidered belt, Queen Elizabeth and Princess Margaret in white.

Casson's entry for the next day describes how he spent the following morning completing the drawing: 'I find Queen Elizabeth difficult to draw at the size of my finger-nail but by lunchtime it's done. I give it to Bob, the frame-maker at the RA, and with luck it will be delivered to Clarence House by Friday.' He concludes: 'Buy a pair of shoes to celebrate a task done.'[1]

Pencil, watercolour and white bodycolour

47.1 × 37.6 cm (18⁹⁄₁₆" × 14⁹⁄₁₆")

Inscribed in pen at bottom right *Royal Opera House / Covent Garden / August 4th 1980* and at bottom edge *Upon the occasion of the birthday of HM Queen Elizabeth The Queen Mother.* Signed bottom right *Hugh Casson*

RCIN 453383

PROVENANCE Presented by the Royal Opera House as an eightieth birthday present, 1980

LITERATURE Casson 1981, pp. 94–5

1. Casson 1981, p. 95.

From the occasion of the Birthday of Her Majesty Queen Elizabeth the Queen Mother

Hugh Casson.

15. Charlotte Halliday (b.1935)
The Queen Mother's birthday parade, 2000

With Queen Elizabeth as their Patron, the Royal Watercolour Society was allocated seats for the great birthday parade held on 19 July in celebration of her hundredth birthday. Charlotte Halliday, a member of the Society, who recorded the scene in this drawing, recalled the event as 'wonderful – quite unique of course, not only for the extraordinary variety of the processions and choirs and floats, but for the atmosphere. The affection for the Queen Mother was palpable.'[1]

Halliday attended the Royal Academy Schools (1953–8). She was encouraged both by the watercolourist and draughtsman Henry Rushbury, a family friend, and by the architect Sir Albert Richardson, President of the Royal Academy of Arts from 1954 to 1956 (see page 92). From these mentors Halliday developed her interest in topographical drawing. She was made a member of the New English Art Club in 1961 and the Royal Watercolour Society in 1976.

Pencil, watercolour and white bodycolour on buff paper

25.3 × 34.7 cm (19¹⁵/₁₆" × 13¹¹/₁₆")

Signed and dated bottom right
Charlotte Halliday 19.7.2000

RCIN 453457

PROVENANCE Presented by the QM 100 Committee, 2000

EXHIBITION London 2000, no. 24

1. Correspondence with the artist.

Charlotte Halliday 19.7.2000

Queen Elizabeth's Residences

Throughout her life Queen Elizabeth collected watercolours of her residences, and the selection here includes pictures of her childhood home Glamis Castle; Birkhall in Aberdeenshire and Royal Lodge in Windsor Great Park, her homes as the Duchess of York and later as the Queen Mother; Windsor Castle; Sandringham House in Norfolk; the Castle of Mey in Caithness; and the place most closely associated with her, Clarence House in London.

Queen Elizabeth attached great importance to Windsor Castle, where a suite of rooms was reserved for her use until her death. She and King George VI are buried in St George's Chapel. As well as collecting a spectacular group of watercolours by Paul Sandby of the Castle and surrounding area, in her most significant act of patronage she commissioned John Piper to produce views of Windsor during the Second World War.

16. R. Beatrice Lawrence Smith (*fl.*1896–1911)
Glamis Castle, the yew walk, *c.*1900–10

Glamis Castle, which lies twelve miles north of Dundee next to the river Dean, has belonged to the Lyon family since the fourteenth century. The Castle became Lady Elizabeth Bowes-Lyon's home in 1904, when, on the death of her grandfather, her father became 14th Earl of Strathmore and Kinghorne. During Lady Elizabeth's childhood the family spent three months of each year at Glamis; the remainder of the year was spent in London or at St Paul's Walden Bury in Hertfordshire.

The oldest surviving parts of the Castle date from 1372, when Sir John Lyon was granted the thanage of Strathmore by Robert II of Scotland. The red sandstone Castle was built on the site of a fortified royal hunting lodge where, according to legend, King Duncan was murdered by Macbeth in 1040. The Castle was remodelled in the seventeenth century by the 3rd Earl of Strathmore, who added the distinctive coned turrets.

During the First World War the Castle became a Red Cross hospital and was used as a convalescent home for wounded soldiers; Lady Elizabeth helped to look after the men. It was at Glamis that the Duke of York's courtship of Lady Elizabeth took place.

Beatrice Lawrence Smith exhibited at the Royal Academy between 1896 and 1904, and in 1911 held an exhibition of her topographical watercolours at Walker's Galleries in London.

Watercolour and pencil

37.8 × 49.5 cm (14⅞" × 19½")

Signed lower right
RB Lawrence-Smith

RCIN 453578

PROVENANCE Unknown

17. Sir Albert Richardson (1880–1964)
Glamis Castle, 1950

Sir Albert Richardson recorded making this watercolour of Glamis on 22 September
1950, writing in his diary of how he 'spent the whole day sketching and colouring in
the wet.' In April the following year he presented the picture to Queen Elizabeth,
recording the conversation thus:

> I mentioned the drawing in watercolour of Glamis which I made last year
> and said I should like Her Majesty to most graciously accept this. The Queen
> discussed the rosy glow which invariably came over the Castle at 6 o'clock in
> the evening. I replied and said that although it rained all day while I made the
> drawing, the rosy colour came as well as the shadows. Her Majesty said she
> was thrilled to have the drawing.[1]

Sir Albert Richardson, always known as 'the Professor', had a long and
distinguished career as an architect, writer and lecturer. He was Professor of Architecture
at the Bartlett School, University College London, 1919–46, and President of the
Royal Academy 1954–6. In the years following the Second World War Richardson
restored many bomb-damaged buildings in London, including Merchant Taylors' Hall
(1953), Hawksmoor's St Alfege's, Greenwich (1959) and Wren's St James's, Piccadilly
(1947–54). Queen Elizabeth's day books record that on Friday 29 July 1955 she
attended a lecture given by Professor Richardson at the Guildhall of St George on
'The Significance of the Fine Arts'.[2]

Richardson also made a series of ten watercolour drawings of Frogmore House in
Windsor Home Park and of Royal Lodge and the village in the Great Park in 1956,
which are preserved in the Print Room at Windsor (RL 32416–25).

Pencil and watercolour
sight size;
27.4 × 37.9 cm (10¹³⁄₁₆″ × 14¹⁵⁄₁₆″)
Signed and dated bottom right
A.E. Richardson / 1950

RCIN 453477

PROVENANCE Presented by
the artist, 1951

1. From the diary of Sir Albert
 Richardson, courtesy of Simon
 Houfe.
2. RA QEQM/DIARY/1955: 29 July.

18. Alan Carr Linford (b.1926)
Birkhall, 1991

Birkhall, built in 1715, is situated on the Balmoral Estate in Aberdeenshire above the river Muick. It came into royal possession in 1849, the year after Queen Victoria and Prince Albert took the lease of Balmoral, when they bought Birkhall for the Prince of Wales, later King Edward VII. When he was young the house was let, and one of the tenants was the Queen's physician Sir James Clark. During his tenancy, in 1856, Florence Nightingale stayed at Birkhall. From around 1930 King George V lent the house to the Duke and Duchess of York, and they replanned the gardens. Queen Elizabeth moved from Balmoral to Birkhall, which would effectively become the dower house, after the King's death in 1952. She did much to modernise the house, adding a new wing (on the left in this view) in the mid-1950s and carrying out the garden plans which she had made with her husband in the 1930s. Birkhall is now the Scottish residence of HRH The Prince of Wales.

Alan Carr Linford studied at the Royal College of Art, where he was awarded the Prix de Rome, attending the British School at Rome from 1947 to 1949. He was introduced to the Royal Family by the artist Edward Halliday, and was subsequently commissioned on a number of occasions. In 1949 HRH The Duke of Edinburgh commissioned sixteen watercolour views along the river Thames between Chelsea and Greenwich, and ten years later a series of watercolours of Windsor Castle. These, like John Piper's watercolours of the early 1940s and Claude Muncaster's post-war views, were conceived as modern equivalents of the famous group of views of Windsor in the Royal Collection by Paul and Thomas Sandby; some of the same viewpoints were deliberately chosen.

Queen Elizabeth was active in planting the garden at Birkhall, which is a version of a Scottish pleasaunce, incorporating fruit and vegetables as well as flowers, arranged decoratively within a structure of hedges, paths and topiary.[1] Carr Linford's watercolour was painted when the double border of pink *Phlox paniculata* 'Windsor', a flower of which Queen Elizabeth was particularly fond, was in full bloom.[2]

Pen and ink and watercolour

32.8 × 45.8 cm (12¹⁵⁄₁₆″ × 18″)

Signed and dated bottom right
A Carr Linford 91

RCIN 453459

PROVENANCE Commissioned by Victoria de Rin and given as a Christmas present, 1991

1. See Strong 1992, p. 148.

2. Correspondence with the artist.

19. Paul Sandby (1731–1809)

Deputy Ranger's Lodge, Windsor Great Park, with figures in foreground, 1798

See also no. 20

Deputy Ranger's Lodge, in the heart of Windsor Great Park, eventually became Royal Lodge, Queen Elizabeth's Windsor home from 1932. A house is recorded on this site from 1662; it may have been built around ten years earlier, during the Commonwealth period. It has had a very varied history; in the early eighteenth century it was known as Garden House and was presumably the residence of the gardener at the Great Lodge (now Cumberland Lodge). By 1750 it had been turned into a dairy. Thomas Sandby, who in 1764 was appointed Steward to the Ranger of Windsor Great Park (the Duke of Cumberland), may have lived there from around 1770, and in the 1790s it was recorded in several watercolours by Thomas's younger brother Paul Sandby. The children who play outside the house in the upright view (no. 19) are perhaps the grandchildren of both Paul and Thomas, whose children married. Queen Elizabeth acquired Sandby's study for these figures in 1968 (RCIN 453781).

During Thomas's occupancy of the Deputy Ranger's Lodge, as it was then known, the house was enlarged. But the greatest structural changes were made by the Prince Regent, later George IV, who moved there around 1813 while structural work was undertaken at Cumberland Lodge, which was to have become his Great Park residence. Rapidly escalating costs soon led to the abandonment of Cumberland Lodge, and the temporary use of Deputy Ranger's Lodge became permanent. Plans for the renovation of the Deputy Ranger's Lodge were made by the Prince Regent's architect John Nash, the creator of the Royal Pavilion at Brighton. Perhaps unsurprisingly these were extraordinarily elaborate, and the plain, elegant house depicted in Sandby's watercolours was transformed into a rambling *cottage orné*. Nash – and later Sir Jeffry Wyatville – extended the building to provide a long south façade, encompassing a conservatory supported by thirty free-standing columns. The name Royal Lodge became current in the mid-1820s.[1]

The next great change occurred in the reign of William IV, who in 1830 pulled down all of the original building (shown here) and much of the new building too. The Gothic Saloon (George IV's dining room) is the principal survival. From the 1930s this served as a drawing room; it is shown in the views by Hugh Buchanan and Hugh Casson (nos. 22 and 37), and forms the setting for Sir James Gunn's celebrated portrait of the Royal Family (National Portrait Gallery).

Pencil, watercolour and bodycolour

51.9 × 41.3 cm (20⁷⁄₁₆" × 16¼")

Signed and dated on tree trunk lower right *P.S / 1798*

RCIN 453594

PROVENANCE William Sandby; purchased at William Sandby collection sale (II) at Christie's, London, 26 May 1959 (lot 41) by HM The Queen; by whom presented

LITERATURE Roberts 1995, p. 116

1. Roberts 1997, pp. 311–21.

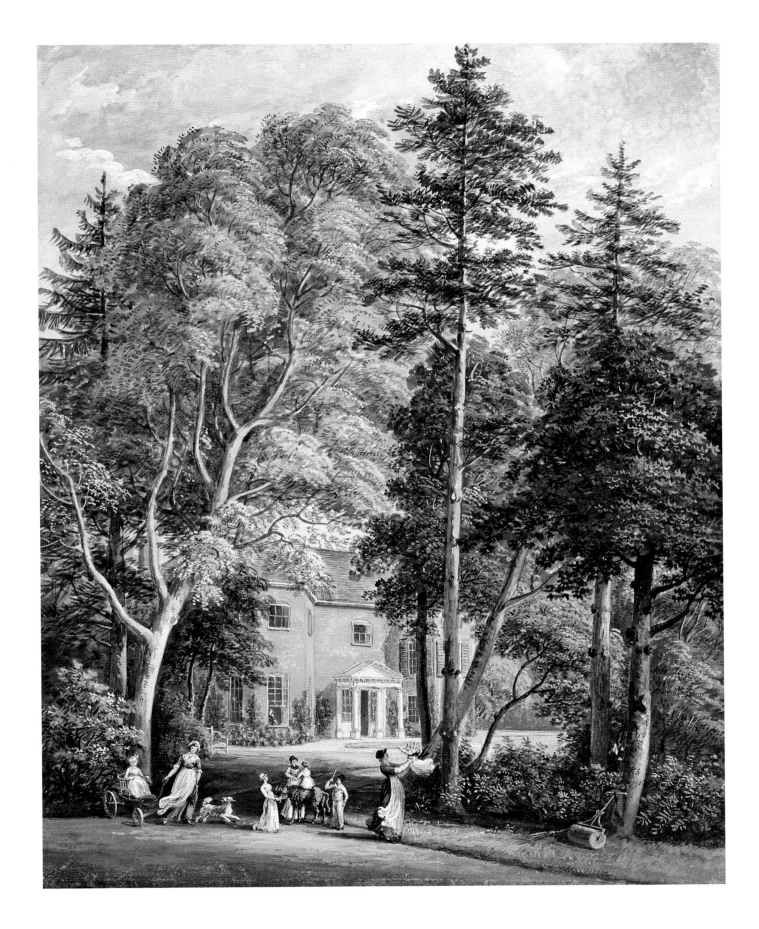

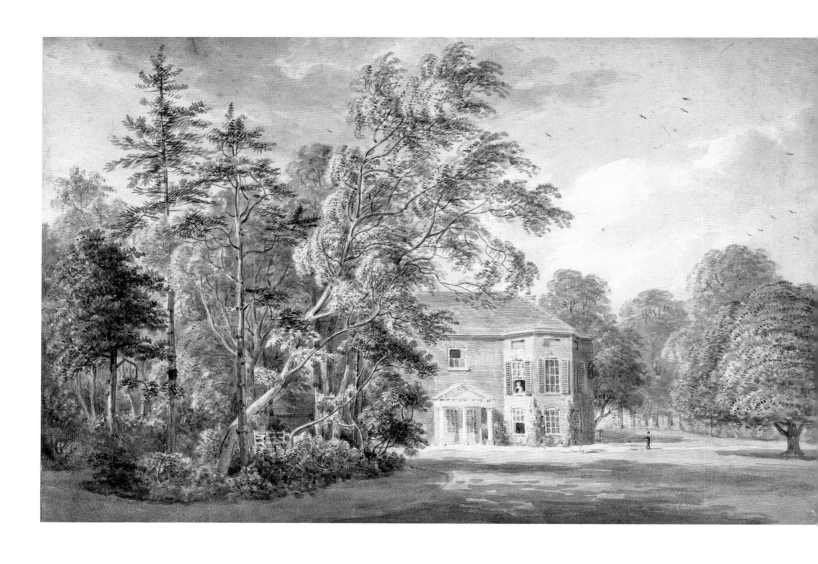

20. Paul Sandby (1731–1809)
Deputy Ranger's Lodge, Windsor Great Park, c.1798

Pencil, watercolour and bodycolour

35.9 × 52.4 cm (14⅛" × 20⅝")

Inscribed in pencil at bottom of sheet
*Deputy Rangers Lodge Windsor
Gt Park / Thoˢ Sandby Esqʳ*

RCIN 453595

PROVENANCE William Sandby;
purchased at William Sandby
collection sale (I) at Christie's,
London, 24 March 1959 (lot 69)
by HM The Queen; by whom
presented

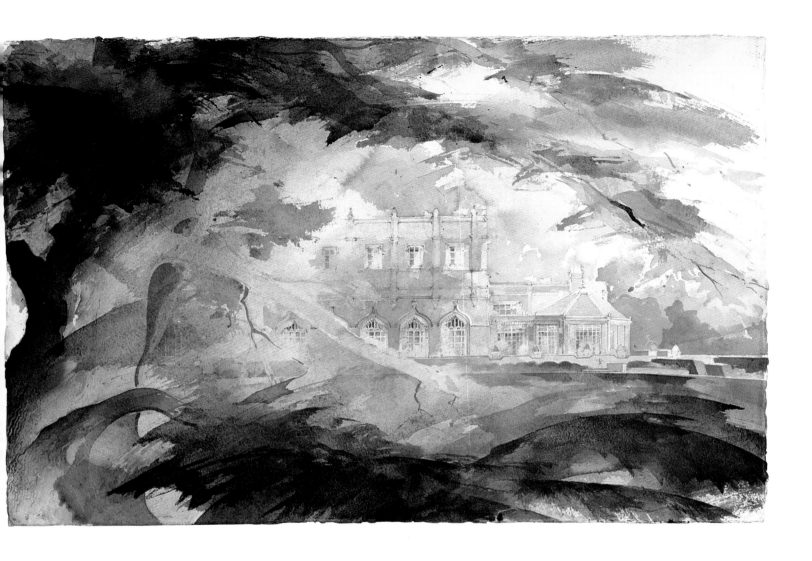

Pencil and watercolour

37.7 × 56.6 cm (14¹³⁄₁₆″ × 22⁵⁄₁₆″)

RCIN 453275

PROVENANCE Commissioned
by the Crown Estate staff of Windsor
Great Park through the Francis Kyle
Gallery and given as a ninetieth
birthday present, 1990

21. Hugh Buchanan (b.1958)
Royal Lodge, Windsor Great Park, 1990

22. Hugh Buchanan (b.1958)
Desks in Royal Lodge, 2000

See also no. 21

King George V offered Royal Lodge to the Duke and Duchess of York in 1931. At this time it was in a very dilapidated condition, and the couple set about transforming it into a family home, demolishing the old conservatory and building a residential wing, into which they moved in November 1932. They designed the garden at Royal Lodge to be informal, and to combine woodland with azaleas and rhododendrons. From 1937 King George VI and Queen Elizabeth used Windsor Castle, but on the King's death in 1952 Queen Elizabeth resumed occupancy of Royal Lodge. It was here that she died, on 30 March 2002.

The oldest part of the house, the Saloon, with its distinctive Gothic windows designed by Wyatville in the late 1820s, is depicted in both the exterior and the interior view here. An artist of great technical skill, Hugh Buchanan has been commissioned several times by the National Trust to record country-house interiors. Buchanan's association with the Royal Family began when the City of Edinburgh purchased his painting of the gates of Hopetoun House at his degree show and presented it to the Prince and Princess of Wales as a wedding present in 1981. HRH The Prince of Wales commissioned Buchanan in 1986 to record the gardens at Frogmore as a sixtieth birthday present for HM The Queen. Buchanan went on to paint interior views of Balmoral in October of that year, of Sandringham in 1987 and of Highgrove in 1994.[1] In 2002 he was commissioned by the House of Lords to record Queen Elizabeth's lying-in-state at Westminster Hall.

Pencil, watercolour and acrylic with airbrush

76 × 56.4 cm (29¹⁵⁄₁₆" × 22¹⁄₁₆")

Signed and dated bottom right
Buchanan 2000

RCIN 453573

PROVENANCE Commissioned by the Royal Household through the Francis Kyle Gallery and given as a hundredth birthday present, 2000

1. Evans 1998, p. 161.

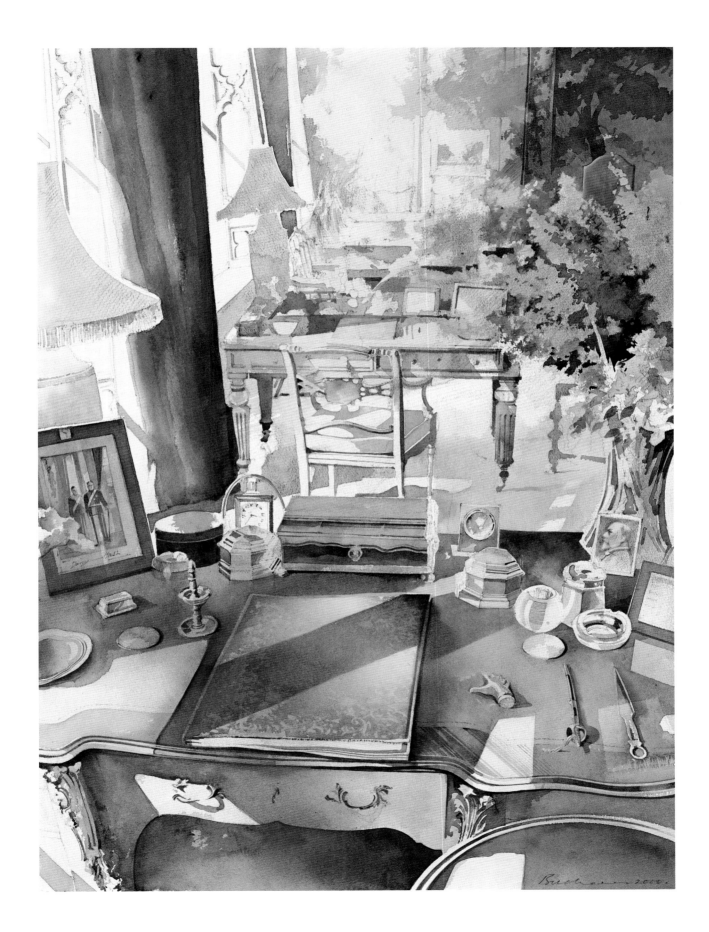

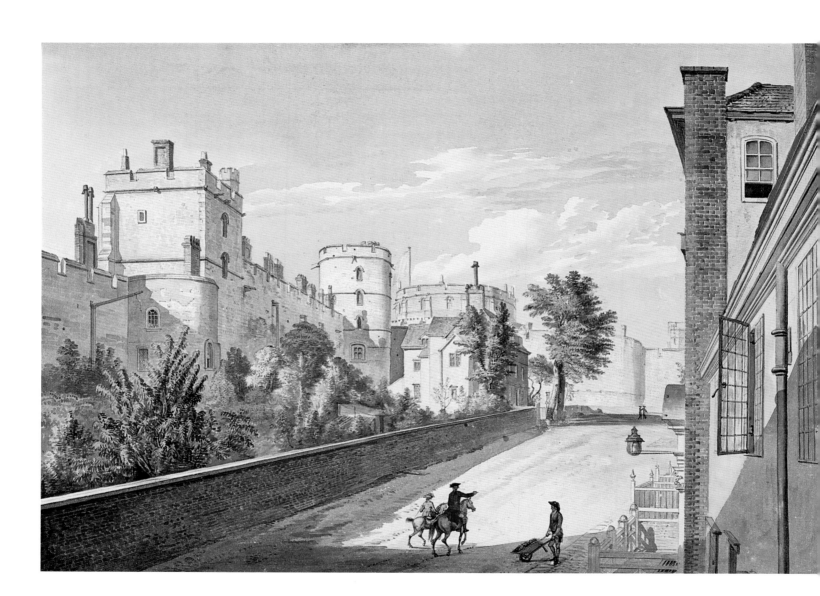

See also no. 24

23. Paul Sandby (1731–1809)
Castle Hill from the Town Gate, Windsor Castle, *c.*1765

Pencil and watercolour

31 × 44 cm (12 ¾₆″ × 17 ⁵⁄₁₆″)

Inscribed on verso *Windsor / View up the Castle Hill from the Gate*

Inscribed in pen on paper label attached to backboard *Windsor / View of the Castle Hill from the Gate*

RCIN 453596

PROVENANCE Sir Joseph Banks; Sir William Knatchbull; sale, Christie's, 23 May 1876 (lot 38); purchased 1876 by Colonel Hibbert; the Hon. Sir Richard Molyneux; by whom presented, 1954

LITERATURE Roberts 1995, p. 88

The landscape watercolourist and topographical draughtsman Paul Sandby was one of the founder members of the Royal Academy in 1768, and in the same year was appointed chief drawing master at the Royal Military Academy in Woolwich. Sandby spent much time at Windsor with his brother Thomas, and between the 1750s and around 1800 he produced many views of the Castle and the surrounding parkland, in both watercolour and bodycolour. Although, surprisingly, no watercolours of Windsor Castle by either of the Sandby brothers seem to have been acquired by George III, the foundation for the great collection held in the Royal Library at Windsor – currently around 500 works – was laid by George IV.

The view of Castle Hill from the old Town Gate is to the east, along the outside of the southern side of the Lower Ward of the Castle: the backs of the Military Knights' houses are shown on the left with the square Garter Tower and the curved Henry III Tower. Until the changes introduced by George IV in the 1820s (the results of which are shown in Piper's view: fig. 16 on page 36), the main pedestrian route between Windsor and Datchet passed along the road shown here. The houses on the right (also seen in Oppé 1947, nos. 21 and 22) were private residences. No. 24 is a distant view of the Castle from Sheet Street, the ancient route to the south from Windsor to the Great Park. Both watercolours belonged to Sir Joseph Banks in the late eighteenth century and may have been commissioned by him. There are thirty further views of Windsor from the Banks collection in the Royal Collection.[1]

Because of their meticulous depictions of architectural detail and their keen observations of human activity in and around the grounds of the Castle, these tightly controlled watercolours constitute a remarkable record of the period. Sandby's panoramic gaze gives the illusion of camera-like inclusivity, capturing informal aspects of daily life; in no. 23 the house on the right with its incidentally open windows is represented with as much care as the Castle buildings on the left. Many of his watercolours include small figures in groups, talking, or going about their business – like the man with a wheelbarrow in the foreground here.

Sir Richard Molyneux (1873–1954), who presented these two watercolours to Queen Elizabeth, was a Groom in Waiting to King George V from around 1919 until the King's death in 1936, and thereafter Extra Equerry to Queen Mary. He became a close friend and frequent guest of Queen Elizabeth, and was a valued adviser on picture hangs, room arrangements and potential acquisitions.

1. See Roberts 1995, pp. 136–7.

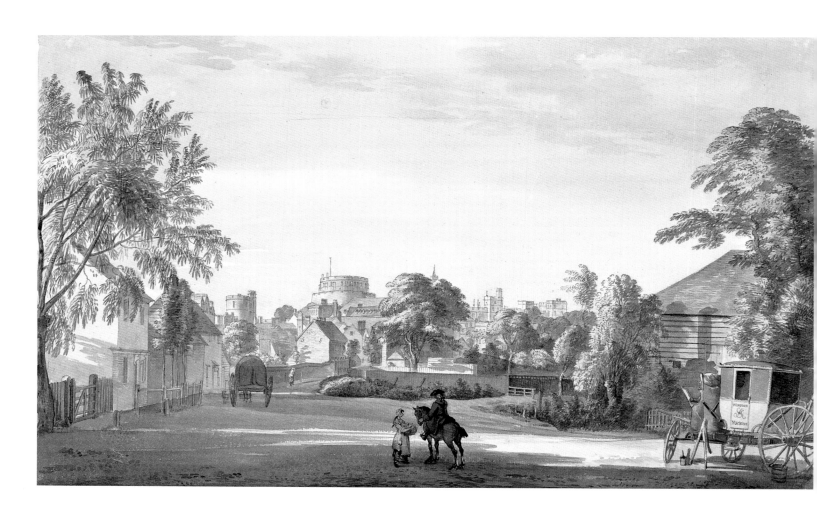

24. Paul Sandby (1731–1809)
Windsor Castle and part of the town, *c.*1765

Pencil, watercolour and touches
of bodycolour

30.3 × 48.6 cm (11¹¹⁄₁₆″ × 19⅛″)

Inscribed in pen on paper label
attached to backboard *Windsor / View
of the Castle and part of the Town
from the / lower end of Sheet Street*

RCIN 453597

PROVENANCE Sir Joseph Banks;
Sir William Knatchbull; sale,
Christie's, 23 May 1876 (lot 30);
purchased 1876 by Colonel Hibbert;
the Hon. Sir Richard Molyneux;
by whom presented, 1954

25. James Baker Pyne (1800–1870)
The North Terrace at Windsor Castle, looking west, c.1839

Pencil, watercolour and white bodycolour

28.8 × 39.1 cm (11⁵⁄₁₆″ × 15⅜″)

RCIN 453333

PROVENANCE Purchased from Leggatt Bros, 8 February 1945

This is the original watercolour for a lithograph in Pyne's large-format album of views, *Windsor, with its Surrounding Scenery, the Parks the Thames Eton College &c.*, published in 1839. *The North Terrace, Windsor Castle* is reproduced as plate III. In the making of this album Pyne visited some of the sites from which Paul Sandby had worked in the second half of the eighteenth century. The North Terrace, perched on the edge of a steep slope and affording views which encompass both the Castle buildings and the surrounding countryside, was a favourite site for Sandby, as it would be for many later artists – including John Piper.

A self-taught artist, James Baker Pyne first exhibited in his native Bristol in 1824, eventually moving to London in 1835. A painting by Pyne of Windsor Castle from the Thames was shown at the Royal Academy in the following year. In addition to English views he painted scenes in Venice and the Swiss lakes.

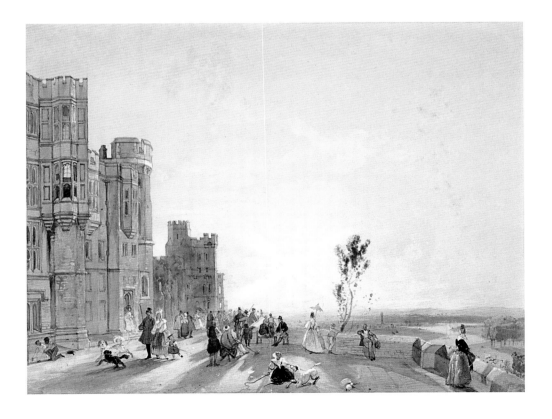

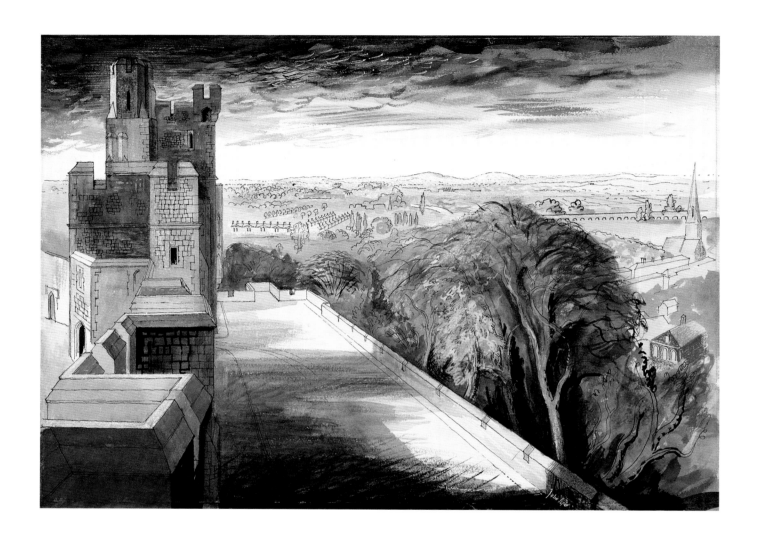

26. John Piper (1903–1992)

The North Terrace and Winchester Tower, Windsor Castle, 1941

Pencil, pen and ink, watercolour, bodycolour and pastel

41.2 × 57.1 cm (16¼" × 22½")

Signed lower right *John Piper*

RCIN 453347

PROVENANCE Commissioned in 1941

EXHIBITIONS London 1942; King's Lynn 1983, no. 13

See also nos. 27, 28, 29, 30 and 31

Queen Elizabeth's commission of watercolour views of Windsor Castle from John Piper during the war resulted in a virtuoso performance of topographical draughtsmanship allied with a powerful evocation of imminent threat. Whatever her feelings about the sombre mood of these works (see page 41), there can be no doubt that they succeeded in providing a valuable contemporary record of the Castle and surrounding buildings. The twenty-six watercolours which Piper produced between 1941 and 1944 include views of the Castle from various vantage points inside the walls, distant views of the Castle from the park, and buildings in Windsor Home and Great Parks: the Gothic summer-house and stable block at Frogmore, Blacknest Gate Lodge and the ruins from Leptis Magna at Virginia Water.

In contrast with the lively scenes by Paul Sandby in the Print Room at Windsor, which Piper had been instructed to study closely before beginning his series, human figures are absent from Piper's compositions. As a result the towers of the Castle assume an eerie quality of animation, like sentinels beneath impending, apocalyptic clouds. This Romantic investment of expression in architecture was warily noted by Sir Owen Morshead, who described Piper's watercolours to Queen Mary on 10 December 1941 as 'hot and violent, deriving in feeling from Samuel Palmer, or even William Blake.'[1] A quality of watchful isolation is particularly marked in the two views of the North Terrace here, one showing the Winchester Tower and looking west (no. 26), the other looking east from the roof of the State Apartments past the Brunswick Tower, where the bleak grey walls contrast sharply with the parkland far below (no. 30). In *Curfew Tower and Horseshoe Cloister* (no. 29) there is a similar sense of discord in the contrast between the medieval walls and the encroaching sweep of railway lines beyond.

Piper's watercolours of Windsor Castle create an extraordinary illusion of depth, which is owing partly to the artist's skill as an architectural draughtsman and partly to the sheer scale of the Castle; the views it commands from its high position and the broad spaces between its different parts result in extensive and magnificently varied vistas. In contrast, his watercolours of single buildings in Windsor Home and Great Parks, such as the Gothic summer-house (see fig. 18, page 40) and stable block at Frogmore (RCIN 453360), and Blacknest Gate Lodge (RCIN 453337), are flatly monolithic. In the Castle, Piper deliberately sought out dramatic vistas, such as the view of the Round Tower sketched from the roof of St George's Chapel, down the sharp perspective of the Albert Memorial Chapel roof (no. 28). From another high vantage point Piper made a vertiginous composition looking down into the Dean's Cloisters (RCIN 453356), and he attained sweeping views from two high, contiguous windows at the west end of the Upper Library, one which affords a view along the North Terrace towards the Winchester Tower (no. 26), the other over the other side of the wall looking down towards the Middle Ward (no. 31).

1. RA GV/CC 48/994.

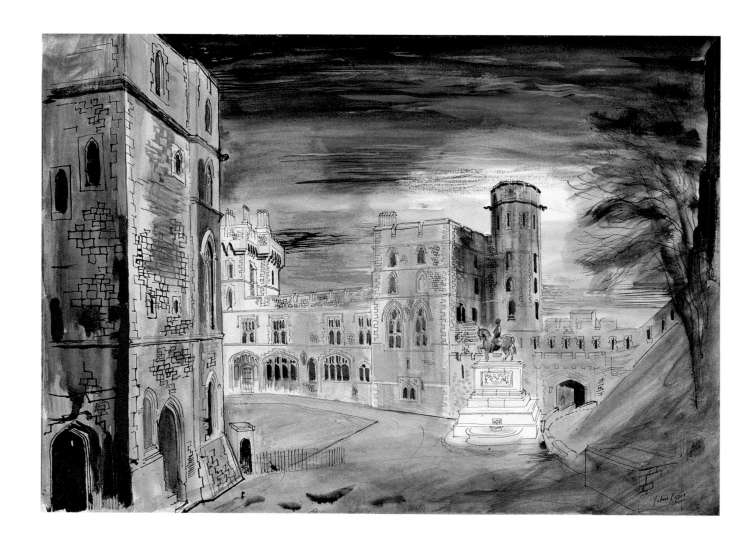

27. John Piper (1903–1992)

The Quadrangle from Engine Court, Windsor Castle, 1941/2

Pencil, pen and ink, watercolour and bodycolour

41.3 × 55.6 cm (16⅛″ × 21⅞″)

Signed lower right *John Piper*

RCIN 453345

PROVENANCE Commissioned in 1941

LITERATURE Betjeman 1944, pl. 15

EXHIBITIONS London 1942; Norwich 1957–8, no. 68; King's Lynn 1983, no. 12

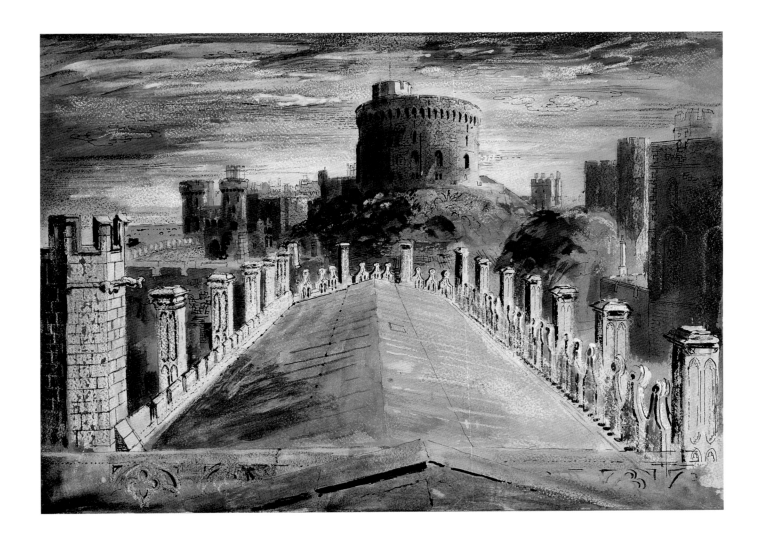

Pencil, pen and ink, watercolour,
bodycolour and pastel

40 × 54.3 cm (15¾˝ × 21⅜˝)

RCIN 453339

PROVENANCE Commissioned in 1941
or 1942

EXHIBITIONS King's Lynn 1983, no. 6;
London 2000–1, no. 60

28. John Piper (1903–1992)

*The Round Tower from the roof
of St George's Chapel,* c.1942–4

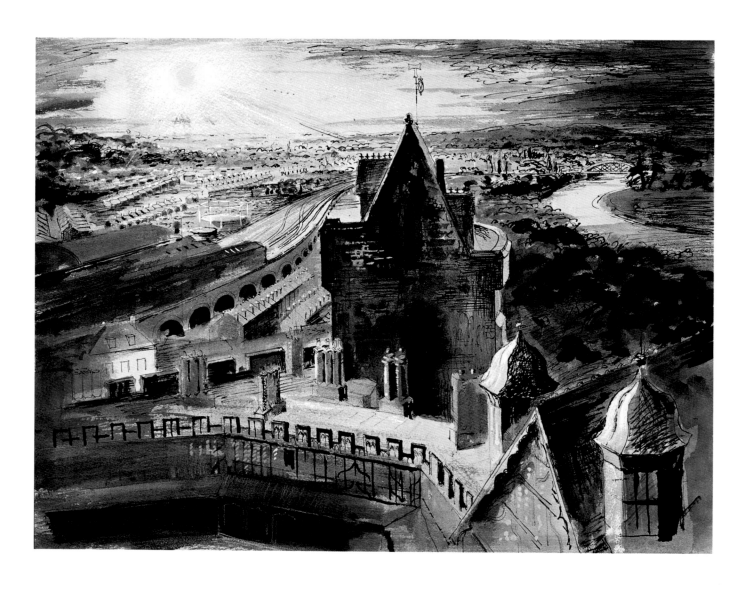

29. John Piper (1903–1992)

Windsor town, railway and the Curfew Tower and Horseshoe Cloister, Windsor Castle, c.1942–4

Pencil, pen and ink, watercolour, bodycolour and pastel

42.5 × 54 cm (16¼" × 21¼")

RCIN 453335

PROVENANCE Commissioned in 1941 or 1942

EXHIBITIONS King's Lynn 1983, no. 2; London 2000–1, no. 59

The dark storm clouds in these watercolours, the cause of so much contention during the period of their commission, are a dramatic backdrop to the pale grey stone of the Castle and give a powerful sense of threat from the skies. Piper himself resolutely resisted Queen Elizabeth's reported suggestions that he might 'try a spring day', somewhat mischievously writing to Clark in August 1943, by which point the subject had been raised several times, 'I have been enjoying some wonderful thunderstorms piled behind Windsor Castle ... Dark grey scudders rising against pale dove colour, and pinks and dingy purples.'[2]

Piper began work on the watercolours in the autumn of 1941, and his invoice for the first group of 10 is dated 31 May 1942.[3] He was asked to make a further set at this point, upon which he worked intermittently throughout 1942 and 1943. His second invoice, for fourteen watercolours, was dated 24 April 1944.[4] In total there are twenty-six watercolours; the two not included in the invoices were perhaps presented as gifts. Unfortunately, as none of the works is dated, they cannot be separated into two distinct groups. However, it is possible to identify those eight watercolours lent to the Recording Britain exhibition in June 1942, which include *The North Terrace and Winchester Tower* and *The Quadrangle from Engine Court* (nos. 26 and 27), as belonging to the first sequence and therefore produced between autumn 1941 and May 1942. Piper's own casual reference to working from the Castle roof in July 1942, and Clark's diplomatic assurances that black clouds were parting to reveal blue skies in the second set, are insufficiently precise to allow definite conclusions to be drawn about the date of each watercolour.

2. John Piper to Kenneth Clark, 3 August 1943, Tate Gallery Archive.

3. RA QEQM/TREAS/ACC/BILLS/1942/215.

4. RA QEQM/TREAS/ACC/BILLS/1944/88.

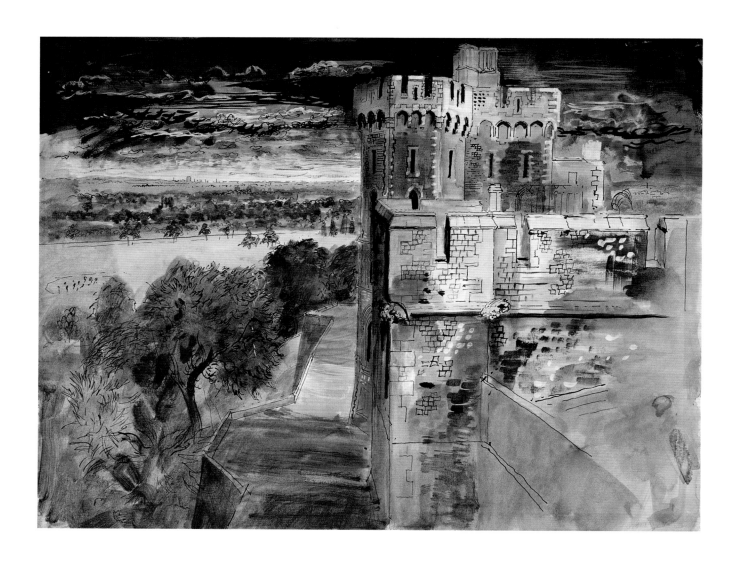

30. John Piper (1903–1992)

The North Terrace and Brunswick Tower, Windsor Castle, c.1942–4

Pencil, pen and ink, watercolour and bodycolour

42.6 × 55.1 cm (16¾″ × 21¹¹⁄₁₆″)

RCIN 453343

PROVENANCE Commissioned in 1941 or 1942

EXHIBITIONS London 1963, no. 5; King's Lynn 1983, no. 10

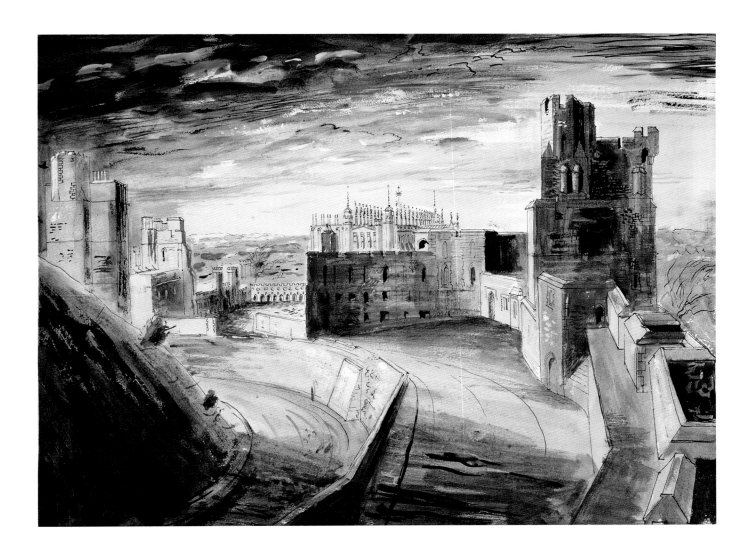

Pencil, pen and ink, watercolour and
bodycolour

43.4 × 56.7 cm (17 1/16" × 22 5/16")

RCIN 453346

PROVENANCE Commissioned
in 1941 or 1942

EXHIBITIONS King's Lynn 1983, no. 11;
London 1983–4, no. 56

31. John Piper (1903–1992)
The Middle Ward, Windsor Castle, c.1942–4

32. Claude Muncaster (1903–1974)
Salisbury Tower, Windsor Castle, night, 1946

This watercolour of the outside wall of the thirteenth-century Salisbury Tower, in the south-western corner of the Lower Ward of Windsor Castle, forms part of the series of what Sir Owen Morshead termed 'straight drawings' of Windsor Castle, commissioned from the topographical artist Claude Muncaster in the wake of Piper's series. Ironically, Muncaster's debt to Piper is particularly evident in this night scene.

Muncaster recorded this commission in his diary:

I completed ten watercolours which may not sound many for the hours I worked, but they were exacting works as architectural subjects always are. Also, they were required to be as topographically correct as possible, and I was anxious that they should be the very best that I could do since much might hang upon the success of my efforts. My endeavours were made lighter and more pleasant through the kind assistance and encouragement of Sir Owen Morshead, the King's Librarian who, steeped more deeply than anyone in the history of Windsor, could add interest to all the things he showed me by the amusing anecdotes he would recount so humorously. I enjoyed the privilege.[1]

A letter to Muncaster dated 31 July 1946, from Captain Arthur Penn, who organised the project, describes Queen Elizabeth's reaction: 'I have, as I promised, now shown your sketches to the Queen and you will, I am sure, be gratified to know that Her Majesty was so pleased by them that she wishes to purchase them all.'[2] Muncaster was subsequently commissioned to paint views of Sandringham and Balmoral.

Charcoal, watercolour and brush and ink

33.7 × 50.3 cm (13¼" × 19¹⁵⁄₁₆")

Signed and dated lower right
Claude Muncaster / July. 1946

RCIN 453483

PROVENANCE Commissioned in May 1946

1. Muncaster 1978, pp. 72–3.

2. *ibid.*, p. 73.

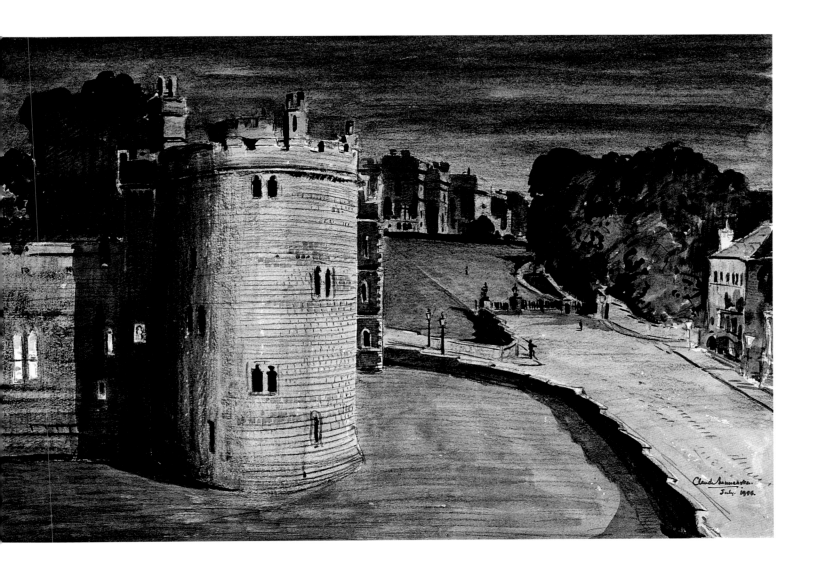

33. John Piper (1903–1992)
Sandringham House, 1970

Built in the second half of the eighteenth century, Sandringham Hall in Norfolk became a royal residence in 1863 when the Prince and Princess of Wales, later King Edward VII and Queen Alexandra, moved there shortly after their wedding. The Georgian structure was found to be too small for the demands of a growing family and the Prince of Wales's frequent house-parties; the Hall was demolished and Sandringham House, a brick structure in the Jacobean style with gabled roofs, was completed in 1870. In more recent years Queen Elizabeth, with HM The Queen and other members of the Royal Family, traditionally stayed at Sandringham from Christmas until February each year, and again in July.

John Piper presented this drawing of the house and garden to Queen Elizabeth in July 1970.[1] It was made while he was working on the design for the cover of a concert programme of music by Benjamin Britten and Peter Pears to be held at Sandringham House in honour of Queen Elizabeth's seventieth birthday in the following month.

The loose brush and pen work, flashes of bright pigment and increased use of mixed media here are typical of Piper's later architectural studies, and present a contrast with the subdued, earthy colours and linear precision of his drawings dating from the 1940s, particularly the watercolours of Windsor Castle.

Pencil, pen and ink, wax resist, indian ink, bodycolour and coloured chalks

39.3 × 58.7 cm (15½″ × 23⅛″)

Signed lower right *John Piper*

RCIN 453454

PROVENANCE Presented by the artist, July 1970

1. RA QEQM/PRIV/PIC: July 1970
John Piper to Queen Elizabeth.

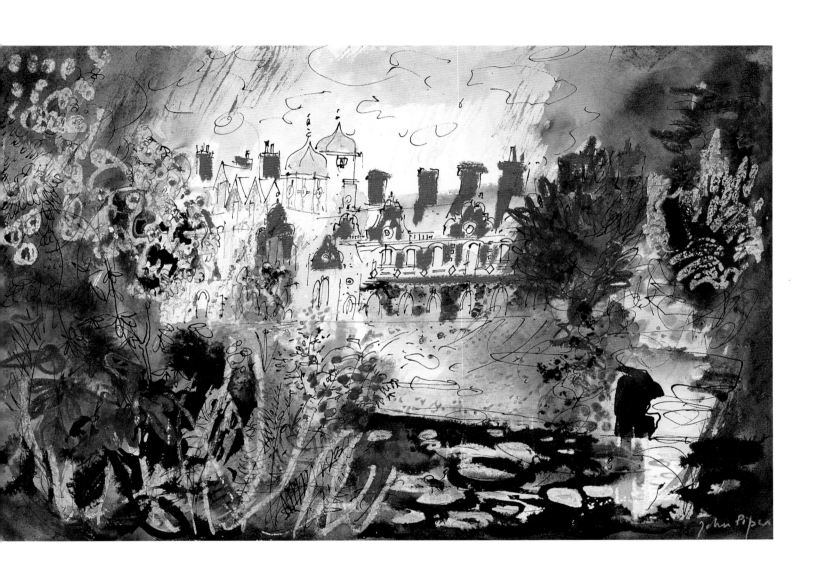

34. David Addey (b. 1933)
The Castle of Mey, 1999

Queen Elizabeth bought the isolated sixteenth-century Castle of Mey in 1952, shortly after the death of King George VI. The Castle stands on the northernmost coast of the Scottish mainland in Caithness, on the coast road about six miles west of John o' Groats. When Queen Elizabeth bought Mey (or Barrogill as it was then called, before she reverted to its original name), which she had first seen earlier that year when driving past with friends, it was extremely dilapidated; the roof was falling in, there was no electricity and the garden was a wilderness. Queen Elizabeth saved it from demolition and transformed the castle. An account of the decorative scheme which she brought to Mey is given in 1960 in the popular magazine *The House Wife*:

> Today, the Castle is a delightfully feminine mixture of eighteenth-century console tables, Victorian needlepoint chairs, Queen Anne bureaux, and Regency and Empire lamps, clocks and candelabra. Mey's chatelaine has filled it with whimsies in startling contrast to the grim grey of its walls – bedrooms in pink, turquoise, coral and blue, crisp chintzes …[1]

David Addey trained as an architect but since 1975 has been a full-time artist specialising in topographical subjects. His most ambitious project, which he began in 1988, was to follow the footsteps of the artist William Daniell (1769–1837), whose eight-volume work *Picturesque Voyage round Great Britain* – aquatints produced by Daniell from drawings he made during long tours – was published between 1814 and 1825. Addey set off from Sheerness in Kent 'with the intention of visiting the same sites and depicting them as they are today', and has published his watercolours in four volumes as *A Voyage round Great Britain*, reproducing Daniell's images and commentaries on facing pages to his own. Addey visited the Castle of Mey in the course of his tour on 11 September 1999, 181 years after Daniell.

Pencil and watercolour

26.1 × 36 cm (10 ¼" × 14 ¼")

Signed lower right *D Addey*

RCIN 453260

PROVENANCE Presented by the artist, 1999

LITERATURE Addey 2002, no. 13

1. Quoted in Duff 1965, p. 274.

35. Sir Hugh Casson (1910–1999)
Clarence House from the Mall, 1990

See also nos. 36, 37 and 38

The architect Sir Hugh Casson, who was President of the Royal Academy from 1976 to 1984, became a close friend of several members of the Royal Family and over the years undertook a number of architectural projects for HM The Queen and HRH The Duke of Edinburgh. He was well known for his small and witty drawings of buildings and figures. In his introduction to Casson's *Sketch Book. A Personal Choice of London Buildings from 1971–1974*, published in 1975, Sir John Betjeman wrote: 'Hugh Casson draws all the time just as some people hum tunes. But he gets his drawings *right*.' [1]

Clarence House was the best known of Queen Elizabeth's residences, and the one with which her name will continue to be closely associated. She moved there from Buckingham Palace with Princess Margaret in 1953, and it was Queen Elizabeth's London home until her death in 2002. The house was designed by John Nash and built between 1825 and 1827 for William, Duke of Clarence (later William IV), the third son of George III. When he succeeded his brother George IV in 1830, rather than moving to Buckingham Palace he remained at Clarence House until his own death in 1837. Princess Elizabeth and her husband The Duke of Edinburgh made this their London residence between 1949 and her accession as Queen in 1952. Queen Elizabeth kept the major part of her collection of pictures at Clarence House; an entry in her day book in 1953 records that on moving in she supervised the picture hanging.[2] Casson's watercolour shows a view of the house from the Mall.

Pencil, pen and ink and watercolour
37.5 × 27.2 cm (14¼″ × 10¹¹⁄₁₆″)

Inscribed lower left *Clarence House*; signed lower right *HC*.

RCIN 453385

PROVENANCE Presented by the artist as a ninetieth birthday present, 1990

1. Casson 1975, p. 3.
2. RA QEQM/DIARY/1953.

Clarence House

HC

The Royal Chapel – Windsor Great Park.

Hugh Casson
1990

Pencil, pen and ink and watercolour

24.8 × 44.1 cm (9¼" × 17½")

Inscribed lower left
*The Royal Chapel – Windsor Great
Park.* Signed and dated lower right
Hugh Casson / 1990.

RCIN 453411

PROVENANCE Presented by the
congregation of the Royal Chapel,
Windsor Great Park, as a ninetieth
birthday present, 1990

36. Sir Hugh Casson (1910–1999)
The Royal Chapel, Windsor Great Park, 1990

The Royal Chapel of All Saints serves as the parish church for those who live or work
in Windsor Great Park. It was built in the early nineteenth century as the private chapel
to Royal Lodge and is within easy walking distance of that residence. It was extensively
refurbished after the accession of King George VI, and Queen Elizabeth was a regular
worshipper there. After her death at Royal Lodge her coffin lay in the Royal Chapel
during the early days of April 2002, before being transported to Westminster Hall in
London for the lying-in-state.

37. Sir Hugh Casson (1910–1999)
The Saloon, Royal Lodge, 1990

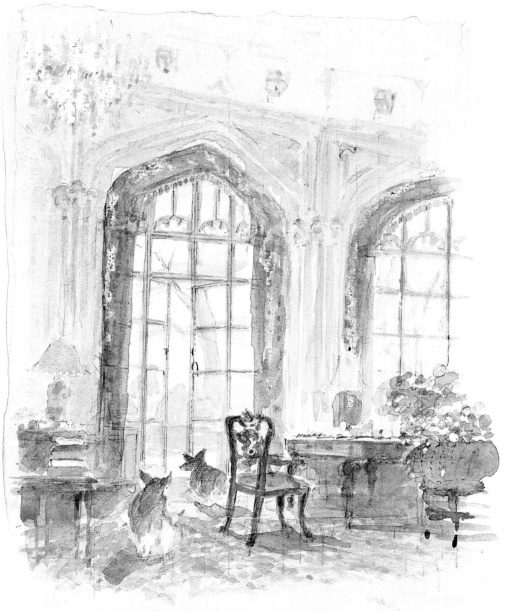

The Saloon. Royal Lodge.
August 4th. 1990.

HC.

Pencil and watercolour

30.9 × 23 cm (12⅛" × 9⅛")

Inscribed lower left *The Saloon. Royal Lodge. / August 4th. 1990*; signed lower right *HC*.

RCIN 453409

PROVENANCE Presented by the artist as a ninetieth birthday present, 1990

38. Sir Hugh Casson (1910–1999)
Tea time, Sandringham, 1986

Pencil, pen and ink and watercolour

24.6 × 21.4 cm (9¹¹⁄₁₆″ × 8⁷⁄₁₆″)

Inscribed lower left
Tea time Sandringham. '86;
signed lower right *HC*.

RCIN 453410

PROVENANCE Presented by
the artist, 1986

A Great Pleasure in Pictures

The works in Queen Elizabeth's collection not acquired specifically for their biographical or topographical resonances are a very diverse group, ranging widely not only in period, but also in subject matter and treatment. Arranged here in chronological order of artist's birth date, beginning with Thomas Gainsborough and ending with John Bratby, they give a vivid picture of a collector with a light touch as well as a discerning eye.

Shortly before the outbreak of war, in the summer of 1939, Queen Elizabeth began to form a small collection of late eighteenth- and early nineteenth-century English watercolours and drawings. These include Michael 'Angelo' Rooker's *Castle Acre Priory, Norfolk* (no. 41) and David Roberts's *The Town Hall, Ghent* and *On the Bridge of Toledo, Madrid* (nos. 45 and 46), choices which reflect her taste for precise draughtsmanship and architectural subjects. Other works from this period have royal connections, such as three sketches by Sir David Wilkie of Queen Victoria as a girl of twelve (no. 44), preparatory studies for an oil painting also in Queen Elizabeth's collection.

Queen Elizabeth collected contemporary watercolours and drawings in a more spontaneous way. Some were purchased from charity auctions during the war, others from dealers or from exhibitions at the Royal Watercolour Society, of which she was Patron; some were acquired directly from artists and many came to her as gifts. Central to Queen Elizabeth's collection are wartime works, represented here by a pastel drawing of sailors on leave by the Official War Artist William Dring (no. 60), a watercolour of a prison-camp orchestra by Lord Haig (no. 71), and drawings of bomb-damaged London buildings by the Australian artist Norma Bull (nos. 64–5).

39. Thomas Gainsborough (1727–1788)
A figure in a landscape, c.1775–80

Born in Sudbury, Suffolk, Gainsborough trained in London, possibly at the St Martin's Lane Academy established by William Hogarth in 1735. In 1748 Gainsborough returned to Suffolk and began to establish himself as a portraitist, moving to the fashionable spa town of Bath in around 1759 and finally back to London in 1774. He was a founder member of the Royal Academy, established by George III in 1768. Gainsborough is recorded as one of the drawing masters who taught Queen Charlotte, Consort of George III. Twenty-two of his compositions were included in the sale of her collection in 1819.

Throughout his career Gainsborough painted and drew landscapes, a subject he professed to have found much more sympathetic than portraiture. He produced a large number of free chalk sketches such as this one, not intended as studies for oil paintings but made purely for pleasure.

Black fabricated chalk and touches of white chalk

27.5 × 37 cm (10¹³⁄₁₆″ × 14⁷⁄₁₆″)

RCIN 453587

PROVENANCE Collection of Alistair Horton; purchased from the Palser Gallery, c.1934

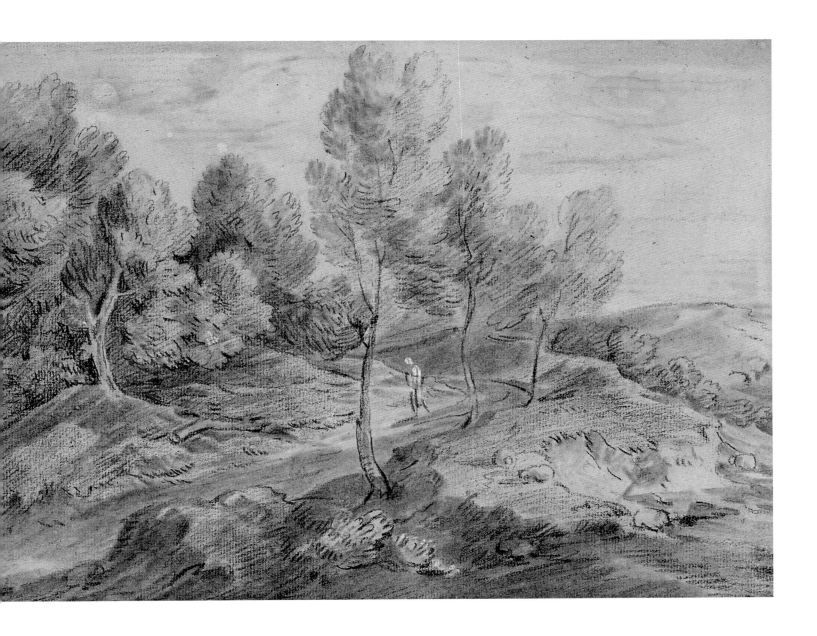

40. Joseph Wright of Derby (1734–1797)
A study of a wall with a house, c.1773

By the time Joseph Wright of Derby departed for Italy in order to undertake a Grand Tour in 1773 he had already completed the paintings which had made his name in London and for which he is still best known. These included the scenes of scientific experimentation *A philosopher lecturing on the orrery* (1766; Derby Museum and Art Gallery) and *Experiment on a bird in the air pump* (1768; National Gallery, London).

Wright sailed for Italy on 1 November 1773 and stopped *en route* at Nice, where bad weather prolonged his stay for three weeks. During this time he made a number of wash drawings of buildings in and around the town, sometimes sketching side-by-side with John Downman (1750–1824), who was accompanying him. This study of a wall with a house was probably executed during this time, prior to Wright's arrival in Rome. A drawing from the Oppé collection now in the Tate Gallery, *Nice: a tower on a hill*, is inscribed in the top left-hand corner with the number 244.[1] The number 224 inscribed in the same position on the present sheet may indicate precedence, suggesting that this drawing may also have been made in the south of France in the winter of 1773.

Naturally Wright sought out and was inspired by the light effects he saw during his Grand Tour, which included the annual fireworks display in Rome, and the spectacular eruption of Vesuvius which he witnessed in October 1774. He also made a number of sketches of the interior of the Colosseum, capturing the subtle effects of light and shade created by the sweeping internal structure of the building and the scarified textures of the ancient stones. This watercolour drawing of a house built into a brick wall, although a comparatively modest subject, is consonant with these studies in its concentration on the appearance and textures of decaying bricks. The use of watercolour is unusual for Wright, most of whose drawings are executed in grey wash.

Pencil and watercolour

28.8 × 42.1 cm (11⁵⁄₁₆" × 16⁹⁄₁₆")

Inscribed in top left corner *224*

RCIN 453281

PROVENANCE Probably by descent from the artist to his great-granddaughter Margaret Romana Simpson; donated to Derby Museum and Art Gallery, either by Charles Bemrose in 1914 or by Florence May Lousada in 1937; presented by Derby Borough Council, 1971

LITERATURE Nicolson 1968, p. 92

EXHIBITIONS London 1958, no. 42; Norwich 1959, no. 62

1. Lyles & Hamlyn 1997, p. 94.

224

41. Michael 'Angelo' Rooker (1746–1801)
Castle Acre Priory, Norfolk, c.1796

The topographical draughtsman Michael Rooker began his training in engraving and draughtsmanship as an apprentice to his father, and was later taught by Paul Sandby in the 1760s, who as a joke attached 'Angelo' to his Christian name. Rooker entered the Royal Academy Schools in 1769, and was elected ARA the following year. He was also employed by the Theatre Royal, Haymarket, as chief scene-painter, for which he used the name 'Signor Rookerini'. In 1788 Rooker made the first of many autumn walking tours across England and Wales, during which he would visit and sketch picturesque ruins for an audience increasingly attracted to antiquarian subjects.

Castle Acre Priory, near Swaffham in Norfolk, is a former Cluniac priory founded in the eleventh century. It is about twelve miles from Sandringham and this watercolour may have been acquired by Queen Elizabeth as a record of a favourite site. The ruins harbour superb examples of blind arcading, which can be seen particularly in the shadowy area on the right in this view. Much of the church was already ruined in Rooker's day, except for the elaborately decorated west front which still stands, and which Rooker chose to draw. Rooker visited Castle Acre Priory on 16 and 17 August 1796, during a sketching tour of Norfolk, Essex and Oxfordshire.[1] The flinty beauty of the ruins, which despite their state of collapse retain much decorative detail, must have appealed greatly to him. Rooker made few concessions to the fashionable Romantic evocation of misty atmosphere, and his watercolours are remarkable for their meticulous detail.

It is an eccentric though typical aspect of Rooker's work to include labourers and farm animals ambling among the ruins, where a more conventional watercolourist would have added picturesque groups of visitors. Rooker's small figures seem to be oblivious to the crumbling grandeur of their surroundings, and thus contribute subtle *memento mori* overtones to the composition.

Pencil and watercolour

31.1 × 47.7 cm (12¼" × 18¾")

Signed lower centre *MARooker*

RCIN 453577

PROVENANCE Purchased from Walker's Galleries, 5 August 1939, no. 101

EXHIBITION Possibly Royal Academy 1798, no. 368

1. Conner 1984, p. 173.

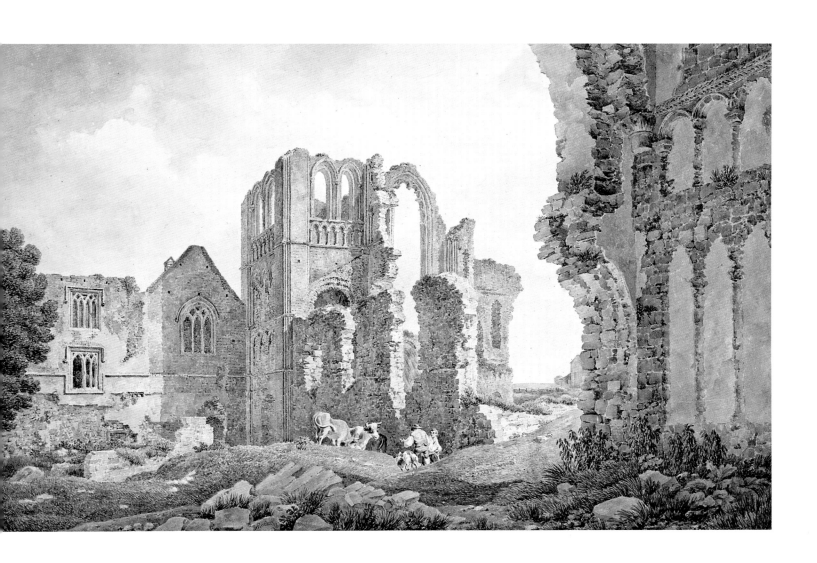

42. John Varley (1778–1842)
Snowdon, c.1810–20

See also no. 43

John Varley was a founder in 1804 of the Society of Painters in Watercolours (later the Royal Watercolour Society). An extremely prolific painter throughout his life, he contributed 42 of the 275 watercolours included in the first exhibition of the Society in 1805. A man of immense energy – he claimed to have worked for fourteen hours a day for forty years – and boundless enthusiasm, he was generous to a fault and perpetually in debt, filling his house with friends and pupils. He taught John Linnell and Samuel Palmer, and in 1818 Linnell introduced Varley to William Blake, who became a close friend. Varley published *A Practical Treatise on the Art of Drawing in Perspective* (1815–20) and *A Treatise on the Principles of Landscape Design with General Observations and Instructions to Young Artists* in eight parts between 1816 and 1821.

Varley made a number of visits to Wales, the first in either 1788 or 1789, and again in around 1800 and 1802, and made many watercolours of Snowdon. This panoramic view (no. 42) shows Varley's characteristic delicacy of handling and precise application of each brushstroke.

The view from Porchester Terrace (no. 43) was painted the year after Varley moved to Bayswater, where he lived for the rest of his life. The sheet is inscribed 'Study from Nature' in the bottom left-hand corner, an inscription that Varley very often added to his watercolours, indicating that the composition was largely painted on the spot. This is also suggested by the bright, fresh colours of the sunlit landscape, which present a contrast to the soft light effects of the studio work *Snowdon*.[1]

Pencil and watercolour

23.9 × 46.9 cm (9 7/16" × 18 7/16")

Signed lower right *J. Varley*; inscribed on verso *Snowdon* / *J. VARLEY*

RCIN 453583

PROVENANCE Unknown

1. See Lyles 1994, p. 19.

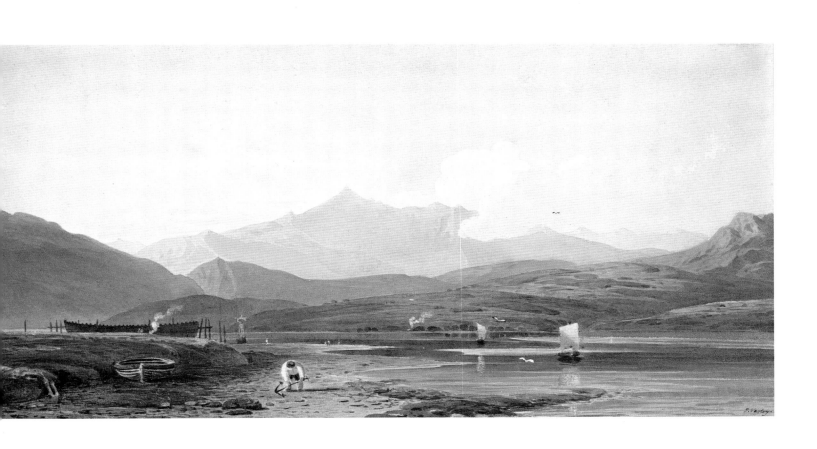

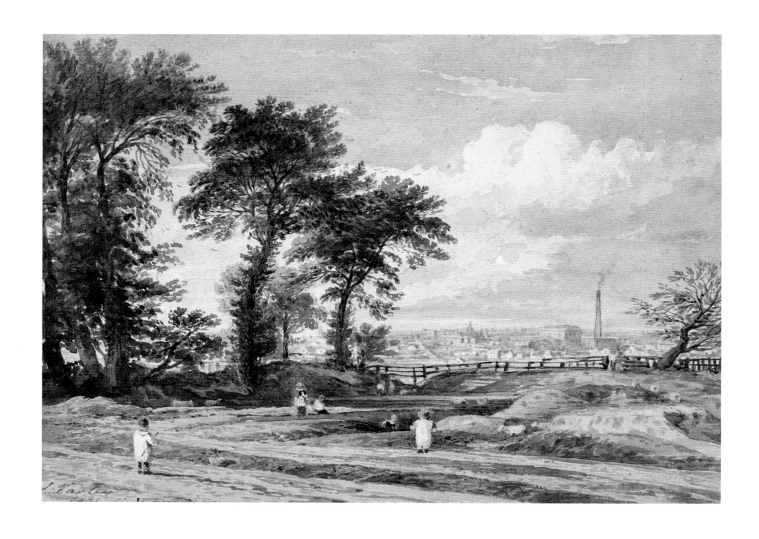

43. John Varley (1778–1842)

A view across London from Porchester Terrace, Bayswater, 1831

Pencil and watercolour

22.5 × 31.1 cm (8⅞″ × 12¼″)

Signed and dated lower left *J. Varley / 1831*; inscribed *Study from Nature*

RCIN 453581

PROVENANCE Anthony Reed; Agnew's 1994; presented by the Lord Mayor and Commonality of the Corporation of London as a hundredth birthday present, 2000

EXHIBITIONS New York 1978, no. 42; London 1978, no. 42

44. Sir David Wilkie (1785–1841)

Three sketches of Queen Adelaide with Princess Victoria and members of her family, 1831

PROVENANCE Purchased from
Colnaghi's, 12 February 1964

LITERATURE Millar (O.) 1969,
p. 144; Cornforth 1996, p. 127

1. Information supplied by
 Mrs Nesta MacDonald.

These three studies by David Wilkie are preparatory drawings for an unfinished oil painting of Princess Victoria holding a casket in her hands, surrounded with members of her family, which was acquired by Queen Elizabeth in July 1948 (fig. 32; Millar (O.) 1969, no. 1187). Mounted and displayed in a single frame, the drawings hung in Clarence House beneath the painting. It is not known who commissioned the painting, nor why it was left unfinished. A contemporary inscription on the back of the frame records that the drawings were made when Princess Victoria was twelve years old. It is thought that the painting represents the first Drawing-Room given by Queen Adelaide, Consort of William IV, in February 1831.[1] It was typical of Wilkie's working method to produce a number of small studies of different parts of a composition, trying out variations of position and setting. His use of various drawing media, and the different effects thus obtained, is also notable.

Wilkie was born in Cults, Fifeshire. He entered the Royal Academy Schools in 1805, and was elected an Academician in 1811 at the age of only twenty-six. In 1823 he was appointed King's Limner in Scotland, and he was knighted by William IV in 1836. George IV had purchased a number of his paintings, and commissioned *The Entrance of George IV at Holyroodhouse* in 1822 (RCIN 401187), although in the event the painting was not finished until the end of 1829 or the beginning of 1830. In the same year that Queen Elizabeth acquired the painting of the twelve-year-old Queen Victoria she also purchased an oil sketch for *The Entrance of King George IV at Holyrood* (RCIN 409055).

Figure 32
Sir David Wilkie, *Queen Adelaide and Princess Victoria, c.*1831–2
Oil on canvas. 127.1 × 102.3 cm (50 ¹⁄₁₆" × 40 ¼") RCIN 409157

(a)

(a) Charcoal
25.8 × 21.5 cm (10¹⁄₁₆″ × 8⁷⁄₁₆″)
RCIN 453425a

(b) Pen, brown ink and brown wash
22.8 × 17.5 cm (9″ × 6⁷⁄₈″)
RCIN 453425b

(c) Fabricated crayon and charcoal
25.8 × 21.5 cm (10³⁄₁₆″ × 8⁷⁄₁₆″)
RCIN 453425c

(b)

(c)

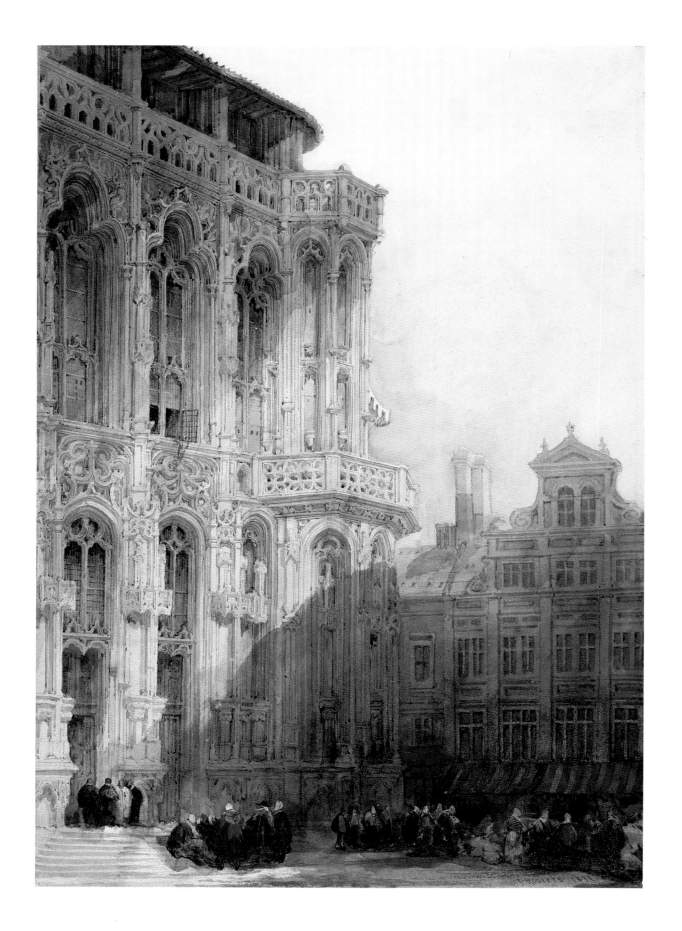

See also no. 46

45. David Roberts (1796–1864)
The Town Hall, Ghent, 1831

Pencil, watercolour, bodycolour with white heightening and gum arabic

32.6 × 22.5 cm (12¹³/₁₆″ × 8⅞″)

Signed and dated lower right
D Roberts 1831

RCIN 453586

PROVENANCE Purchased from Walker's Galleries, 18 July 1939 (unnumbered)

1. Ballantine 1866, p. 70.

The topographical artist David Roberts began his career as a house painter, subsequently graduating to scene painting at Covent Garden and Drury Lane. In 1824 he first exhibited at the Royal Society of British Artists, an institution of which he became president in 1830. In 1825 he began to exhibit at the British Institution; his work was also shown at the Royal Academy between 1826 and 1864. In the course of his career he travelled widely, making trips to the Low Countries and to Spain, to Egypt and Syria in 1838, and to the Holy Land the following year.

Roberts's watercolour of the Town Hall at Ghent was made during a sketching tour principally to the Rhine, begun in summer 1830. Some of the watercolours he worked up from sketches made during this tour were published on his return in a book of colour lithographs, *Continental Album*. However, Roberts's real coup came in 1832–3 when, attracted by the reported wildness of the countryside and the remains of Moorish architecture, he made a visit to Spain. Unlike Italy, where he had initially planned to go at this time, Spain was little visited by tourists, and Roberts was one of the first British artists to travel there. He returned with over two hundred sketches. Some he worked up into oil paintings, and a large group – including another study of the Bridge of Toledo in Madrid – was published in 1834 in the *Landscape Annual*.[1]

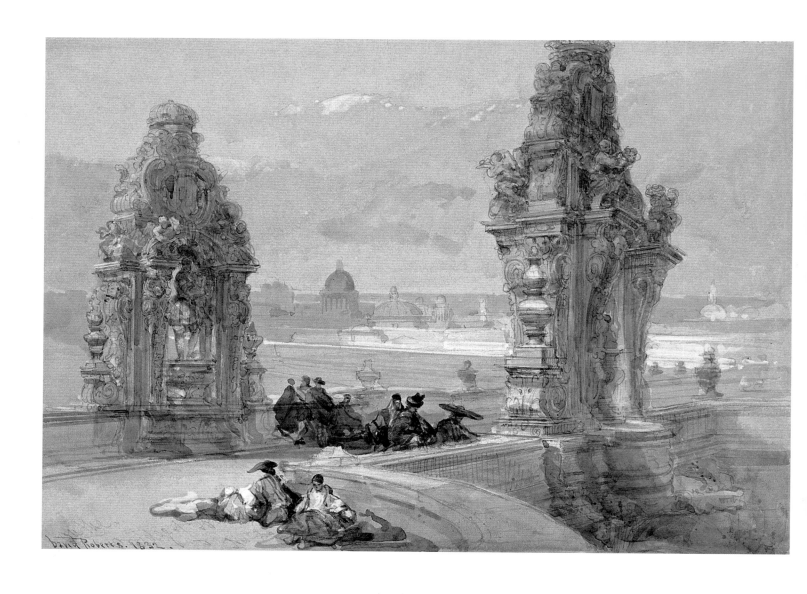

46. David Roberts (1796–1864)
On the Bridge of Toledo, Madrid, 1832

Pencil and watercolour with white
heightening on grey paper

24.5 × 34.2 cm (9⅝″ × 13⁷⁄₁₆″)

Signed and dated bottom left
David Roberts. 1832.;
inscribed bottom left *On the / Bridge
of Toledo / D* [illeg.]

RCIN 453588

PROVENANCE Purchased from Walker's
Galleries, 18 July 1939, no. 88

47. Charles Decimus Barraud (1822–1897)
A southern landscape, New Zealand, 1892

Watercolour

35.4 × 52.6 cm (13¹⁵⁄₁₆″ × 20¹¹⁄₁₆″)

Signed bottom left *C D BARRAUD* and inscribed *NZ*

RCIN 453430

PROVENANCE Presented by the Mayor, councillors and citizens of Auckland, 1958

Charles Decimus Barraud was born in Camberwell, south-east London. As a young man he had wanted to become a doctor, but his father died when he was eleven years old and the training was too expensive for the family to afford. Barraud became instead a chemist and druggist. He married in 1849, and shortly afterwards he and his wife emigrated to New Zealand, where he established himself as a chemist with a shop in Lambton Quay, a district of Wellington. Barraud rose to eminence in his field and was influential in the introduction of legislation to regulate the sale of drugs. He called the meeting which led to the formation of the Pharmaceutical Society of New Zealand and was elected its first president, becoming president of the Pharmacy Board in 1881.

Barraud was a keen amateur artist, and from his arrival in New Zealand in 1849 he travelled widely over the North and South Islands, making numerous sketches. In 1877 he published *New Zealand Graphic and Descriptive*, a large-format book of colour lithographs which he dedicated to the Prince of Wales (later King Edward VII). He was the principal founder, in 1882, of the Fine Arts Association, later to become the New Zealand Academy of Fine Arts, and president of the organisation from 1889 until his death.

This watercolour was presented to Queen Elizabeth in the course of her visit to New Zealand in 1958.

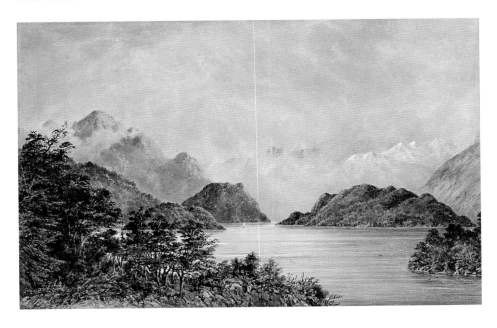

48. Berthe Morisot (1841–1895)
A study of a seated girl, c.1891

Berthe Morisot was one of the central figures of the French Impressionist group, who organised exhibitions of their work in the 1870s and 1880s independently of the official Salon. Her painting is characterised by free, gestural brushstrokes which capture the effects of light falling on natural forms. In around 1868 Morisot met Edouard Manet, for whom she modelled, and who became a close friend. Morisot married his brother Eugène, and their daughter, Julie, was born in 1878.

Julie is the model in this drawing; her cast of features and the hat she wears are recognisable from other sketches made at around the same time, particularly a

preparatory study for Morisot's 1891 painting *Little girl with a goat*.[1] The present drawing is remarkable for the freshness and simplicity conveyed by its deft economy of line. The flowing contours and the rounded shape of the girl's dress suggest the influence of Renoir, who frequently worked alongside Morisot during the summer of 1891 when she rented a house at Mézy in northern France.[2]

Pencil

31.6 × 23 cm (12⁷⁄₁₆" × 9¹⁄₁₆")

Stamped bottom left with initials *B.M* (Lugt 388a)

RCIN 453402

PROVENANCE Possibly purchased from Knoedler & Company, May–June 1936

1. Moskowitz 1961, pl. 48.
2. *ibid.*, p. 130.

Pencil and watercolour

35.3 × 50.5 cm (13⅞" × 19⅞")

Signed lower left *D. Y. Cameron*

RCIN 453575

PROVENANCE Cotswold Gallery, London, 1930

EXHIBITION Chicago 1930, no. 6

49. Sir David Young Cameron (1865–1945)
The carse of Stirling, c.1925–30

The painter, watercolourist and etcher David Young Cameron studied at both the Glasgow and Edinburgh Schools of Art. He became a leading member of the Scottish etching revival, and his early works are principally devoted to architectural subjects. After the turn of the century Cameron became increasingly interested in the Scottish landscape. In 1899 he moved to Kippen, a small village near Stirling, where he lived for the rest of his life. This view, showing Stirling Castle on the horizon, is one of the many watercolours and paintings he made of his local landscape.

The combination of linear detail and areas of rich colour surrounded by paler

wash is characteristic of Cameron's watercolour technique, which in part derives from the balance of fine lines and rich chiaroscuro masses found in his etchings. The immensity of sky and the expanse of the carse – the fertile lowland beside the river – punctuated at its farthest reaches by mountains, are emphasised by the distant shape of Stirling Castle on the horizon. The romance and poetry of landscape, deeply felt by Cameron, was always allied in his work with a muscular rendition of solid form and precise detail.

In 1917 Cameron, along with Augustus John, was appointed as a War Artist and assigned to the Canadian Expeditionary Force on the Western Front. In 1920 he was elected Royal Academician and appointed a trustee of the Tate Gallery, and in 1922 – with the painter, wood-engraver, illustrator and collector Charles Ricketts – he was asked to join the Committee of the National Art Collections Fund, where he served until 1938. He was knighted in 1924. In 1933 Cameron was appointed the King's Painter and Limner in Scotland, a post created by Queen Anne in 1703, and which had come to be an honorary position for an eminent Scottish artist, to be held until his or her death.

50. Sir Max Beerbohm (1872–1956)
'HRH in the sixties', 1921

Pencil and watercolour

31.5 × 19.7 cm (12⅜" × 7¾")

Signed and dated lower right
Max / 1921; inscribed at right
H.R.H. / in the 'sixties

RL 17171

PROVENANCE Gerard T. Meynell;
purchased through Messrs J. and
E. Bumpus, June 1943

LITERATURE Hart-Davis 1972, no. 507;
Hall (N.J.) 1997, p. 174

EXHIBITION Leicester Galleries,
May 1923 (withdrawn)

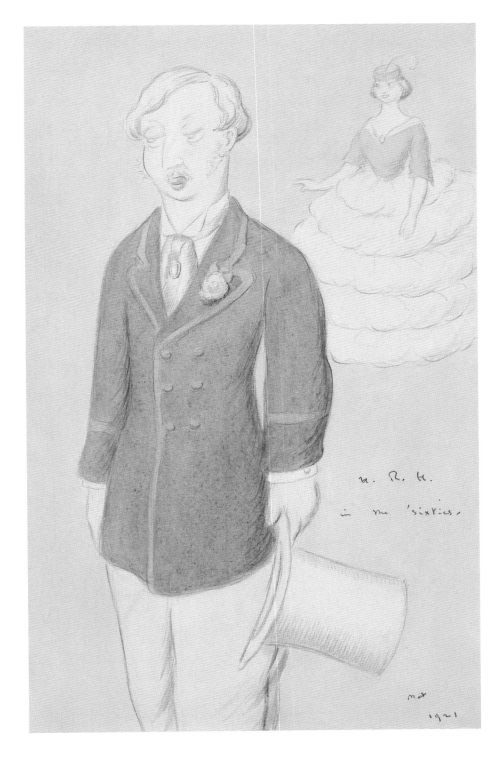

51. Sir Max Beerbohm (1872–1956)
'HRH in the nineties', 1921

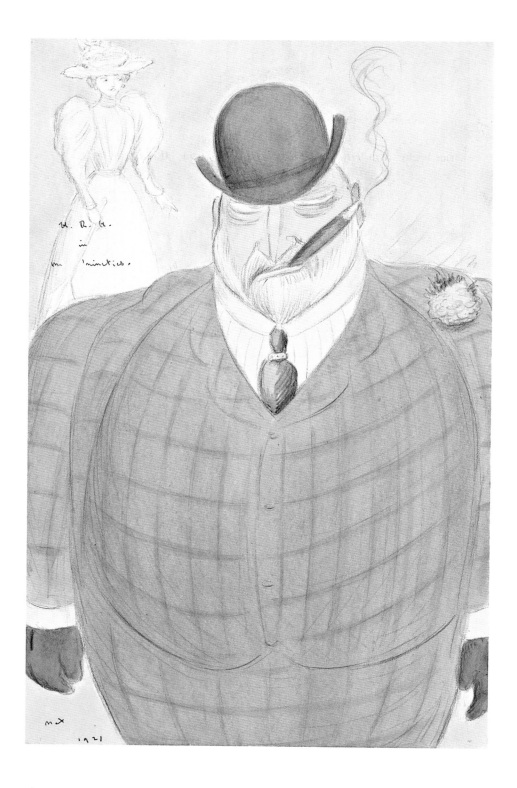

Pencil and watercolour

31.4 × 19.8 cm (12½" × 7¹³⁄₁₆")

Signed and dated lower left
Max / 1921; inscribed at left
H.R.H. / in / the 'nineties

RL 17174

PROVENANCE Gerard T. Meynell;
purchased through Messrs J. and
E. Bumpus, June 1943

LITERATURE Hart-Davis 1972, no. 510;
Hall (N.J.) 1997, p. 174

EXHIBITION Leicester Galleries, May
1923 (withdrawn)

A central member of the 'decadent' artistic milieu of 1890s London which included Oscar Wilde and Aubrey Beardsley, Max Beerbohm showed precocious talents as a caricaturist and writer, contributing to the *Yellow Book* while still an undergraduate at Oxford. He wrote brilliant literary parodies, and developed a form of graphic caricature reliant upon a high degree of physiognomic distortion. Beerbohm's style owed little to previous conventions of the genre, and has continued to exert a strong influence.

Although the majority of his subjects were artists and writers, Beerbohm returned frequently to the subject of the Prince of Wales, later King Edward VII; in fact the number of caricatures Beerbohm made of him is exceeded only by the number of self-caricatures he drew. These two examples are selected from a series of eight dating from 1921. The series begins with *'HRH in the forties'* (fig. 33) and *'HRH in the fifties'* (fig. 34), showing the Prince first as a young boy studying a globe (prefiguring his later expeditions abroad), next as a youth chaperoned by two grim-faced schoolmasters; as the series progresses, the Prince is shown expanding steadily in girth, always with a different fashionably dressed woman in the background (figs. 35–7). The final watercolour of the series, *'A.E. in the teens'* (fig. 38), shows a corpulent King Edward VII (Albert Edward) playing a harp in heaven. Beerbohm's fascination was with the Prince's reputation as a bluff philistine who rejected the values of refinement and industry so firmly espoused by his parents, and whose principal interests lay in racing and womanising.

Below: left to right
Figure 33
Max Beerbohm, *'HRH in the forties'*, 1921
Pencil and watercolour
31.4 × 19.6 cm (12⅛" × 7¹¹⁄₁₆")
RL 17169

Figure 34
Max Beerbohm, *'HRH in the fifties'*, 1921
Pencil and watercolour
31.2 × 19.5 cm (12⁵⁄₁₆" × 7¹¹⁄₁₆")
RL 17170

Figure 35
Max Beerbohm, *'HRH in the seventies'*, 1921
Pencil and watercolour
31.5 × 19.8 cm (12⅛" × 7¹³⁄₁₆")
RL 17172

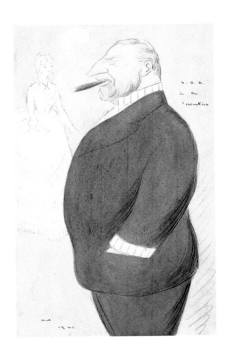

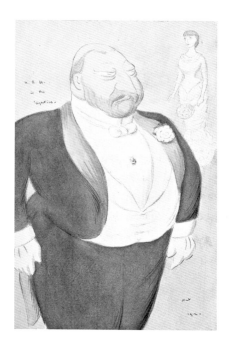 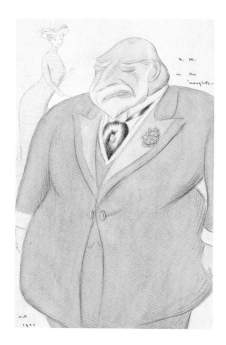 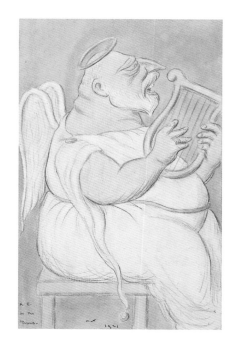

When in 1923 this series was included in an exhibition of Beerbohm's work at the Leicester Galleries in London, it provoked a scandal, partly because Beerbohm mischievously called his caricatures 'Proposed Illustrations for Sir Sidney Lee's Forthcoming Biography'. Lee, an eminent Shakespearian scholar and an editor of the *Dictionary of National Biography*, was writing the official biography of King Edward VII at the request of King George V; this was published in two volumes, in 1925 and 1927. In reviews of Beerbohm's exhibition the right-wing press responded furiously to what it perceived to be an attack on the monarchy; the *Daily Chronicle* declared it to be 'The end of Max Beerbohm', and another journal concluded that the artist must be 'either a shameless bounder or a stealthy Bolshevist.'[1] Beerbohm, who decided to withdraw the pictures from the exhibition after the opening, described the furore in a letter to his friends William and Alice Rothenstein: 'I had foreseen that these pictures would make the injudicious grieve; but I hadn't guessed that the heathen would rage furiously together. As their rage (mostly simulated as it was, I suppose) seemed likely to infect the general public, and perhaps lead to "incidents" in the Leicester Gallery, I decided to do what I did.'[2]

In his memoir of Beerbohm, S.N. Behrman records a conversation many years later in which the artist fancifully imagined his drawings in royal hands:

Above: left to right
Figure 36
Max Beerbohm, *'HRH in the eighties'*, 1921
Pencil and watercolour
31.5 × 19.9 cm (12⅜" × 7¹³⁄₁₆")
RL 17173

Figure 37
Max Beerbohm, *'HM in the noughts'*, 1921
Pencil and watercolour
31.4 × 19.6 cm (12⅜" × 7¹¹⁄₁₆")
RL 17175

Figure 38
Max Beerbohm, *'A.E. in the teens'*, 1921
Pencil and watercolour
31.6 × 20 cm (12⁷⁄₁₆" × 7⅞")
RL 17176

'a series I did of Edward VII was bought by the Royal Family, don't you know. It is not generally known, but they are at Windsor. The tenants keep them behind a panel in the drawing-room. I am told that when they have people they are cosy with, they take them out from behind the panel and show them. I hope that, unlike this lady on a historic occasion' – he made a flicking gesture towards Queen Victoria – 'they *are* amused.'[3]

In 1942 these watercolours were shown to Sir Owen Morshead by the director of the bookshop Bumpus, who was, as the Librarian put it, 'anxious from patriotic motives that they should not fall into the wrong hands.'[4] Acting on the advice of Morshead, Queen Elizabeth – who evidently *was* amused – purchased them for the Royal Library. In a letter of July 1943, just after the purchase of this group of drawings, Morshead wrote to her enclosing one of Beerbohm's publications: 'I think Your Majesty is one of the discerning people who would like to read this little pamphlet by Max Beerbohm, if it has not already come your way. Unfortunately it only takes ¾ of an hour.'[5]

1. Quoted in Cecil 1964, p. 398.

2. Beerbohm & Rothenstein 1975, p. 116.

3. Behrman 1960, p. 73.

4. File note, Print Room acquisitions file, June 1943.

5. RA QEQM/PRIV/PIC: 31 July 1943 Owen Morshead to Queen Elizabeth.

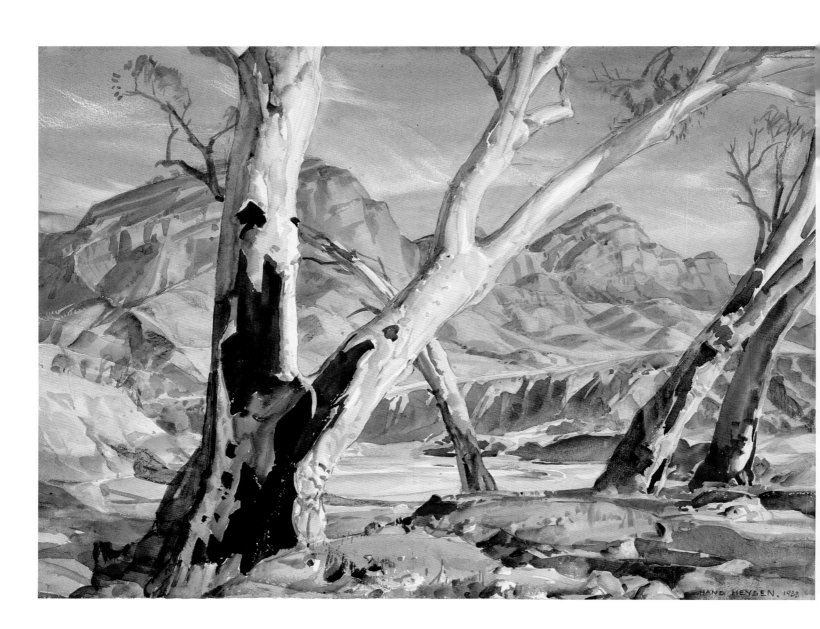

52. Sir Hans Heysen (1877–1968)
Brachina Gorge, 1933

Pencil, watercolour and bodycolour

39 × 52.7 cm (15⅜″ × 20¾″)

Signed and dated lower right
HANS HEYSEN. 1933.

RCIN 453426

PROVENANCE Presented by
the people of Adelaide, 1966

EXHIBITION Adelaide 1986

Born in Hamburg, Germany, in 1877, Hans Heysen moved with his parents to Australia in 1884. He attended the Adelaide Art School, and at the age of twenty he went abroad to study in Paris, and later at Italian art schools. His contact with European painters, particularly those associated with the Realist and Impressionist movements of the late nineteenth century, was to have a profound effect on his treatment of landscape. When Heysen returned to Australia in 1903, he quickly established a reputation as the country's foremost landscape painter.

Heysen's life-long preoccupation was with the Australian interior, which in the early years of the twentieth century offered new territory for the artist. As Heysen himself put it the year before the execution of this watercolour: 'There is an undeniable call about this interior which covers by far the greater portion of Australia, and offers, for the artist, a wide field as yet practically untouched.'[1]

This watercolour represents Brachina Gorge in the Flinders Ranges National Park, about three hundred miles north of Adelaide. Heysen's technique of building up and overlapping flat planes of colour within precisely delineated contours is wonderfully expressive of the massive forms of the gum trees which extend beyond the edges of the composition, and of the mountain range in the background. Heysen also captured in watercolour the intense light and colour which contribute to the alien quality of the landscape of the Australian bush. In a letter of 1926 to the Australian artist Lionel Lindsay, Heysen wrote: 'There is something immensely exhilarating when tall white gums tower into the blue heavens – the subtle quality of the edges where they meet the sky – how mysterious.'[2]

Queen Elizabeth was Patron of the Adelaide Festival of Arts. When she opened an exhibition at Adelaide in 1966 she was presented with *Brachina Gorge* and another work by Heysen, *Timber haulers* (RCIN 453427). She had first visited Australia in 1927, as Duchess of York. Australian artists are well represented in Queen Elizabeth's collection; as well as works by Norma Bull in the present catalogue (see nos. 12 and 63–5), she also acquired paintings by Sidney Nolan (RCIN 409045), Kenneth Jack (RCIN 409168) and Russell Drysdale (RCIN 409154).[3]

1. North 1979, p. 13.
2. *ibid.*, p. 12.
3. See Cornforth 1996, pp. 39–41.

53. Augustus John (1878–1961)
Dorelia, standing, c.1907–10

One of the outstanding draughtsmen of his generation, Augustus John studied at the Slade School of Fine Art in London between 1894 and 1898 under Henry Tonks. Believing passionately in the supreme importance of observation in artistic training, Tonks insisted upon constant drawing from the life model, teaching his students to construct the illusion of form through accurate, rapidly executed lines, rather than through careful shading and rubbing, the method taught in more traditional art schools. After the Slade, John's work continued to be based on figure compositions, which he drew with great facility, and as his career progressed he worked increasingly as a portraitist, Queen Elizabeth herself sitting for him during the war (see fig. 25, page 49).

Pencil
39.5 × 26.2 cm (15⅝" × 10⅜")
Signed lower right *John*
RCIN 453278
PROVENANCE Unknown

The subject of this full-length figure study is Dorelia, born Dorothy McNeill, who became John's mistress in 1903. She lived with John and his wife Ida Nettleship, whom he had married in 1901, in a *ménage à trois* until Ida's death in 1907, and Dorelia survived John by eight years. John drew Dorelia countless times, and no. 53 is consonant with a large group of drawings of her of around this date. This drawing may have entered Queen Elizabeth's collection as a private purchase or as a gift from John, who in 1957 presented her with an inscribed copy of his book *Augustus John. Fifty-two Drawings* (RCIN 1164933); alternatively it may have been bequeathed to her by Lady Cavendish-Bentinck (Olivia), a relation by marriage on her mother's side of the family, who on her death in 1939 gave a group of similar drawings of Dorelia to the Tate Gallery.

54. Augustus John (1878–1961)
Robin, *c*.1912

Black chalk

28 × 24 cm (11″ × 9⁷⁄₁₆″)

Signed lower right *John*

RL 14764

PROVENANCE Purchased from the
Redfern Gallery, 5 September 1941

EXHIBITION London 1986, no. 139

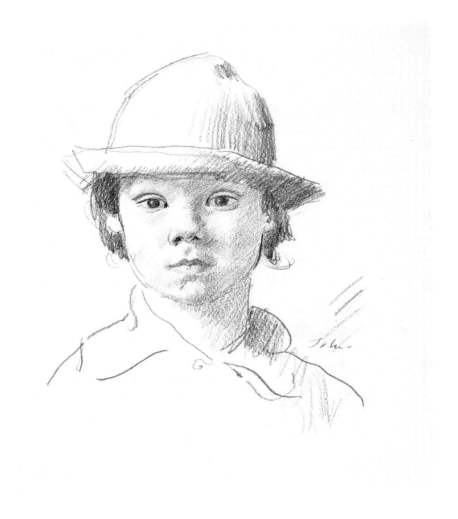

1. RA QEQM/PRIV/PIC: 20 February
 1939 (postmarked) Kenneth Clark
 to Queen Elizabeth.

In September 1941 Queen Elizabeth acquired this chalk drawing of John and Ida's
third son Robin, which Sir Jasper Ridley had arranged to have sent to Buckingham Palace
for Queen Elizabeth's inspection. Queen Elizabeth owned three oil paintings by John,
including *'When Homer nods'*, his 1915 portrait of George Bernard Shaw, one of her
first important purchases (see fig. 1, page 12). In February 1939 she bought a red chalk
drawing of Ida and Dorelia (fig. 24, page 48) from the Redfern Gallery, described by
Clark in a letter of congratulation as 'brilliant [and] vigorous ... a valuable addition to
the Royal Collection.'[1]

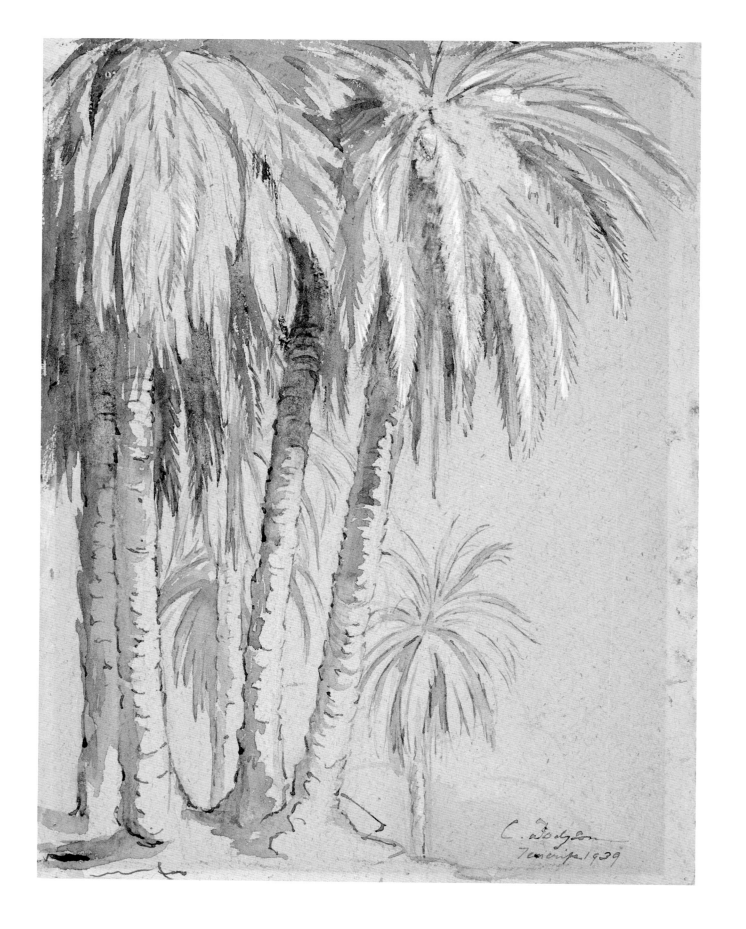

C. Dodgson
Tenerife 1939

55. Catharine Dodgson (1883–1954)
Tenerife, 1939

Pen and ink, brown wash, touches
of white bodycolour

37.9 × 28.5 cm (14¹⁵⁄₁₆″ × 11¼″)

Signed and dated lower right
C. Dodgson / 1939 and inscribed
Tenerife; inscribed on verso
MRS DODGSON. D

RCIN 453478

PROVENANCE Unknown

Catharine Dodgson was the daughter of the Revd William Archibald Spooner (1844–1930), Warden of New College, Oxford, who is best remembered today for his peculiar lapse of speech which came to be known as the spoonerism. Catharine studied drawing at the Ruskin School of Drawing and Fine Art, and then attended the Royal Academy Schools and the Slade School of Fine Art. She married Campbell Dodgson (1867–1948), then aged forty-six, in 1913. After their marriage the Dodgsons lived at 22 Montague Square, London.

Campbell Dodgson began working in the Department of Prints and Drawings at the British Museum in 1893. He succeeded Sir Sidney Colvin as Keeper of the Department in 1912, a post he held until his retirement in 1932. He was renowned as an authority on early German prints, and also wrote a series of catalogues on contemporary British etchers, among whom were Muirhead Bone and Augustus John. In 1919 Dodgson set up the prints and drawings fund for the Contemporary Art Society, as a way of supporting living graphic artists.

Queen Elizabeth's friend Sir Jasper Ridley was closely involved with the Contemporary Art Society, and this delicate drawing of palm trees by Catharine Dodgson may have entered her collection via this route. When in 1952 the Contemporary Art Society held an exhibition at the Tate Gallery of paintings owned by members of its executive committee, Queen Elizabeth lent works by Alfred Sisley, Walter Sickert and Matthew Smith.

56. Elizabeth Keith (1887–1956)
Returning from the funeral, Korea, 1922

See also no. 57

The first half of the twentieth century in Japan witnessed a revival of the traditional *ukiyo-e* ('pictures of the floating world') woodblock print which had generally declined in quality towards the end of the previous century, and in the early years of the twentieth century a number of western artists went to Japan to study the old methods of papermaking, woodblock-cutting and printing.

Elizabeth Keith first visited Japan, where her sister lived with her husband, the publisher J.W. Robertson-Scott, in 1915. What had been intended as a short holiday extended into a stay of nine years, during which time Keith travelled extensively in Japan and visited China, Korea and the Philippines. Through making contacts with missionaries Keith was able to travel to remote and otherwise barely accessible places. She began to explore colour woodblock printing after an exhibition was held of her caricatures of local dignitaries. The publisher Shosaburo Watanabe suggested publishing her designs as colour prints, and thus Keith began to learn traditional Japanese printmaking techniques.

Keith's woodcuts are remarkable both for delicacy and detail and for the glimpses they afford of the places she visited: a funeral procession led by lantern bearers passing through a city gate in Seoul, or domestic activity on a spring day in Soochow, Taiwan. Regarding two of her prints Keith wrote: 'They convey the very clamour and smell and confusion of Chinese Streets … it is the unusual, the picturesque, the macabre which attract … as well as the purely beautiful.'[1]

Although on her return to Britain Keith's work won renown, towards the end of the 1930s the deterioration of the relationship between Britain and Japan began to jeopardise her livelihood. Keith's dealer at the Beaux-Arts Gallery in London warned her to avoid exhibiting in London until 'a little of this anti-Japanese feeling is gone.'[2] It is a reflection of Queen Elizabeth's public support of British artists that she visited the monographic exhibition held at the Beaux-Arts Gallery in London in 1937 and bought a group of seven prints. It is recorded that Keith's 'spirits were lifted by the visit of the Queen.'[3] However, her last prints are dated 1939, the year of the outbreak of war.

Colour woodcut

37.5 × 23.8 cm (14¼" × 9⅜")

Stamped bottom right *E.K. / 1922*; signed bottom right beneath image *Elizabeth Keith*; inscribed on the block lower left *Returning from the funeral. KOREA*

RCIN 504344

PROVENANCE Purchased from Beaux-Arts Gallery, London, 26 November 1937, no. 34

LITERATURE Miles 1991, no. 56

1. Miles 1991, p. 24.
2. *ibid*., p. 19.
3. *ibid*.

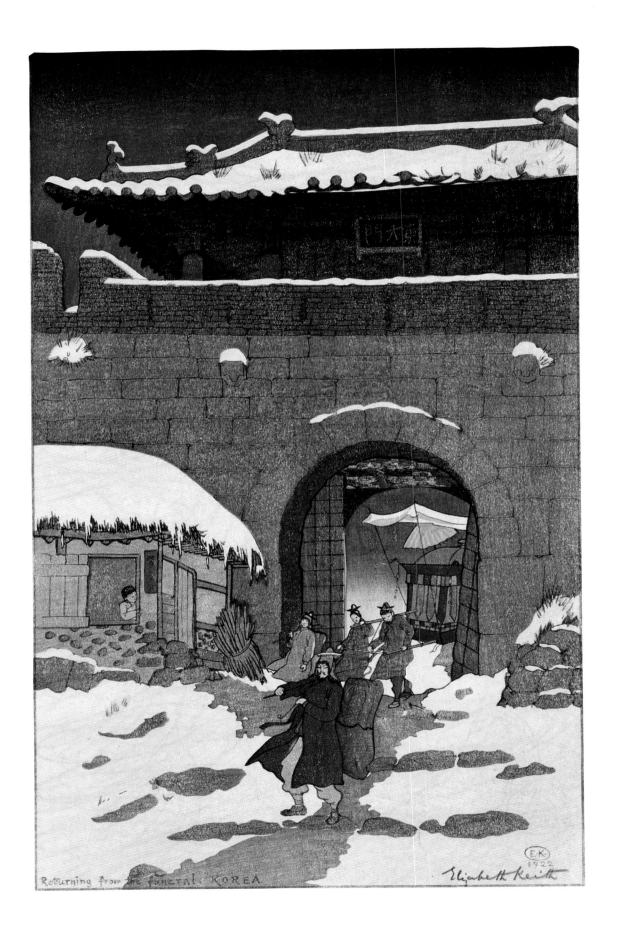

Returning from the funeral. KOREA Elizabeth Keith

57. Elizabeth Keith (1887–1956)
Spring in Soochow, *c.*1922

Colour woodcut

27.9 × 39.8 cm (11" × 15¹¹⁄₁₆")

Signed bottom right *Elizabeth Keith*;
signed bottom right beneath image
Elizabeth Keith; inscribed on verso
bottom left *Spring in Soochow*; on
verso top right *C16538 25*

RCIN 504347

PROVENANCE Purchased from Beaux-
Arts Gallery, London, 26 November
1937, no. 12

LITERATURE Miles 1991, no. 23

58. David Jones (1895–1974)
'The outward walls', 1953

Pencil, coloured pencil, watercolour
and bodycolour

79 × 58.7 cm (31⅛" × 23⅛")

Signed and dated lower right
David J. '53; inscribed on verso
Arts Council Ex, Tate /
Title The Outward Walls / date 1953 /
David Jones / Macbeth V6 /
To E. Wheatley, Frame-Makers /
32 Fourberts Place W1 / Regent Street

RCIN 453574

PROVENANCE Collection of the artist in
1954; probably purchased in 1955

LITERATURE Miles & Shiel 1995,
p. 204

EXHIBITION London 1954–5, no. 73

A painter, illustrator, printmaker and poet, David Jones was one of the artists most assiduously supported by Kenneth Clark. Clark and Jones corresponded over a long period; between 1944 and 1953 Clark supported Jones financially through a fund organised by Jim Ede, assistant to the Director of the Tate Gallery from 1921 to 1936 and founder of Kettle's Yard in Cambridge; and in 1953 Clark was influential in procuring a Civil List Pension for the artist.[1] In 1949 Robin Ironside contributed a volume on David Jones to the important Penguin 'Modern Painters' series, which was edited by Clark.

What Ironside termed the 'elaborate fragility' of Jones's watercolour technique sets the artist apart from the muscularity of contemporaries such as Paul Nash, Graham Sutherland and Henry Moore.[2] As well as complex mythological imagery, Jones often took as his subjects everyday scenes, like this overgrown suburban back garden seen from a window, probably at Northwick Park Lodge in Harrow-on-the-Hill where he lodged in a third-floor room between 1947 and 1964. The very 'ordinariness' of such subjects serves to amplify the disturbing overtones of instability implied by Jones's style.

As with many of Jones's works, the title of this drawing is ambiguous. The back of the sheet is inscribed with a reference to *Macbeth*, Act V, Scene 6, which begins with Malcolm commanding his army, which he has led against Macbeth, to throw down the 'leavy screens' with which they had camouflaged themselves on their way to Dunsinane. In the light of this, the foliage outside the window is presented as a disguise for a potentially threatening power behind or within trees and flowers.

However, the phrase 'outward wall' is a quotation not from *Macbeth* but from *The Merchant of Venice*, Act II, Scene 9:

What many men desire! That 'many' may be meant
By the fool multitude, that choose by show,
Not learning more than the fond eye doth teach;
Which pries not to the interior; but, like the martlet,
Builds in the weather on the outward wall,
Even in the force and road of casualty.
I will not choose what many men desire,
Because I will not jump with common spirits
And rank me with the barbarous multitude.

This suggests an imminent disintegration of the surface of things, which is borne out by the tremulous and fractured qualities of the lines in Jones's drawing. The reference can also be taken as a commentary on artistic practice, in which case it serves as a subtle deprecation of artists who, concerned with recording the surface of things, neglected

1. Dilworth 2000, p. 216.
2. Ironside 1948, p. 160.

the spiritual resonances with which Jones was so preoccupied; as he wrote in 1929: 'isn't it awful, these yards of "able" paintings of various kinds that seem only seen with the eye of the flesh.'[3]

The date of acquisition of this drawing is unclear. It was exhibited from December 1954 to January 1955 at the Tate Gallery, the final venue of the major touring exhibition *David Jones. Exhibition of paintings, drawings and engravings* organised by the Welsh Committee of the Arts Council of Great Britain, at which point Jones is identified as the owner in Arts Council records.[4] Jones was awarded the CBE in 1955 and at his investiture at Buckingham Palace during the summer he is said to have told HM The Queen that her mother had bought one of his pictures, so it is likely that Queen Elizabeth purchased *'The outward walls'* – probably directly from the artist or via Clark – in the spring of 1955.

3. Jones 1980, p. 46.

4. ACGB/121/569.

59. John Piper (1903–1992)
The Scuola and Chiesa di San Rocco, Venice, c.1959–60

Pen and ink, watercolour and white
bodycolour

78 × 57 cm (30¹¹⁄₁₆″ × 22⁷⁄₁₆″)

Signed lower right *John Piper*

RCIN 453396

PROVENANCE Presented by the artist,
1962

EXHIBITION London 1963, no. 6

Piper's first working visit to Venice was in 1958. The following year he was
commissioned by Arthur Jeffress, the London-based gallery owner and patron of
Surrealist and Neo-Romantic painters, to return to the city in order to prepare for
an exhibition, which was held in May 1960. The present watercolour was probably
executed for that exhibition.

This work illustrates the development of Piper's style towards a degree of
abstraction, albeit of a different kind from his experimental work of the 1930s.[1]
The close pen and ink lines which underpin the Windsor series (see nos. 26–31) have
been jettisoned, and in *The Scuola and Chiesa di San Rocco* the graceful white lines
describing windows and door-cases deftly suggest architectural detail. The watercolour
washes behind seem to dissolve and run down the paper, so that the picture becomes
a meditation on the effects of light reflected in water which are so characteristic of
Venice. Piper's use of contrasts between dark grey shadow and white linear detail
reveals the influence both of the Franco-Italian Baroque artist Monsu Desiderio
and of Turner's watercolours of Venetian subjects.

Piper continued to return to the city, publishing in March 1965 *Venice*, a book
of twenty-six lithographs printed, bound and published by the Lion and Unicorn Press at
the Royal College of Art, with text by Adrian Stokes.

A letter from John Piper to Queen Elizabeth of 1962 reads: 'I should be so
honoured and pleased if you would accept this picture that you were kind enough
to admire on Sunday. It is of the Scuola San Rocco, which has the splendid Tintoretto
paintings inside, and of the church (of S. Rocco also) just beside it.'[2] This refers to
an informal visit made by Queen Elizabeth at around this time to Piper and his family
at their farmhouse Fawley Bottom, near Henley-on-Thames. Queen Elizabeth first
visited Venice in 1984 (see no. 73).

1. See Fraser Jenkins & Spalding
 2003.

2. RA QEQM/PRIV/PIC: 7 February 1962
 John Piper to Queen Elizabeth.

60. William Dring (1904–1990)
'On leave', 1942

William Dring studied at the Slade School of Art between 1922 and 1925, where he won first prize in the portraiture competition. He taught at Southampton School of Art until 1940, and was subsequently employed as an Official War Artist between 1941 and 1945. Like his fellow War Artist Eric Kennington, he worked rapidly and usually in pastel, and created an extensive series of portraits of naval recipients of battle awards, often ordinary servicemen who were frequently overlooked in military portraiture. Dring's portraits are strikingly direct and executed with a bravura economy of flat planes of colour and white heightening. In *'On leave'* the rich velvety density of the medium invites an aesthetic response quite at odds with the spartan subject matter, conveyed by the awkward postures of the sleeping sailors and the bare boards upon which they lie.

This pastel was purchased by Queen Elizabeth from a London charity sale in 1943, the Artists' Aid China Exhibition which was held at the Wallace Collection for Lady Cripps' United Aid to China Fund. A letter attached to the receipt for the picture, from the organiser Mrs I.G. Tennyson, reads 'It has meant a great deal to Lady Cripps' Fund that Her Majesty should have found time to visit this Exhibition, and it has also given immense pleasure to the artists to know that she found the exhibition interesting.'[1] Queen Elizabeth donated a piece of jade to the sale.

Dring was elected Associate of the Royal Academy in 1944 and a full Academician in 1955. Among his important post-war commissions were *The presentation of the Freedom of the City of London to HRH The Princess Elizabeth* in 1947 (Guildhall Art Gallery) and *The Christening of Prince Charles* in 1948 (collection of HRH The Duke of Edinburgh).

Pastel

37.8 × 47.9 cm (14⅞" × 18⅞"); uneven

Signed and dated bottom right
William Dring 1942

RCIN 453579

PROVENANCE Purchased from a charity exhibition held at the Wallace Collection, 1943

EXHIBITION London 1943, no. 133

1. RA QEQM/TREAS/ACC/BILLS/1943/193.

61. Oliver Messel (1904–1978)

Programme cover for the Royal Opera, March 9th 1950, 1950

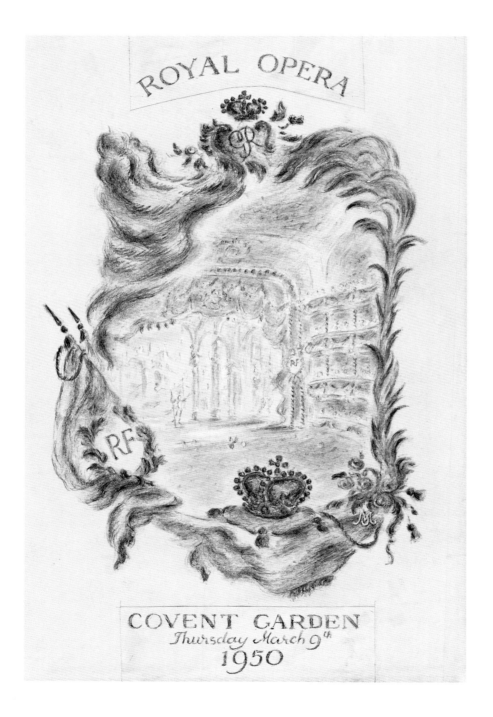

Pencil, watercolour, gold paint and bodycolour

35.9 × 23.7 cm (14⅛" × 9¹⁵⁄₁₆")

Signed lower right with monogram; inscribed top *ROYAL OPERA*; bottom *COVENT GARDEN / Thursday March 9th / 1950*; inscribed top *GR*; lower left *RF*

RCIN 453382

PROVENANCE ?Presented by the artist

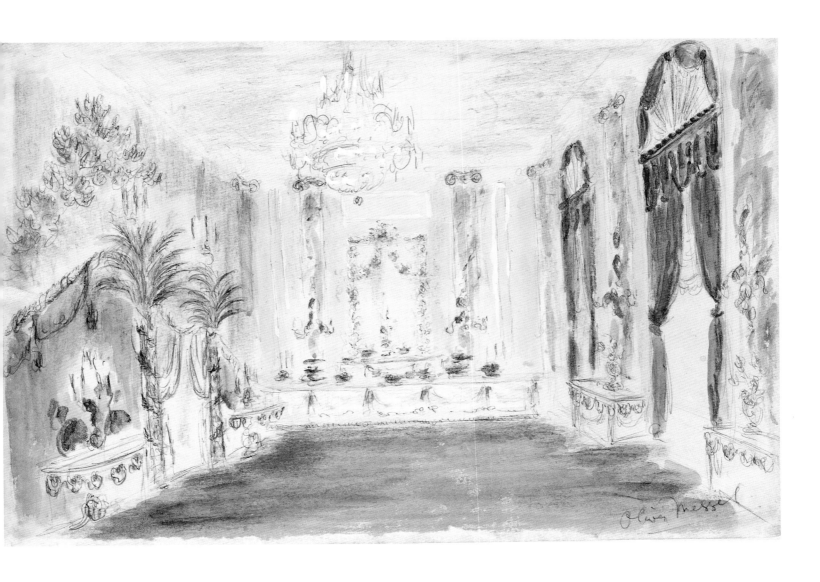

Pencil, pen and ink, watercolour,
gold paint and bodycolour

24 × 34.2 cm (9⁷⁄₁₆″ × 13⁷⁄₁₆″)

Signed lower right *Oliver Messel*

RCIN 453376

PROVENANCE ?Presented by the artist

62. Oliver Messel (1904–1978)

*Decorative scheme for the crush bar
at the Royal Opera House,* 1950

Oliver Messel was the son of Lt.-Col. Leonard Messel and Maud Frances, daughter of the *Punch* cartoonist Linley Sambourne. Educated at Eton, where he claimed that he 'did nothing', Messel went on to study at the Slade School of Art between 1922 and 1924, where he became a friend of fellow student Rex Whistler.[1] Although neither Messel nor Whistler benefited greatly from the academic rigour of the life-drawing classes imposed by the Slade Professor Henry Tonks, during their time at the Slade they realised their shared talent for theatrical design by making papier-mâché masks for parties. Messel's work in this medium was exhibited at a London gallery in 1925 and helped to secure a commission to design masks for Diaghilev's ballet *Zephyre et Flore*. Messel, like Whistler, became a leading theatre designer, mixing eighteenth-century motifs with Neo-Baroque and modern elements.

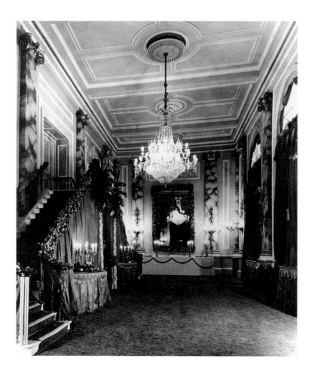

Figure 39
The crush bar at Royal Opera House decorated by Oliver Messel for a gala ballet performance, 9 March 1950. Photograph: Edward Mandinian.

King George VI and Queen Elizabeth were hosts to the President of the French Republic and his wife Madame Auriol on 9 March 1950 for a gala ballet performance at the Royal Opera House. As well as designing the costumes and scenery for a performance of *Sleeping Beauty*, Messel was asked to decorate the Opera House for the event, and no. 62 is his design for the crush bar (see fig. 39). Ten other drawings by Messel from Queen Elizabeth's collection show his decorative schemes for the Royal Box, the foyer, the King's ante-room and the Queen's dressing room (RL 33886–95).

Three years later Messel again decorated the Royal Opera House, on this occasion for the Coronation Gala at which *Homage to the Queen* was performed, written by Benjamin Britten and choreographed by Frederick Ashton. Messel also devised a decorative scheme for the front of the Dorchester Hotel, on the Coronation route to Westminster Abbey.

In his work for the Royal Opera House, Messel was following in the footsteps of Whistler, who in 1939 had designed the programme and decorated the Royal Box for a Royal Command performance, at which the King and Queen were, as they would be in 1950, hosts to the French President and his wife. Whistler had also used palm trees in his decoration, which the American socialite and diarist Henry 'Chips' Channon described as 'light, gay, pretty but a touch tinselly and night-clubbish', adding 'I did not approve of it.'[2] The provenance of these drawings is unknown, although their relevance to specific events and Messel's family connection to Queen Elizabeth through his nephew, Lord Snowdon, suggests that they might have been informally presented by the artist. Queen Elizabeth hung nos. 61 and 62 prominently, in the first-floor corridor at Clarence House.

1. Pinkham 1983, p. 18.

2. Channon 1967, p. 188.

63. Norma Bull (1906–1980)
The Dandenongs, c.1935–7

Pencil, pen and ink and watercolour

50.2 × 38.9 cm (19¾" × 15⅜")

Signed bottom right *Norma Bull*

RCIN 453683

PROVENANCE Purchased from
Australia House, 1947

EXHIBITION London/Melbourne
1947 & 1949, no. 168

Norma Bull was born in Melbourne, Australia. She studied at Melbourne University, graduating in 1929, after which she joined the National Gallery School in the same city, where she spent the next seven years. She won the Sir John Longstaff Scholarship to work overseas, and travelled to England in around 1937. Here she held several exhibitions of her work in provincial galleries and worked as an unofficial War Artist (see nos. 64 and 65). On her return to Australia after ten years abroad, Bull spent a year following Wirth's Circus around the country, painting scenes of circus life, and later she established a reputation as a landscape artist. This watercolour shows forested hillsides in the Dandenong Ranges National Park outside Melbourne; the trees represented in the background are eucalypti.

Bull taught privately for many years and continued to hold exhibitions of her work. From 1960 she served as the Secretary of the Fellowship of Australian Artists.

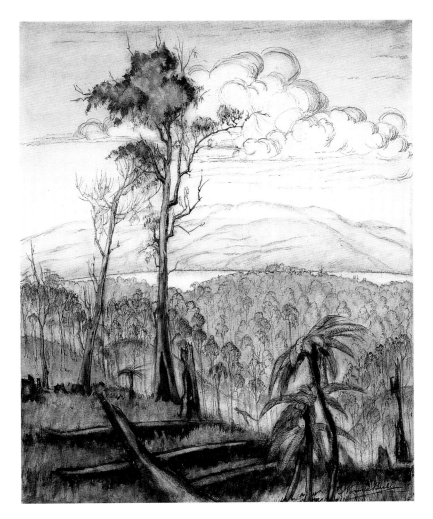

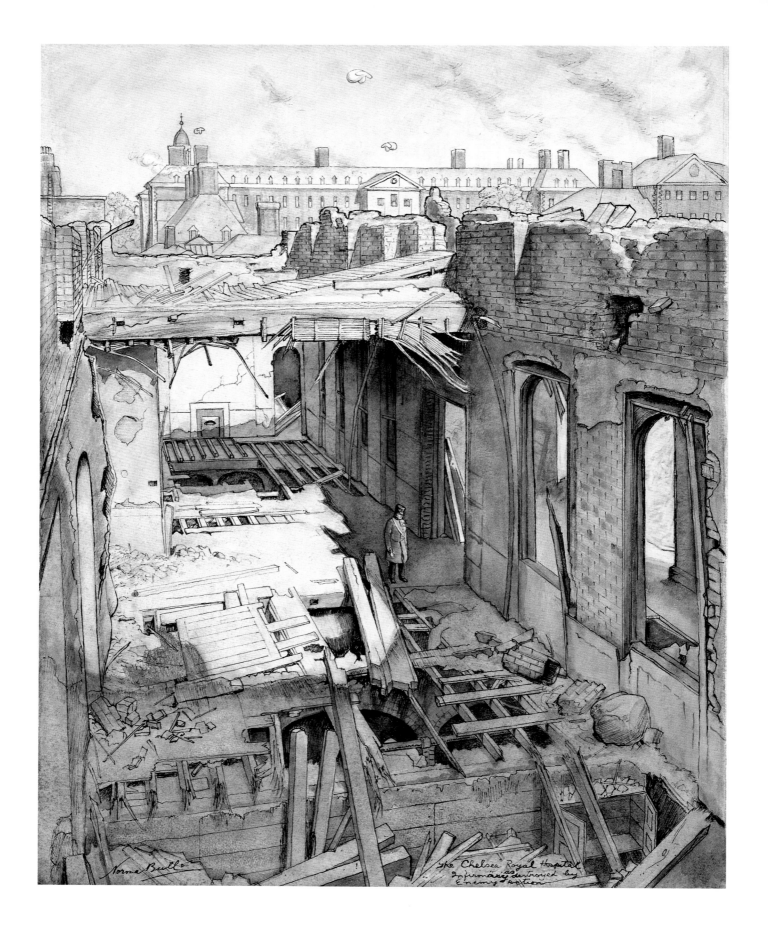

Norma Bull

The Chelsea Royal Hospital
Infirmary as destroyed by
Enemy Action

See also no. 65

64. Norma Bull (1906–1980)

The Chelsea Royal Hospital Infirmary, as destroyed by enemy action, 1941

Pencil, pen and ink and watercolour

56.8 × 45 cm (22 ½" × 17 ¾")

Signed bottom left *Norma Bull*; inscribed bottom right *The Chelsea Royal Hospital / Infirmary as destroyed by / Enemy action*

RCIN 453416

PROVENANCE Purchased from Australia House, 1947

EXHIBITION London/Melbourne 1947 & 1949, no. 40

During the war Bull worked unofficially as a War Artist, making independent submissions, which were encouraged by the War Artists' Advisory Committee. Like John Piper's, her subjects were principally bomb-damaged buildings, although an illustrative, sometimes cartoon-like quality characterises her work – particularly evident in the exuberant cloud of *Rocket bomb exploding in the air over London* (no. 65) – which is quite unlike the sombre atmosphere evoked by Piper. Bull's watercolours function as detailed records, and a description of a particular event is often noted on the sheet, for example *Rescue at Knightsbridge by heavy rescue party during a raid – flying bomb incident of 3.8.44*, which is inscribed 'Casualty dropped 3 floors, buried 42 hours, rescued suffering only slight leg injury & shock. Other C.D. personnel just outside range of picture' (see fig. 9, page 25).

The Royal Hospital, Chelsea, was hit by enemy bombs several times during the war. Part of the building – which had been badly damaged by enemy bombing in 1918 and reconstructed in 1923 – was destroyed again by a V2 rocket in 1945. The Infirmary was bombed in 1941. Bull's contemporary watercolour (no. 64) gives an extraordinarily detailed account of the damage, surveyed by a Chelsea Pensioner.

Bull was a friend of the Poet Laureate John Masefield, and it was possibly as a result of his influence that she was able to stage a large one-man show in 1947 at Australia House in London. The exhibition was opened by Masefield, and on a later occasion was visited by Queen Elizabeth, who purchased six watercolours. Bull subsequently presented three more watercolours (including no. 12) to the Queen. According to papers in the accession files at the Ian Potter Museum of Art, University of Melbourne, at this time Bull was invited to afternoon tea at Buckingham Palace by the King and Queen, where she also met Princess Elizabeth and Princess Margaret.

65. Norma Bull (1906–1980)

Rocket bomb exploding in the air over London, 1945

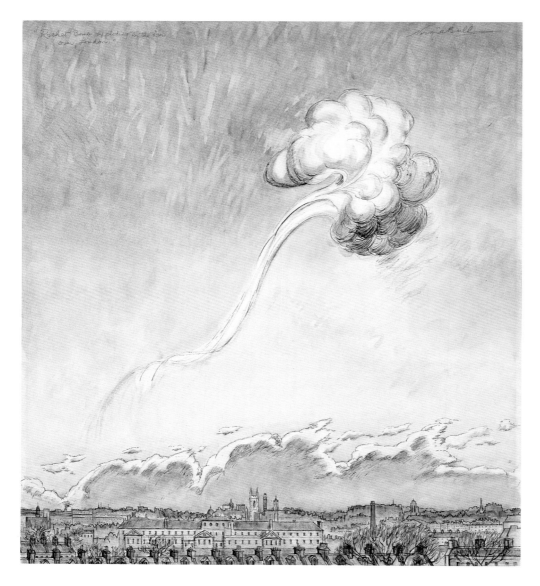

Pencil, pen and ink and watercolour

56 × 49.3 cm (22⅛" × 19⁷⁄₁₆")

Signed top right *Norma Bull*; inscribed top left '*Rocket Bomb exploding in the Air / over London.*'

RCIN 453576

PROVENANCE Purchased from Australia House, 1947

EXHIBITION London/Melbourne 1947 & 1949, no. 49

66. Arthur Henderson Hall (1906–1983)
Dorset quarry, 1961

Pencil and watercolour

37.5 × 53 cm (14¼″ × 20⅞″)

Signed bottom right
A HENDERSON HALL

RCIN 453543

PROVENANCE Purchased from
the Royal Watercolour Society, 1961

EXHIBITION London 1961, no. 26

Born in Sedgefield, County Durham, Arthur Henderson Hall first attended Accrington and Coventry Schools of Art, and then went on to study at the Royal College of Art. He was awarded the Prix de Rome for engraving in 1931. An illustrator and teacher, for ten years he was Instructor of Drawing at the Central School of Art, and became a senior lecturer in graphic design at Kingston School of Art. He was elected to the Royal Watercolour Society in 1958.

Feliks Topolski

67. Feliks Topolski (1907–1989)
A rose and a bee, *c*.1980

Fibre-point pen and ball-point pen

41.7 × 29.6 cm (16 7/16" × 11 5/8")

Signed lower left *Feliks Topolski*

RCIN 453562

PROVENANCE Presented by the directors and staff of F.W. Woolworth and Co. Ltd as an eightieth birthday present, 1980

The Polish painter and draughtsman Feliks Topolski trained at the Academy of Art in Warsaw. After travelling to Paris and Italy, he was sent to London in 1935 by a Polish newspaper to record King George V's Silver Jubilee celebrations. Topolski then settled in Britain, where he worked as the Official Artist to the Polish Forces in England during the war. He became a naturalised British subject in 1947. Topolski made drawings of the funeral procession of King George VI in 1952 (see no. 13) and was one of the official artists appointed to record the Coronation of HM The Queen in 1953. In 1959 he was commissioned by HRH The Duke of Edinburgh to produce a large Coronation mural to be hung in Buckingham Palace. Prince Philip had met Topolski the previous year at the Thursday Club and acquired two of his drawings.

The linear confidence and energy of this drawing of a rose and a bee are typical of Topolski's work, as is its cartoon-like quality. The balance between these elements is particularly interesting in Topolski's portraits, of which a series of thirty was purchased by HM The Queen in 1965. These are all vigorous black chalk drawings of British writers – including Ivy Compton Burnett, Edith Sitwell and John Betjeman – made in connection with John Freeman's *Face to Face* television series which was broadcast on the BBC in the late 1950s and early 1960s. These psychologically penetrating portrait studies are remarkable for their use of caricatural idiom; features and expressions are distorted and exaggerated to achieve a serious, even sombre, result.

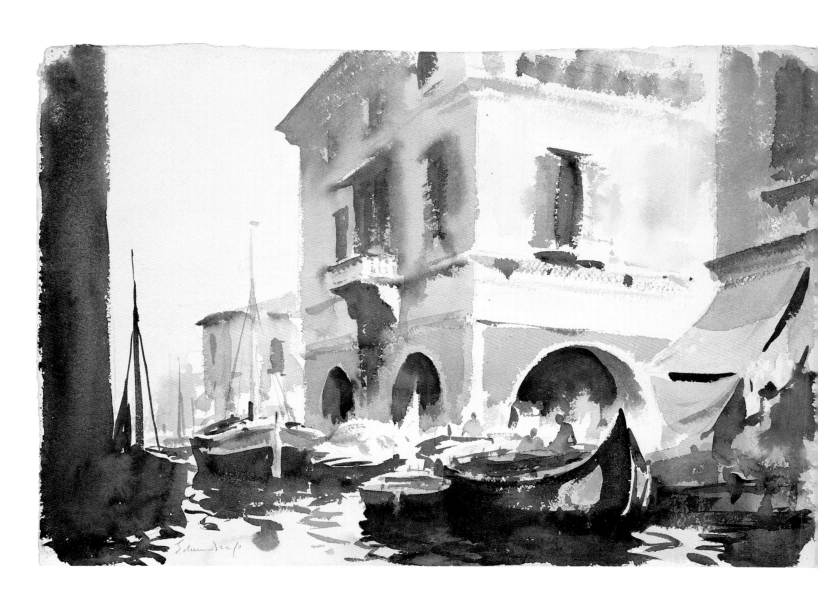

See also nos. 69 and 70

68. Edward Seago (1910–1974)
A canal in Chioggia, c.1950–60

Pencil and watercolour

39.4 × 56.9 cm (15½" × 22⁷⁄₁₆")

Signed lower left *Edward Seago*;
inscribed on verso upper left *345*;
centre *A CANAL IN CHIOGGIA*;
lower right *25*

RCIN 453250

PROVENANCE Presented by the artist

Edward Seago first came into contact with members of the Royal Family in around 1945, when he painted an informal portrait of Princess Margaret (RCIN 409218); two years later, in 1947, he painted the wedding procession of Princess Elizabeth and the Duke of Edinburgh (RCIN 405965). Seago, who lived in Norfolk, quickly became a friend of Queen Elizabeth and visited her at Sandringham every January and July, when the Royal Family were in residence. In 1953 Seago painted HM The Queen's Coronation procession (RCINs 404516 and 405964), and the following year he painted her riding at the Birthday Parade (RCINs 405933 and 405973). When Prince Philip was planning his world tour on the Royal Yacht *Britannia* in 1956, he asked Seago to travel with him for part of the journey, from Melbourne to Antarctica, where the artist would have the rare chance of painting seascapes from the remote South Atlantic. Seago produced around sixty oil paintings during the voyage – the low temperatures precluded the use of watercolour, which would have frozen – which he gave to Prince Philip.

Every year Seago presented a painting or a watercolour to Queen Elizabeth on her birthday, 4 August, and another at Christmas. Personal gifts such as these are mainly undocumented, and the backs of the picture frames bear no inscriptions, so it is not possible to establish the order in which they were given. The watercolour of Chioggia, an island to the south of Venice between the lagoon and the open sea, probably dates from the 1950s when, attracted by the extraordinary quality of light, Seago made frequent visits to the area. In December 1966 he wrote to Queen Elizabeth offering her a Venetian scene as a Christmas present: 'I wondered if at this time of year, in grey London, you might like to look at sunlit Venice – not a usual view, but something bright and cheerful.'[1]

Seago presented a copy of his 1952 book *Edward Seago. Painter in the English Tradition* to Queen Elizabeth, with the inscription 'You have taken a precious interest in this book, and allowed me to speak of it when it was first planned; and I have looked forward so much to the day when I could ask you to honour me by accepting a copy' (RCIN 1196944).

1. RA QEQM/PRIV/CSP/PAL/SEAGO:
 15 December 1966.

69. Edward Seago (1910–1974)
Flowers in a glass vase, *c.*1950–60

Pencil and watercolour

38.1 × 28 cm (15˝ × 11˝)

Signed lower left *Edward Seago*

RCIN 453279

PROVENANCE Presented by the artist

70. Edward Seago (1910–1974)
Flowers in a brown jug, c.1950–60

Pencil and watercolour

39.1 × 28.3 cm (15⅜" × 11⅛")

Signed lower right *Edward Seago*

RCIN 453256

PROVENANCE Presented by the artist

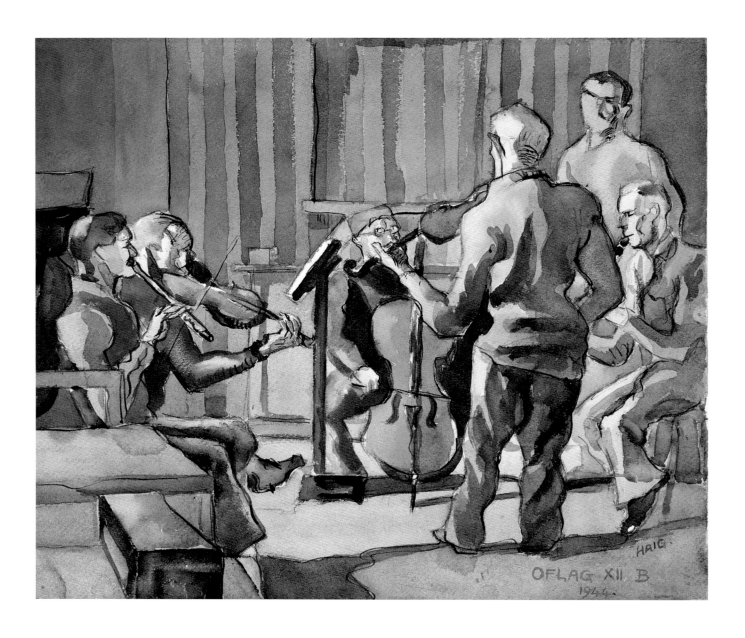

71. George Douglas, 2nd Earl Haig (b.1918)
Orchestra, Oflag XII B, 1944

Watercolour

40 × 45.8 cm (15¼" × 18¹⁄₁₆")

Signed lower right *HAIG*; inscribed
lower right *OFLAG XII B / 1944*

RCIN 453538

PROVENANCE Presented by
the artist, 1945

LITERATURE Hall (D.) 2003, p. 24

EXHIBITION Edinburgh 1945

The son of Field Marshal the Earl Haig, whom he succeeded in 1928, Haig fought in the Second World War with the Royal Scots Greys. He was captured in 1942 at El Alamein. During the following years as a prisoner of war, Haig devoted much of his time to drawing and painting, the total absorption in the subject required by this discipline offering a degree of respite from the anxiety and boredom imposed by captivity. In Haig's autobiography he describes how at first he 'found some scraps of paper and a pencil and began to draw the sprawling bodies of my fellow prisoners lying almost naked in the sun.'[1] Haig began to draw in pencil during his imprisonment at Bari, and then at the next camp, Sulmona in the Abruzzi near Rome, he succeeded in buying watercolour paints on the Italian black market. These had to be in pans, as small rolled maps could be concealed in tubes, which would therefore have been at risk of confiscation. There was a well-stocked library at Sulmona, from which Haig borrowed works by two of the most influential art critics in Britain in the first half of the twentieth century, Clive Bell and Roger Fry.

At the next camp, Oflag XII B in Hadamar, northern Germany, Haig instigated regular sketching trips into the countryside near the camp, and began to paint portraits of fellow prisoners in oil paints supplied by the Red Cross. The Red Cross also sent musical instruments to Hadamar, where the small band depicted in *Orchestra, Oflag XII B* was formed. Haig recalls that 'the effect of a Bach sonata played even by this small amateur orchestra on our morale was profound. Though the players did not pose their likenesses are true. They are shown with their conductor who is keeping the beat with a hand which holds his violin. My aim was to show a group of people sharing the inspiration of music.'[2]

Later Haig was sent to Colditz, where a fellow prisoner was John, 17th Baron Elphinstone (1914–75), a nephew of Queen Elizabeth; they were transferred there as *Prominente*, those whose parentage or connections gave them increased value as hostages. Haig continued to draw and paint at Colditz. An evocative work from this period is a view from a window of the castle to the bleak little town far below; another is a self-portrait from his reflection in a mirror, executed in a tiny bathroom.[3]

After the war Haig determined to become a professional painter. In 1945 the Scottish Gallery in Edinburgh devoted an exhibition to his work (including no. 71: see page 23 and fig. 7), and for the next two years Haig attended Camberwell School of Art, where he was influenced by the Euston Road School. Later he developed a semi-abstract style and concentrated largely on landscape, frequently painting scenes around his home in the Scottish Borders. Queen Elizabeth visited Haig's first professional exhibition in 1949, where she bought a landscape painting (RCIN 400721).

In 2000 Haig attended the pageant on Horse Guards Parade in honour of Queen Elizabeth's hundredth birthday, where he made several drawings that he later worked up into a painting of the event.[4] In 2003 a selection of Haig's recent paintings was shown at the Scottish National Gallery of Modern Art in an exhibition to mark his eighty-fifth birthday.

1. Haig 2000, p. 111.

2. Correspondence with the artist.

3. See Hall (D.) 2003, p. 16.

4. *ibid.*, p. 64.

72. Lionel Bulmer (1919–1992)
The lamp, c.1961

Educated at Christ's Hospital 1928–36, Lionel Bulmer studied at the Clapham School of Art and at the Royal College of Art 1944–8. His work was shown at the Leicester Galleries, the New English Art Club and the Royal Watercolour Society, and Bulmer also exhibited at the Royal Academy Summer Exhibitions from 1947 onwards. He taught at Kingston College of Art.

Bulmer married the painter Margaret Green, a fellow student at the Royal College of Art, and the couple began a close working relationship which was to last throughout their lives. They were drawn to coastal areas, first renting a room above a boathouse overlooking the Arun estuary at Littlehampton in West Sussex, and later finding a permanent home when they restored a dilapidated medieval hall in a Suffolk hamlet by the river Rat, where they created a studio and a garden. They made many paintings of the landscape around Southwold and Walberswick, as well as domestic scenes such as this delicate interior view of a table and lamp against the background of a patterned curtain, achieved with flat areas of watercolour and crisp outlines.

Lady Fermoy, who purchased this watercolour from the Royal Watercolour Society's Autumn Exhibition in 1961, was Queen Elizabeth's Lady-in-Waiting from 1960 and the grandmother of Diana, Princess of Wales. She was the founder, in 1951, of the King's Lynn Festival.

Watercolour

35 × 45.9 cm (13¼" × 18⅕")

RCIN 453439

PROVENANCE Purchased by Lady Fermoy from the Royal Watercolour Society in 1961; presumably presented to Queen Elizabeth

EXHIBITION London 1961, no. 136

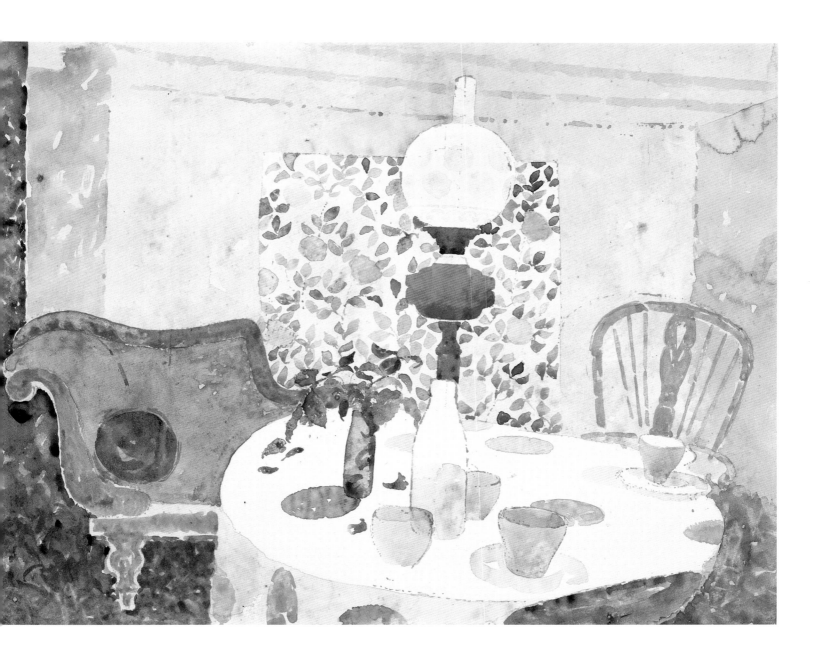

73. John Bratby (1928–1992)
Venezia, 1983

John Bratby executed a number of colourful, linear paintings of Venice in the 1980s, concentrating on the patterns made by reflections in the water and the shapes of gondolas. The view depicted in this wax crayon drawing of Punta della Dogana is seen from a window in the Monaco & Grand Canal Hotel on the San Marco side of the Grand Canal.

Queen Elizabeth visited Venice for the first time in 1984, where she inaugurated the restoration, partly funded by the Venice in Peril Fund, of the Oratory of the Order of Crociferi, which had been badly damaged in the floods of 1966. This trip was widely covered in the media, and on her return Bratby wrote to Clarence House offering this drawing which he had executed the previous year, subsequently sending it to her as a Christmas present. Queen Elizabeth placed it to the left of the chimneypiece in the Morning Room at Clarence House, a room otherwise hung with paintings by Sickert and John.

Bratby first made contact with Queen Elizabeth when he decided to create what he called his 'Hall of Fame' in the mid-1970s, writing to hundreds of famous people inviting them to sit. His portraits, which included Ken Russell, Alec Guinness, Barbara Castle, Tom Stoppard and Iris Murdoch, were to be exhibited at the National Theatre in 1978. In his initial letter to Queen Elizabeth in July 1977 requesting a sitting, Bratby explained that he was making a record 'for future generations of men and women who have marked and influenced this era.'[1]

Bratby, a controversial painter of the 'Kitchen Sink School', admitted to being 'rather surprised' that Queen Elizabeth agreed to sit for the portrait.[2] However, when Sir Oliver Millar, then Surveyor of The Queen's Pictures, was consulted about the proposal, he is reported by Captain Sir Alastair Aird, Comptroller of Queen Elizabeth's household from 1974, to have described Bratby as 'a very entertaining and exciting painter.'[3] A few months earlier Millar had remarked to Aird that in joining Bratby's 'Hall of Fame' Queen Elizabeth would be in 'delightful and – largely – congenial company.'[4] The portrait, however, seems not to have been completed.

Pencil and wax crayon

41.9 × 29.6 cm (16½″ × 11¾″)

Inscribed bottom right *Venezia December 30 1983*; signed bottom right *John Bratby*

RCIN 453373

PROVENANCE Presented by the artist, 1984

1. RA QEQM/POR/18: 28 July 1977 John Bratby to Queen Elizabeth.

2. *Daily Mail*, Friday 30 December 1977, p. 7.

3. RA QEQM/POR/18: 24 October 1977 Alastair Aird to Queen Elizabeth. Aird was also Queen Elizabeth's Private Secretary and Equerry from 1993.

4. RA QEQM/POR/18: 8 August 1977 Oliver Millar to Alastair Aird.

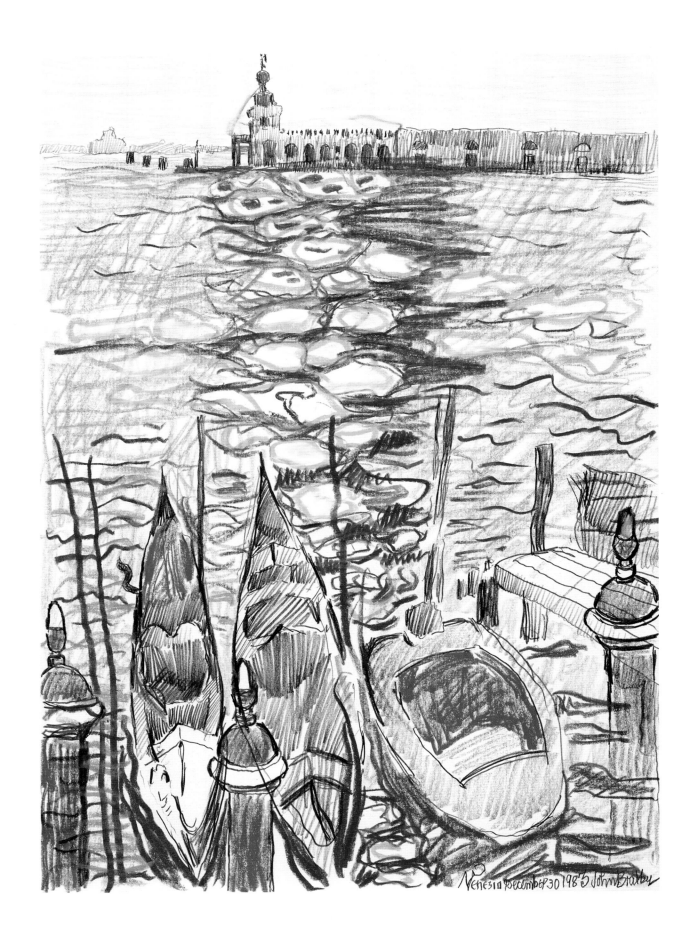

Venezia December 30 1985 John Bratby

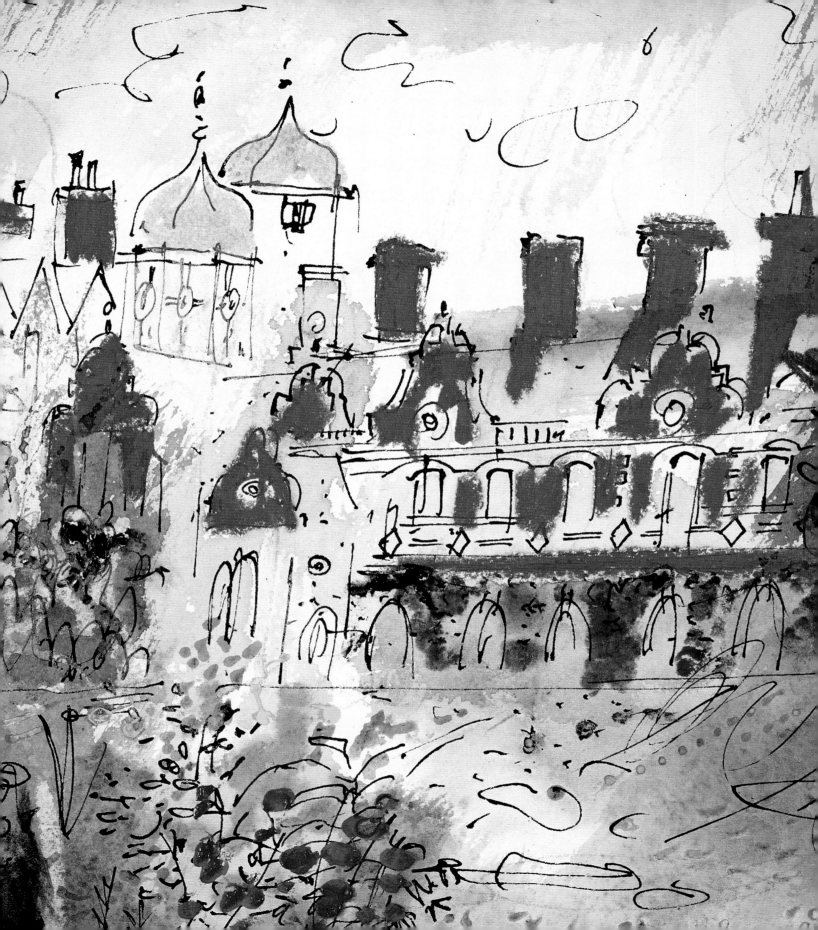

Bibliography

I am indebted to the late John Cornforth's book *Queen Elizabeth The Queen Mother at Clarence House*, and to his two *Country Life* articles 'Pictures at Clarence House: HM Queen Elizabeth The Queen Mother as Collector I' (4 September 1980) and 'Independence and Continuity: HM Queen Elizabeth The Queen Mother as Collector II' (11 September 1980), all of which contain much important material.

Valuable sources of information about the art world in Britain in the 1930s and 1940s have been John Rothenstein, *Brave Day Hideous Night. Autobiography 1939–1965*, London 1966; Meryl Secrest, *Kenneth Clark. A Biography*, London 1984; and Frances Spalding, *The Tate. A History*, London 1998. For my work on John Piper I am indebted to two works by David Fraser Jenkins, *John Piper*, London 1983, and *John Piper. The Forties*, London 2000; for that on Paul Sandby I am grateful to Jane Roberts for her *Views of Windsor. Watercolours by Thomas and Paul Sandby*, London 1995.

Addey 2002
D. Addey, *A Voyage round Great Britain, volume IV: Orkney to Southend-on-Sea*, Kent

Asquith 1928
C. Asquith, *The Duchess of York*, London

Ballantine 1866
J. Ballantine, *The Life of David Roberts, RA*, Edinburgh

Beaton 1946
C. Beaton, *Time Exposure*, 2nd edn, London

Beaton 1979
Self-portrait with Friends. The Selected Diaries of Cecil Beaton, ed. R. Buckle, London

Beerbohm & Rothenstein 1975
Max and Will. Max Beerbohm and William Rothenstein their Friendship and Letters 1893–1945, ed. M.M. Lago and K. Beckson, London

Behrman 1960
S.N. Behrman, *Conversations with Max*, London

Betjeman 1944
J. Betjeman, *The Penguin Modern Painters. John Piper*, London

Betjeman 1994
J. Betjeman, *Letters Volume One. 1926 to 1951*, ed. C. Lycett Green, London

Carter 2001
M. Carter, *Anthony Blunt: His Lives*, London

Casson 1975
H. Casson, *Sketch Book. A Personal Choice of London Buildings from 1971–1974*, London

Casson 1981
Hugh Casson Diary, London

Cecil 1964
D. Cecil, *Max. A Biography*, London

Channon 1967
Chips. The Diaries of Sir Henry Channon, ed. R. Rhodes James, London

Clark 1939
K. Clark, 'Art for the People', *Listener*, XII, pp. 999–1001

Clark 1977
K. Clark, *The Other Half. A Self-portrait*, London

Conner 1984
P. Conner, *Michael Angelo Rooker 1746–1801*, London

Cork 1987
R. Cork, *David Bomberg*, New Haven and London

Cornforth 1996
J. Cornforth, *Queen Elizabeth The Queen Mother at Clarence House*, London

Dilworth 2000
T. Dilworth, 'Letters from David Jones to Kenneth Clark', *Burlington Magazine*, CXLII, pp. 215–25

Duff 1965
D. Duff, *Mother of the Queen. The Life Story of Her Majesty Queen Elizabeth The Queen Mother*, London

Evans 1998
M. Evans, ed., *Princes as Patrons. The Art Collections of the Princes of Wales from the Renaissance to the Present Day: an Exhibition from the Royal Collection*, exh. cat., London

Haig 2000
The Earl Haig, *My Father's Son*, Barnsley

Hall (N.J.) 1997
N.J. Hall, *Max Beerbohm Caricatures*, New Haven and London

Hall (D.) 2003
D. Hall, *Haig the Painter*, Edinburgh

Harries & Harries 1983
M. and S. Harries, *The War Artists. British Official War Art of the Twentieth Century*, London

Hart-Davis 1972
R. Hart-Davis, *A Catalogue of the Caricatures of Max Beerbohm*, London

Hoare 1990
P. Hoare, *Serious Pleasures. The Life of Stephen Tennant*, London

Holroyd 1997
M. Holroyd, *Augustus John. The New Biography*, London

Ironside 1941
R. Ironside, 'The Tate Gallery: Wartime Acquisitions', *Burlington Magazine*, LXXVIII, pp. 53–7

Ironside 1948
R. Ironside, *Since 1939. Ballet Films Music Painting*, London

Fraser Jenkins & Spalding 2003
D. Fraser Jenkins and F. Spalding, *John Piper in the 1930s. Abstraction on the Beach*, exh. cat., London

Jones 1980
Dai Greatcoat. A self-portrait of David Jones in his Letters, ed. R. Hague, London

Lees-Milne 1975
J. Lees-Milne, *Ancestral Voices*, London

Lees-Milne 1977
J. Lees-Milne, *Prophesying Peace*, London

Lyles 1994
A. Lyles, 'John Varley's Thames: Varieties of Picturesque Landscape c.1805–1835', *Old Water-Colour Society's Club Journal*, LXIII, pp. 1–37

Lyles & Hamlyn 1997
A. Lyles and R. Hamlyn, *British Watercolours from the Oppé Collection*, exh. cat., London

McKibbin 1956
D. McKibbin, *Sargent's Boston, with an Essay and a Biographical Summary and a Complete Check List of Sargent's Portraits*, Boston

Miles 1991
R. Miles, *Elizabeth Keith. The Printed Works*, exh. cat., Pasadena

Miles & Shiel 1995
J. Miles and D. Shiel, *David Jones. The Maker Unmade*, Bridgend

Millar (D.) 1995
D. Millar, *The Victorian Watercolours and Drawings in the Collection of Her Majesty The Queen*, London

Millar (O.) 1969
O. Millar, *The Later Georgian Pictures in the Collection of Her Majesty The Queen*, London

Moskowitz 1961
I. Moskowitz, ed., *Berthe Morisot. Drawings / Pastels /Watercolours /Paintings*, London

Muncaster 1978
M. Muncaster, *The Wind in the Oak. The Life, Work and Philosophy of the Marine and Landscape Artist Claude Muncaster*, London

Nicolson 1968
B. Nicolson, *Joseph Wright of Derby. Painter of Light*, 2 vols., London

North 1979
I. North, *Hans Heysen*, Melbourne

Oppé 1947
A.P. Oppé, *The Drawings of Paul and Thomas Sandby in the Collection of His Majesty The King at Windsor Castle*, Oxford and London

Pinkham 1983
R. Pinkham, ed., *Oliver Messel*, exh. cat., London

Roberts 1987
J. Roberts, *Royal Artists from Mary Queen of Scots to the Present Day*, London

Roberts 1995
J. Roberts, *Views of Windsor. Watercolours by Thomas and Paul Sandby*, exh. cat., London

Roberts 1997
J. Roberts, *Royal Landscape. The Gardens and Parks of Windsor*, New Haven and London

Rothenstein (J.) 1966
J. Rothenstein, *Brave Day Hideous Night. Autobiography 1939–1965*, London

Rothenstein (W.) 1931–2
W. Rothenstein, *Men and Memories. Recollections of William Rothenstein*, 2 vols., London

Secrest 1984
M. Secrest, *Kenneth Clark. A Biography*, London

Strong 1992
R. Strong, *Royal Gardens*, London

Thuillier 1985
R. Thuillier, *Marcus Adams. Photographer Royal*, London

Whistler 1985
L. Whistler, *The Laughter and the Urn. The Life of Rex Whistler*, London

Whistler & Fuller 1960
L. Whistler and R. Fuller, *The Work of Rex Whistler*, London

Ziegler 1998
P. Ziegler, *Osbert Sitwell*, London

Exhibitions

London 1926
Exhibition of works by the late John S. Sargent, Royal Academy

Chicago 1930
10th International Exhibition of Watercolours, Art Institute of Chicago

London 1942
Recording Britain, National Gallery

London 1943
Artists' Aid China Exhibition, Wallace Collection

Edinburgh 1945
The Earl Haig Exhibition, Aitken Dott & Son (The Scottish Gallery)

London/Melbourne 1947 & 1949
The Exhibition of Paintings of Wartime Britain by Norma Bull, Australia House 1947; Melbourne Town Hall 1949

London 1954–5
David Jones. Exhibition of Paintings, Drawings and Engravings, Welsh Committee of the Arts Council, Tate Gallery

Norwich 1957–8
Modern Movement in British Watercolour Painting, Norwich Castle Museum

London 1958
Joseph Wright of Derby 1734–1797. An Exhibition of Paintings and Drawings, Arts Council

Norwich 1959
Paintings and Drawings by Joseph Wright of Derby, from the Derby Museum, Norwich Castle Museum

London 1961
Royal Watercolour Society Autumn Exhibition

London 1963
Private Views. Works from the Collections of Twenty Friends of the Tate Gallery, Tate Gallery

New York 1978
English Sketches and Studies, Davis & Long Company

London 1978
English Sketches and Studies, Anthony Reed

Leeds/London/Detroit 1979
John Singer Sargent and the Edwardian Age, Leeds Art Galleries; National Portrait Gallery; Detroit Institute of Arts

London 1980
The Queen Mother. A Celebration, National Portrait Gallery

King's Lynn 1983
John Piper. Watercolours of Windsor, The Fermoy Gallery

London 1983–4
John Piper, Tate Gallery

Adelaide 1986
Adelaide Festival of Arts, Art Gallery of South Australia

London 1986
Master Drawings in the Royal Collection. From Leonardo to the Present Day, The Queen's Gallery

London 2000
Royal Watercolour Society Autumn Exhibition, Bankside Gallery

London 2000–1
John Piper. The Forties, Imperial War Museum

Index

Photographic Acknowledgements

All works reproduced are in the Royal
Collection, © HM Queen Elizabeth II,
unless indicated otherwise below. Royal
Collection Enterprises are grateful for
permission to reproduce the following:

Half title: © Estate of Rex Whistler 2005.
All Rights Reserved, DACS.
Frontispiece: Copyright Trustees of the
David Jones Estate/The Royal Collection.

ACCOMPANYING ILLUSTRATIONS
Fig. 1 By courtesy of the Augustus John
Estate © 2005/The Royal Collection;
fig. 2 © Estate of Sir Matthew Smith/
The Royal Collection; fig. 4 Estate of Lord
Clark; fig. 5 The Times/NI Syndication;
fig. 6 The De Lászlo Archive Trust/

The Royal Collection; fig. 7 The Earl Haig;
fig. 8 V&A Images/Victoria and Albert
Museum; fig. 9 © Reserved/The Royal
Collection; fig. 11 Sir Adam Ridley;
fig. 12 © Estate of Walter R. Sickert 2005.
All Rights Reserved, DACS/The Royal
Collection; fig. 13 © Tate London/
The Royal Collection; fig. 14 V&A Images/
Victoria and Albert Museum; fig. 15 Estate
of Sir John Betjeman; fig. 19 The John
Murray Collection; fig. 20 photograph:
Mark Fiennes, 1996; figs. 21–2 © Estate of
Rex Whistler 2005. All Rights Reserved,
DACS; fig. 23 Picture Post/Getty Images;
figs. 24–5 By courtesy of the Augustus John
Estate © 2005/The Royal Collection;
fig. 26 Estate of Edward Seago;
fig. 28 Trustees of the Royal Watercolour
Society; fig. 29 photographer: Mark Fiennes,
1996; fig. 30 © reserved/The Royal
Collection; fig. 31 photograph: Lafayette;
figs. 33–8 Copyright the Estate of Sir Max
Beerbohm, reprinted by permission of

Berlin Associates; fig. 39 V&A Images/
Edward Mandinian/Theatre Museum.

CATALOGUE ILLUSTRATIONS
Nos. 1, 2, 7, 8, 9 © reserved/The Royal
Collection; 10 ©Trustees of the Claude
Muncaster Estate/The Royal Collection;
11 © Trustees of Sir Muirhead Bone Estate/
The Royal Collection; 12 © reserved/
The Royal Collection; 13 Trustees of
Feliks Topolski Estate/The Royal Collection;
14 © copyright Sir Hugh Casson 2005/
The Royal Collection; 15 Charlotte
Halliday/The Royal Collection;
32 © Trustees of the Claude Muncaster
Estate/The Royal Collection;
35–8 © Sir Hugh Casson 2005/The Royal
Collection; 49 © reserved/The Royal
Collection; 50–1 Copyright of the Estate
of Sir Max Beerbohm, reprinted by
permission of Berlin Associates;
53–4 By courtesy of the Augustus John
Estate © 2005/The Royal Collection;

55 © reserved/The Royal Collection;
56–7 © reserved/The Royal Collection;
58 Copyright Trustees of the David Jones
Estate/The Royal Collection; 60 © courtesy
of the Dring estate/The Bridgeman Art
Library/The Royal Collection;
61–2 Lord Snowdon/The Royal Collection;
63–6 © reserved/The Royal Collection;
66 © reserved/The Royal Collection;
67 with the permission of the Trustees
of Feliks Topolski Estate/The Royal
Collection; 68–70 Estate of Edward Seago;
71 The Earl Haig; 72 The Bulmer Estate/
The Royal Collection.

Every effort has been made to contact the
copyright holders of material reproduced
in this publication. Any omissions are
inadvertent and will be rectified in future
editions if notification of the correct credit
is sent to the publisher in writing.